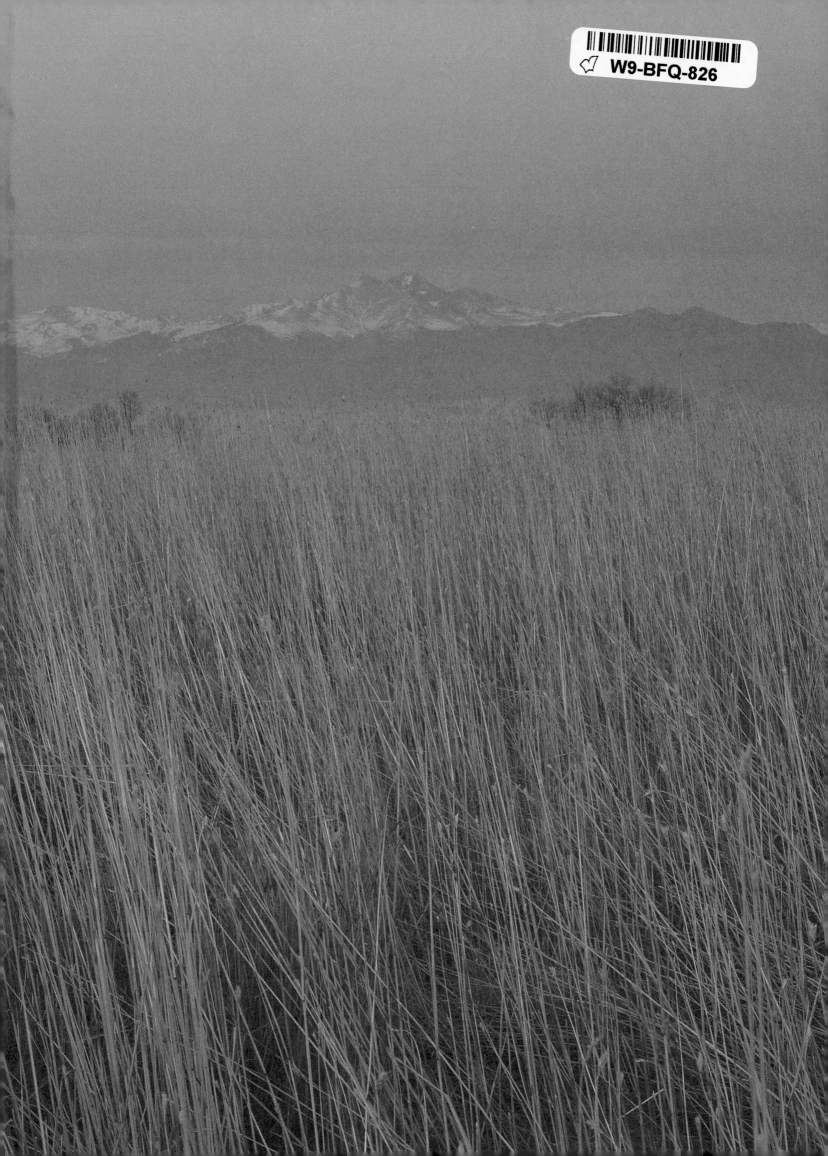

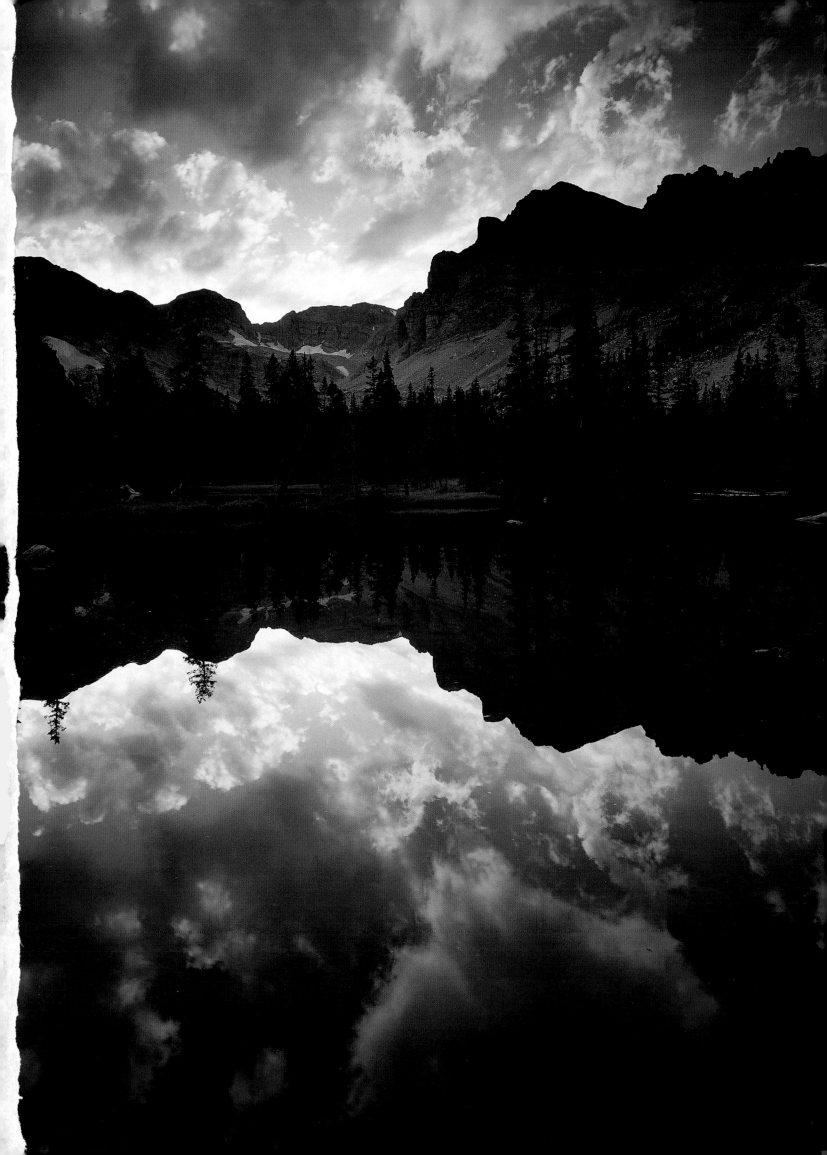

MOUNTAINS

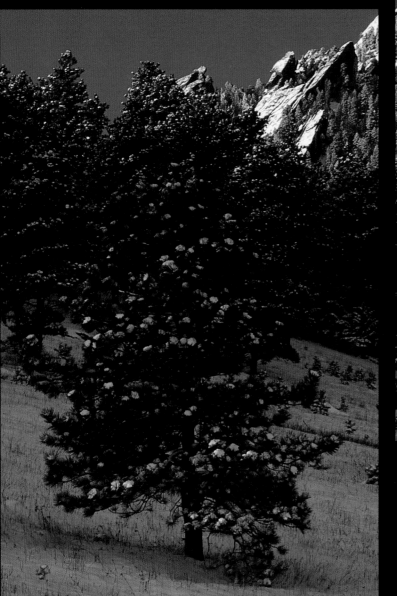
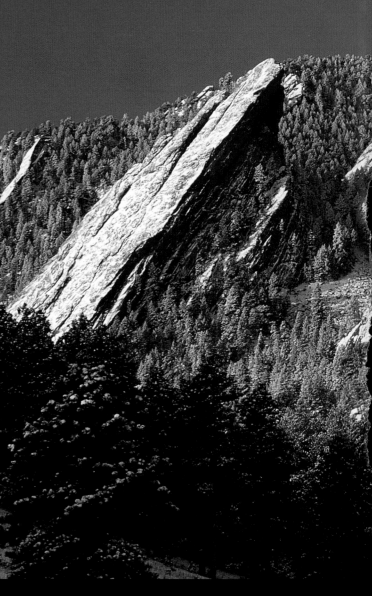

of COLORADO

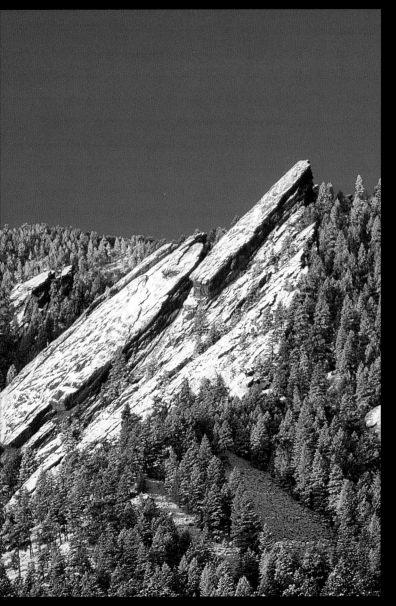

PHOTOGRAPHS BY ERIC WUNROW

ESSAYS BY RICHARD D. LAMM

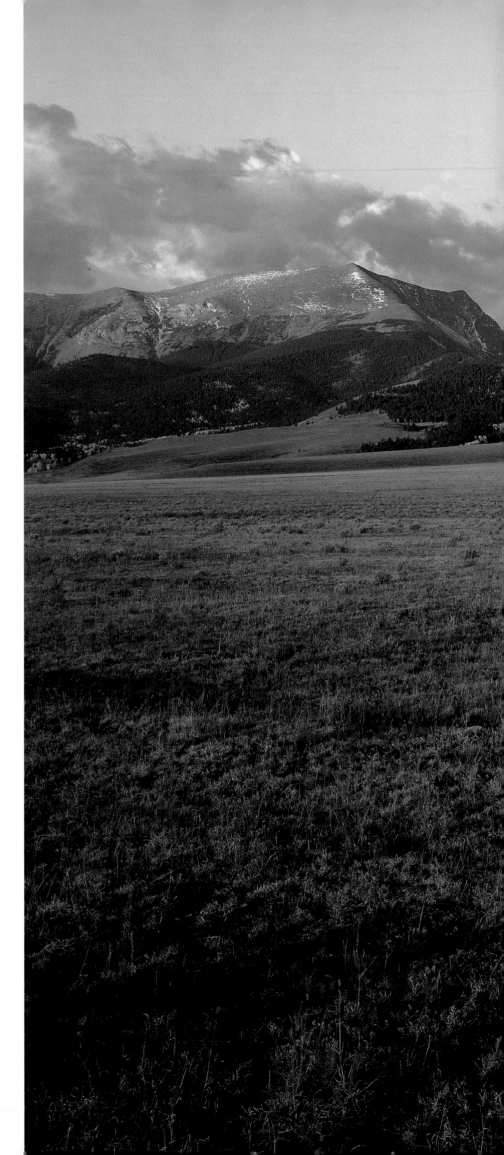

Photographs and essays pages 6, 9, 31, 45, 69, 85, 105, and 127 © *MCMXCIX by* Eric Wunrow

Essays pages 27, 41, 65, 81, 101, and 123 © *MCMXCIX by* Richard D. Lamm

Photos on Pages 26, 40, 64, 80, 100 & 122 by Carl Blaurock, courtesy Nelson Giesecke

Quote on page 81 from Beyond the Aspengrove © 1988 by Ann Zwinger, published by the University of Arizona

Quote on dust jacket back from Our National Parks © 1901 by John Muir, published by Houghton, Mifflin and Company

Compilation of photographs and essays © *MCMXCIX by* Graphic Arts Center Publishing Company P.O. Box 10306 Portland, Oregon 97296-0306 503-226-2402 www.gacpc.com

Library of Congress Cataloging-in-Publication Data:
 Wunrow, Eric, 1960–
 Mountains of Colorado / photography by Eric Wunrow ; essays by Richard D. Lamm
 p. cm.
 ISBN 1-55868-470-0 (hardbound : alk. paper)
 1. Natural history–Colorado. 2. Mountains–Colorado. I. Lamm, Richard D. II. Title.
 QH105.C6W85 1999
 508.788–dc21
 99-25301
 CIP

President/Publisher–Charles M. Hopkins

Editorial Staff–Douglas A. Pfeiffer, Ellen Harkins Wheat, Timothy W. Frew, Diana S. Eilers, Jean Andrews, Alicia I. Paulson, Deborah J. Loop, Joanna M. Goebel

Freelance Editor–David Abel

Production Staff–Richard L. Owsiany, Lauren Taylor, Heather Hopkins

Book Design and Map Art–Eric Wunrow

Book Manufacturing–Lincoln & Allen Co.

Printed in the United States of America First Printing

HALF TITLE PAGE *Sunset clouds reflect Elk Tooth (12,848 feet) and the St. Vrain Glaciers, Indian Peaks Wilderness, Front Range.*

TITLE PAGE *The Third, Second, and First Flatirons (left to right) are visible from the city of Boulder.*

RIGHT *An autumn dawn above the Wet Mountain Valley bathes high peaks of the Sangre de Cristo Mountain Range in gold.*

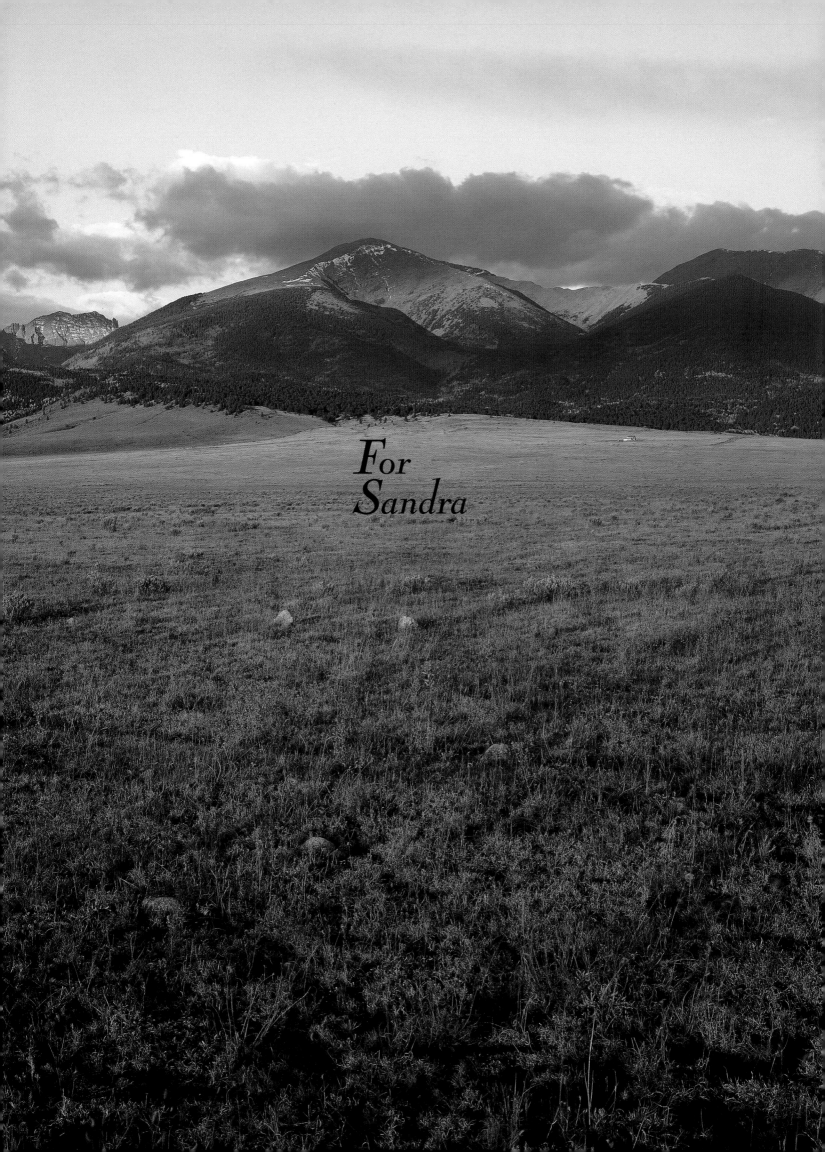

For
Sandra

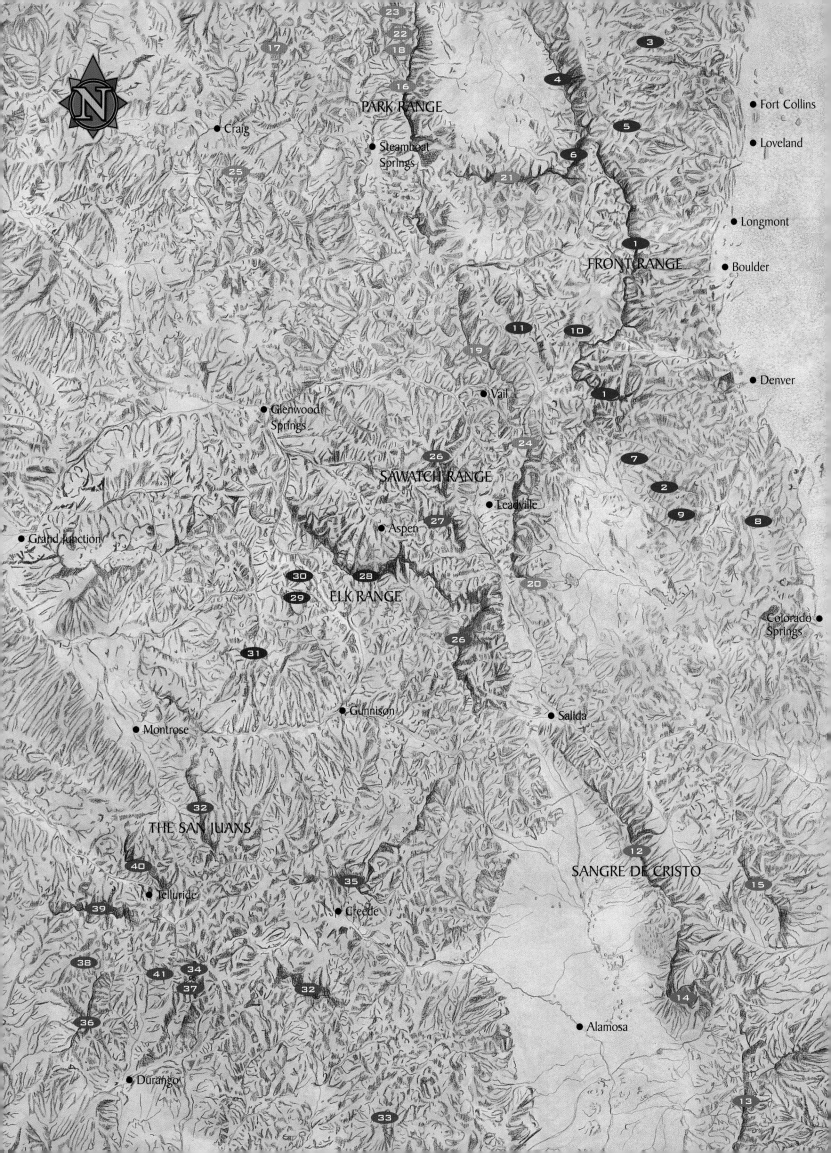

Mountain Ranges

• Pueblo

• Walsenburg

• Trinidad

Contents

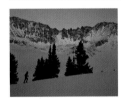
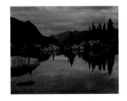
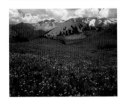

PREFACE *One Step at a Time*

With thousands of miles of trails to explore, and refuges of wilderness deep enough that the wildlife seem hardly to recognize humans, the mountains of Colorado enrapture visitors as much today as they have in centuries past.

Imagine being a mapmaker with the Hayden Survey in the early 1870s, when grizzly bears ran free and thousands of summits awaited the first tread of a modern foot upon them. Crossing Colorado was an enormous proposition in those days; mountain pioneers ventured deep into the unknown with only hand-fashioned clothing and rudimentary equipment. A good mule and common sense were indispensable for survival.

Many wonderful tales of those days were shared with me by Carl Blaurock, who, in 1923 (with partner Bill Ervin), became the first to ascend all of the Colorado fourteeners. Even into his nineties, Carl spoke through an uncanny memory, as if replaying his life. He remembered his "closest call" in vivid detail: narrowly escaping death after a fall of several hundred feet down one of the St. Vrain Glaciers. Our image of those distant glaciers on page 1 is dedicated to Carl's spirit of adventure, and I am honored to share some of his wonderful black-and-white images within these pages.

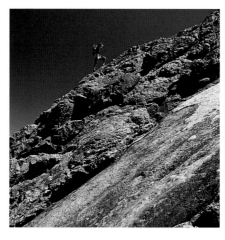

Mountains are a source of inspiration for all those who venture into them, and even for those who merely let them touch their eyes and souls. They seem able to produce miracles, like the one my wife, Sandra, and I experienced on the 14,081-foot summit of Challenger Point, a Sangre de Cristo peak named for the space shuttle. We had planned the climb as a tribute to our friend Lars Grimsrud, an aerospace engineer who lay dying of cancer. We read aloud from the summit plaque that spoke of the shuttle disaster, joining hands to dedicate the climb to Lars. At that very moment, on a windless day, we felt a rush of air brush by our heads. A bald eagle had barely missed us, circling around just long enough to stand our hair on end. That was only the second bald eagle I had seen in a decade of Colorado trekking. In an extension of the miracle, Lars subsequently recovered and continues on the walk of life.

Backcountry travel is the walk of life for us, a constant reminder that things worth doing are never easy. The often unbearable stresses of life are erased in a few steps toward the heights.

Mountains embrace respect, not ego. Falling in love with mountains rewards those who recognize their frailties. The concept of time means very little in the alpine world, yet mountains are products of time. We must treat them with our respect and passion, yet they seem to care nothing about us. Several near misses of rockfall and lightning have etched this into me, but when clouds part at the last moment to give us the only light for fifty miles around, it seems an intentional blessing.

—Eric Wunrow

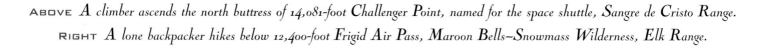

ABOVE *A climber ascends the north buttress of 14,081-foot Challenger Point, named for the space shuttle, Sangre de Cristo Range.*
RIGHT *A lone backpacker hikes below 12,400-foot Frigid Air Pass, Maroon Bells–Snowmass Wilderness, Elk Range.*

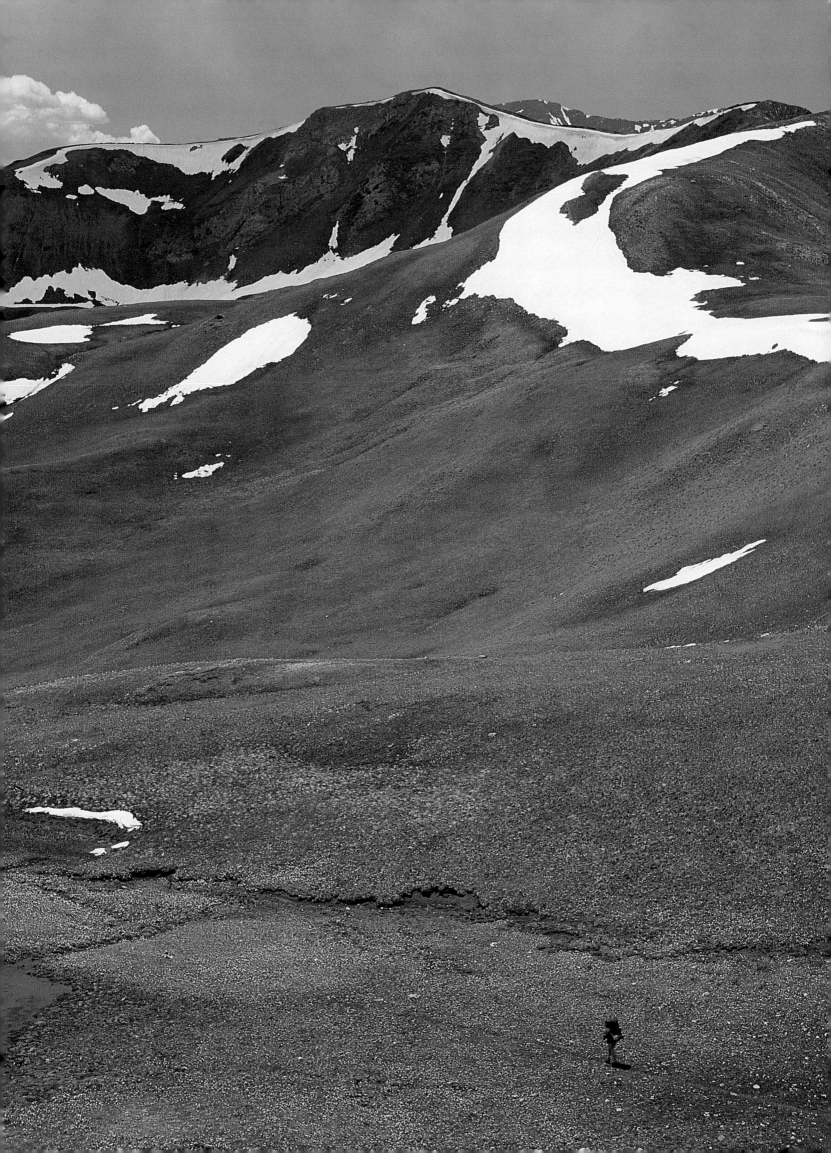

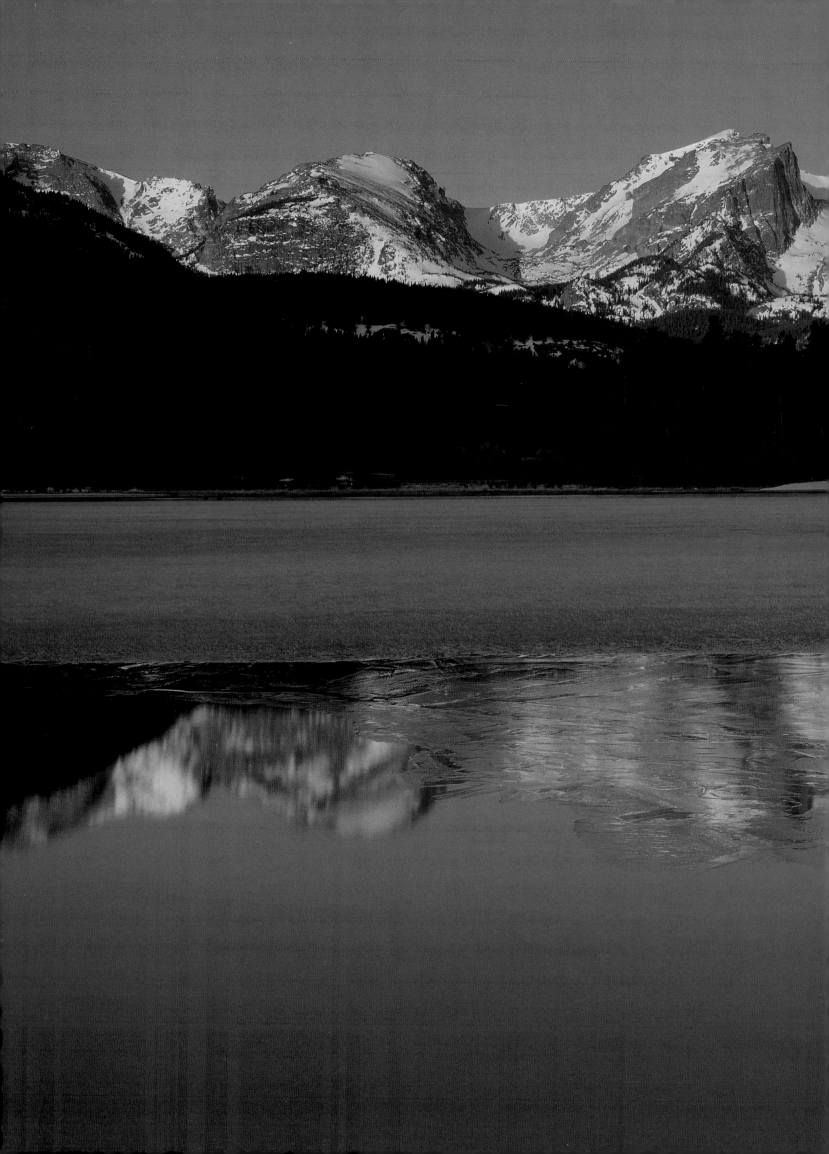

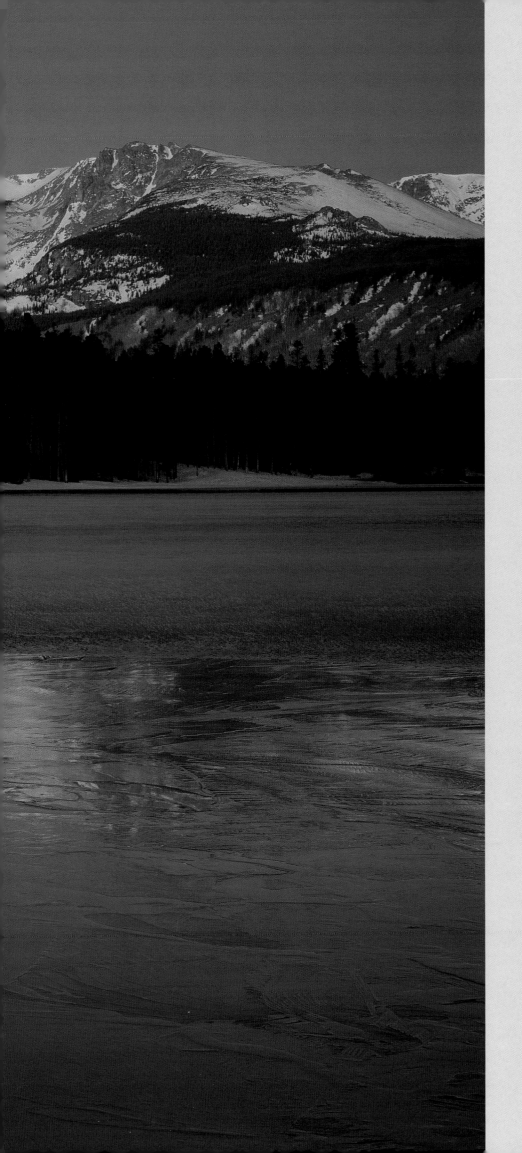

FRONT RANGE

For legions of plains-weary travelers, the Front Range represents the quintessential image of the Colorado Rockies. First-time visitors often become so enamored of Rocky Mountain National Park, the range's northern jewel, that they never manage to explore beyond it.

Extending more than 160 miles, from the Medicine Bows in the north to Pikes Peak in the south, the Front Range contains ten named subranges. Despite its proximity to many of Colorado's major population centers, areas of solitude and reprieve can still be found within it. For instance, Mount Evans offers the people of Denver isolation in their own backyard, a realm of ancient forests and the highest paved road in the Western Hemisphere.

The Front Range was formed through centuries of extensive glaciation. Great rivers of ice and rock carved deep valleys from the high mountain peaks. One of the largest and most impressive headwalls in the United States, the East Face of Longs Peak is a classic glacial cirque, a steep-sided mountain basin. Small glaciers can still be seen in Rocky Mountain National Park, as well as in the Indian Peaks Wilderness Area.

—EW

LEFT *At 12,713 feet, the sheer-walled Hallett Peak (center) stands out among the peaks of the Continental Divide above Sprague Lake in the Rocky Mountain National Park.*

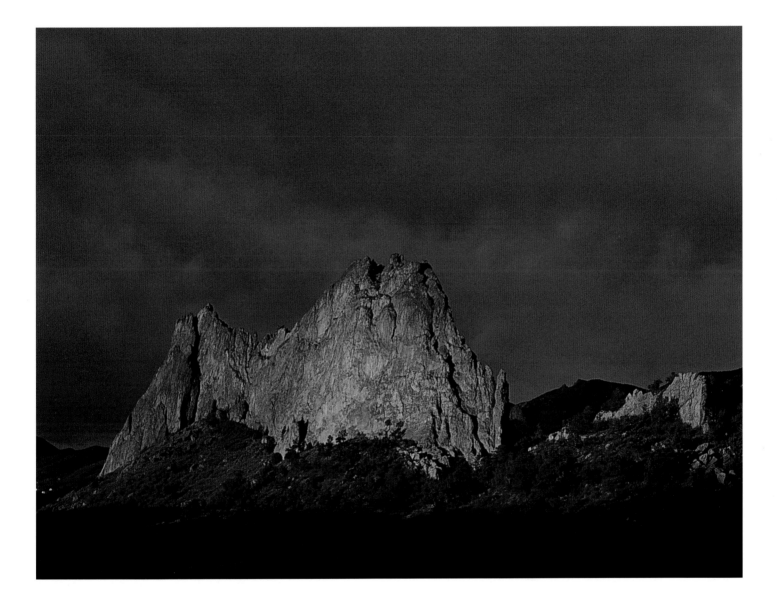

LEFT *Pines cling to boulders above Lost Creek, which flows two hundred feet underground, Lost Creek Wilderness, Tarryall Mountains.*
ABOVE *Cathedral Rock, in the Garden of the Gods Park, Rampart Range foothills, is an eastern remnant of the ancestral Rockies.*

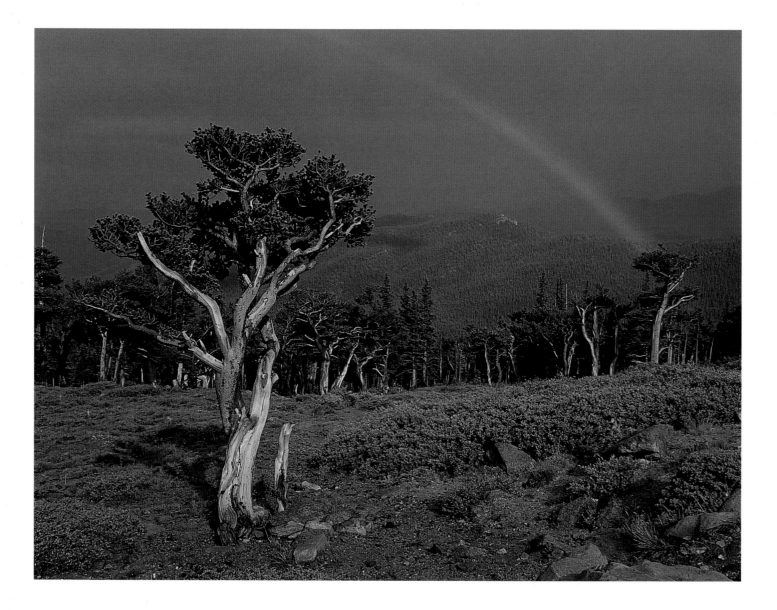

ABOVE *Sunlight pierces a storm to reveal fifteen-hundred-year-old bristlecone pines, Mount Goliath Natural Area, Mount Evans.*
RIGHT *Known as the Boilerplates by mountaineers, the summit cliffs of 14,264-foot Mount Evans tower above Summit Lake.*

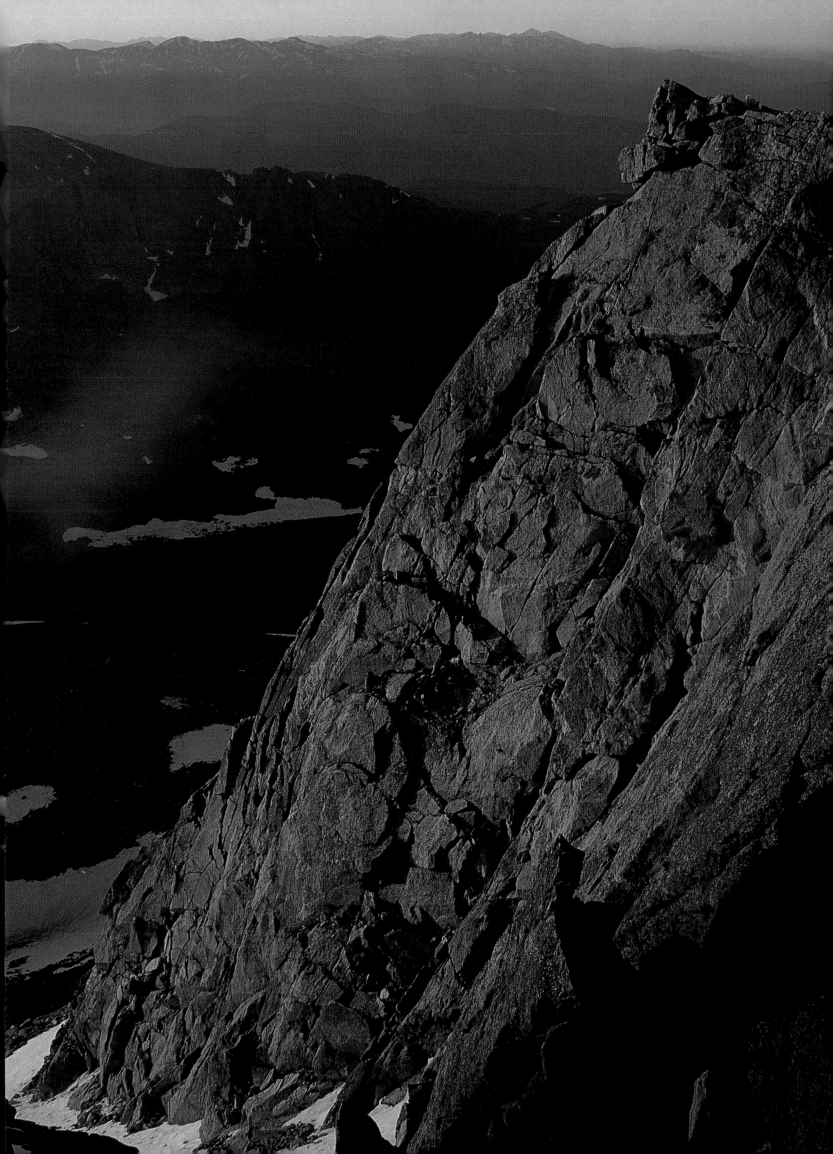

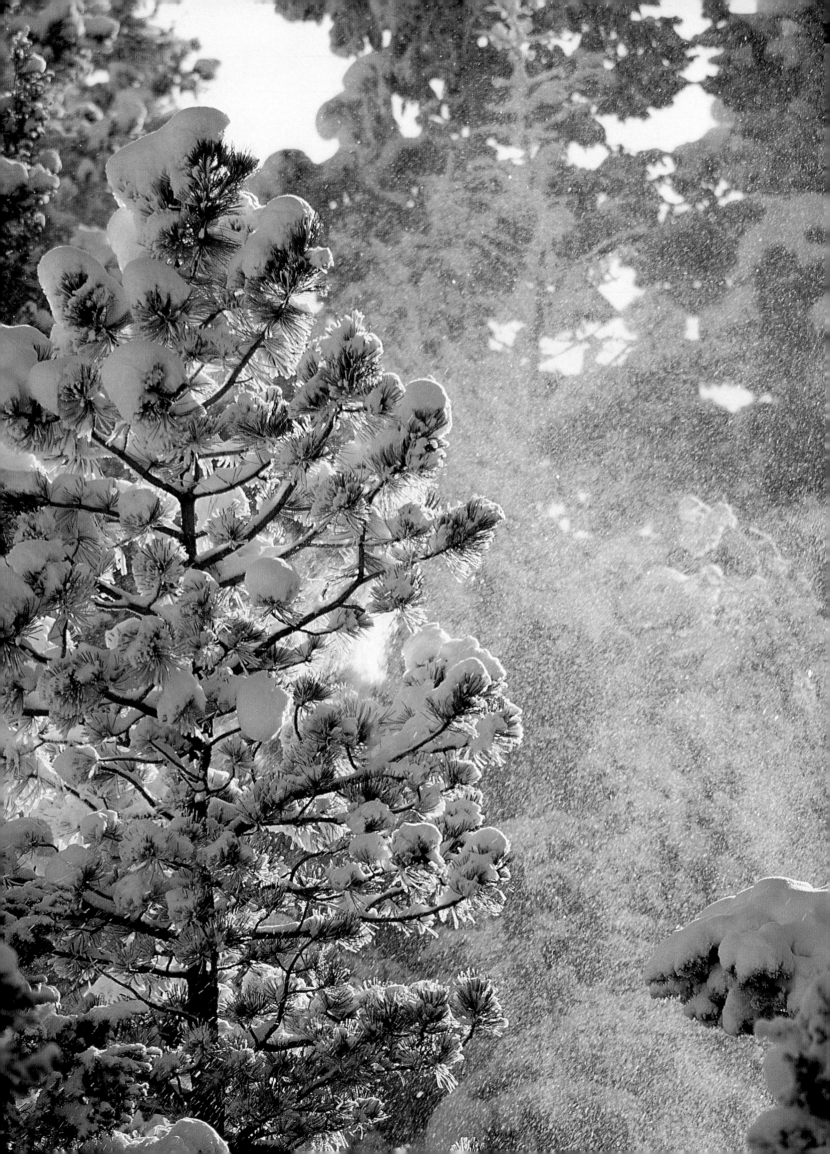

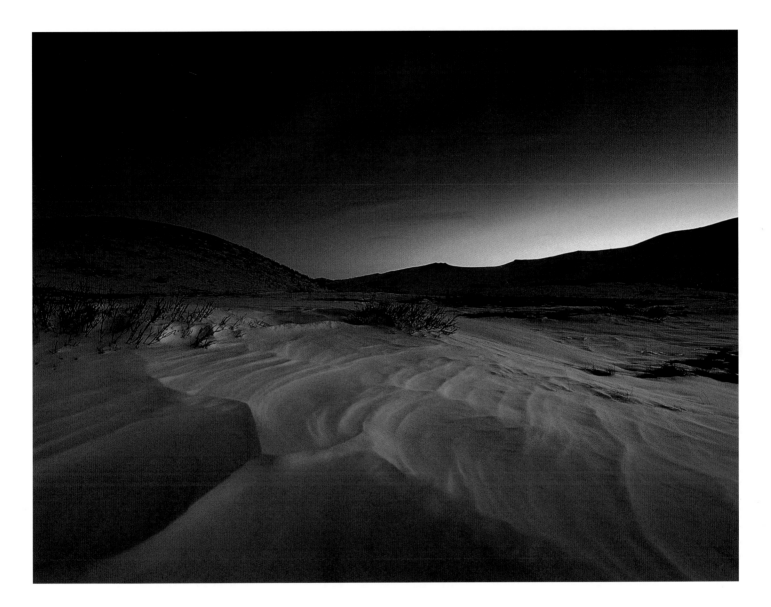

LEFT *Snowflakes wander lazily in the breeze after a Thanksgiving morning storm on Lookout Mountain, a foothill near Denver.*

ABOVE *Blowing snow forms ever-changing drifts as a frigid winter dusk descends into night, Guanella Pass.*

BELOW *A snowshoer reaches 11,669-foot Guanella Pass below Sawtooth Ridge of Mount Bierstadt.*

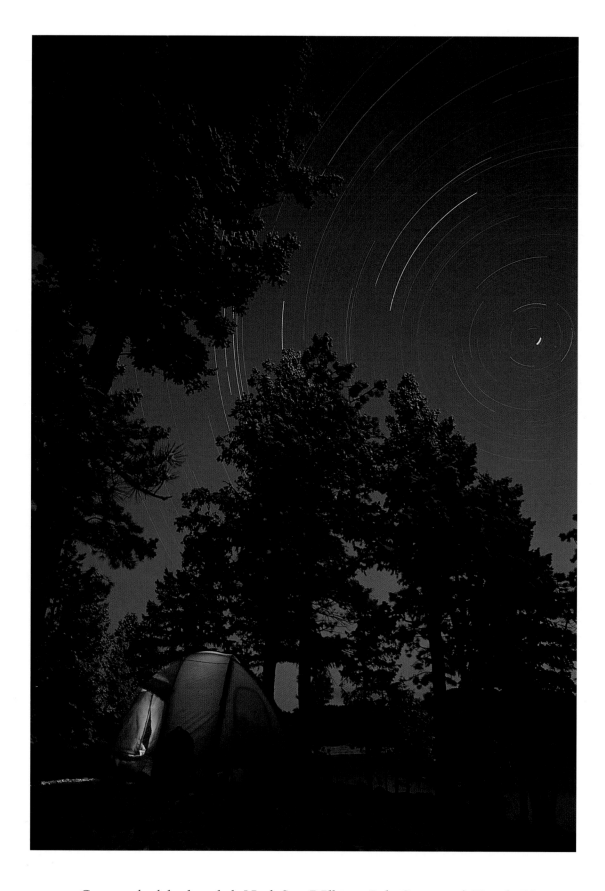

ABOVE *Campers take shelter beneath the North Star, Wellington Lake Campground, Kenosha Mountains.*
RIGHT *A climber negotiates giant icicles on a cliff in Boulder Canyon, near Boulder.*
OVERLEAF *The Flatirons, near Boulder, are a climber's paradise.*

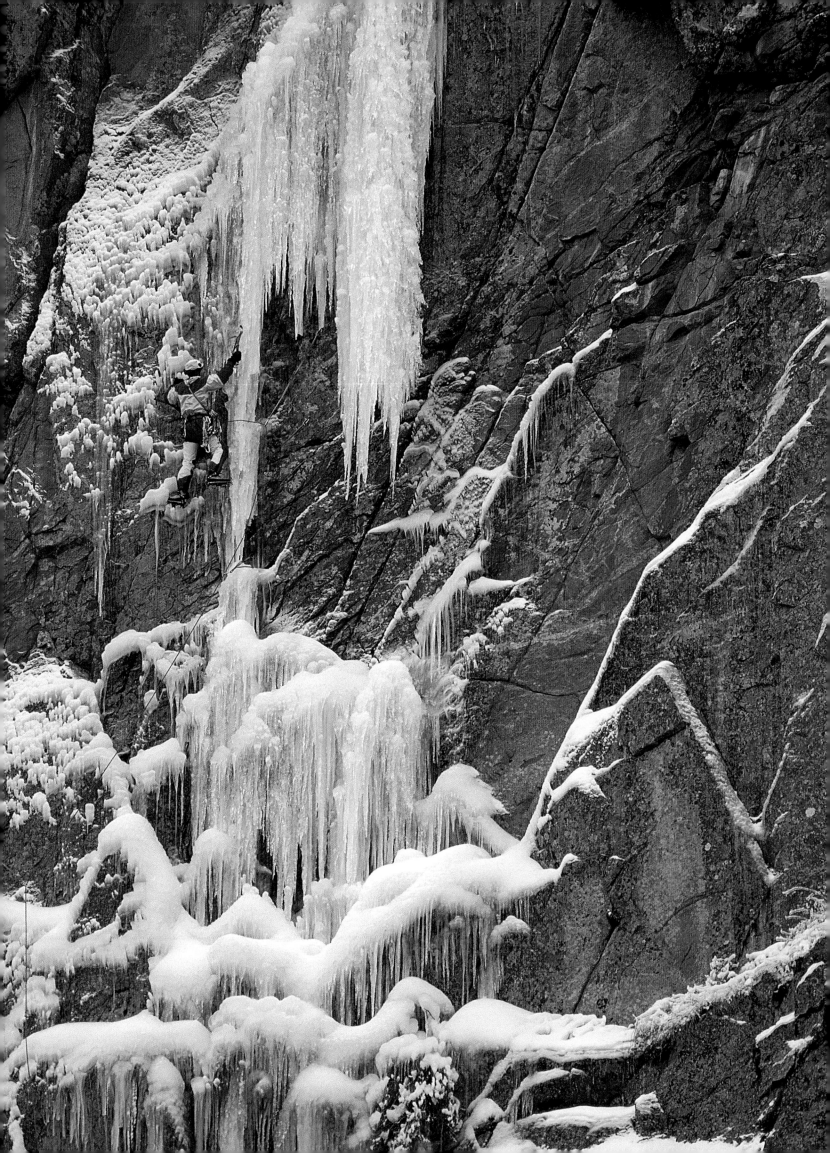

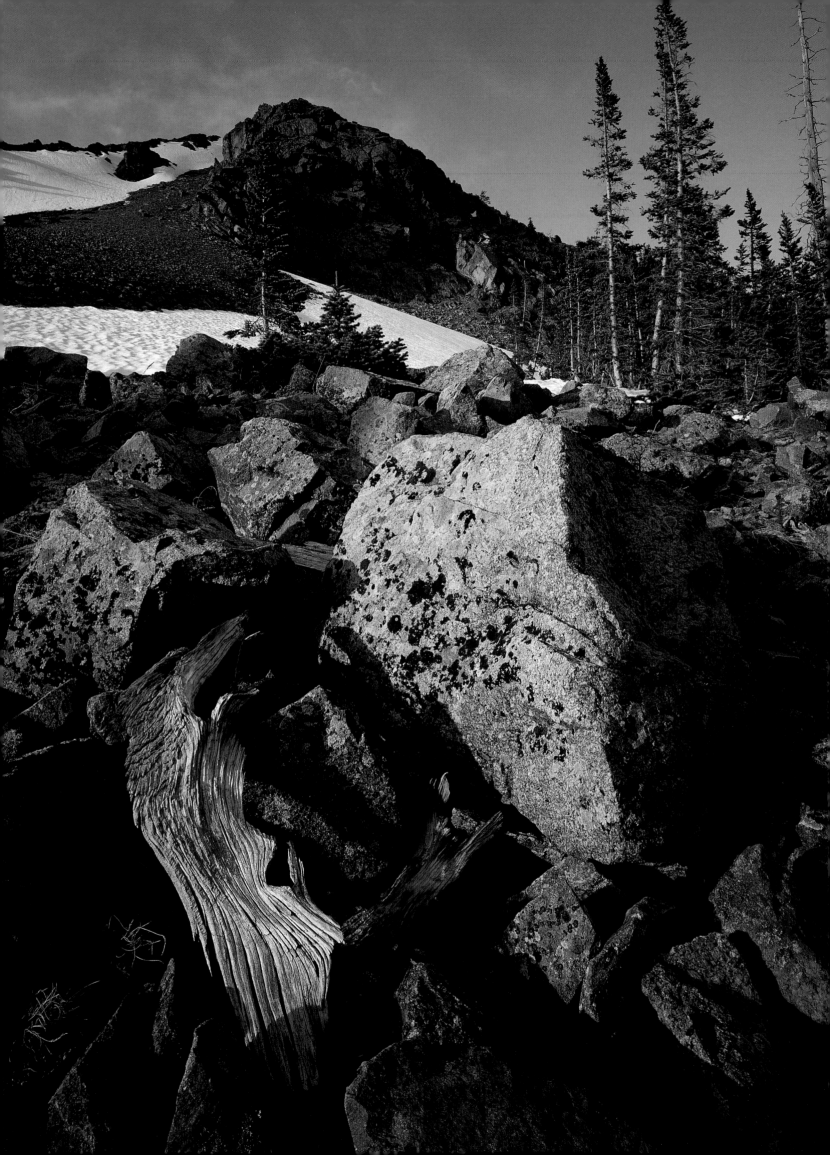

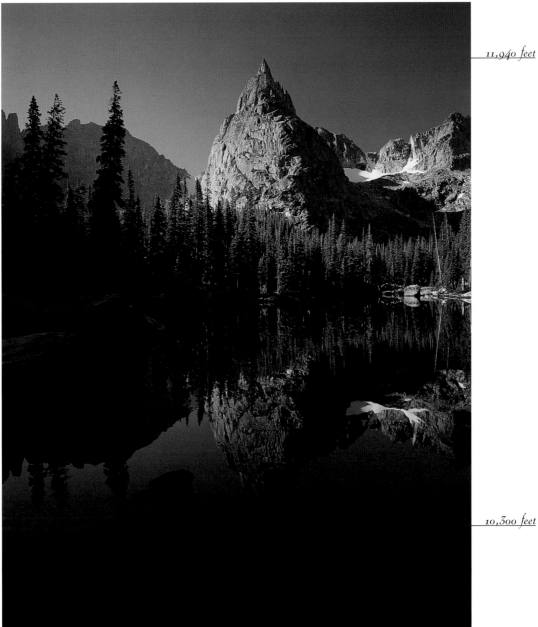

11,940 feet

10,300 feet

LEFT *Granite boulders are strewn below 12,940-foot Woods Mountain, Herman Gulch.*
ABOVE *Lone Eagle Peak, named by Carl Blaurock, honors aviator Charles Lindbergh.*
BELOW *Cascade Falls provide summer relief, Indian Peaks Wilderness.*

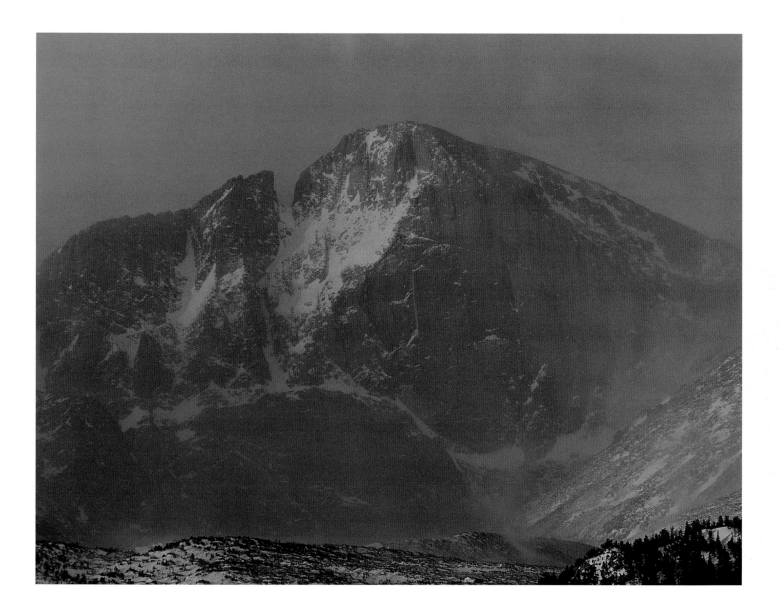

ABOVE *A winter dawn sets clouds afire above the East Face of Longs Peak (14,255 feet), Rocky Mountain National Park.*
RIGHT *Aspens flourish in the shadow of 13,514-foot Ypsilon Mountain, Mummy Range, Rocky Mountain National Park.*

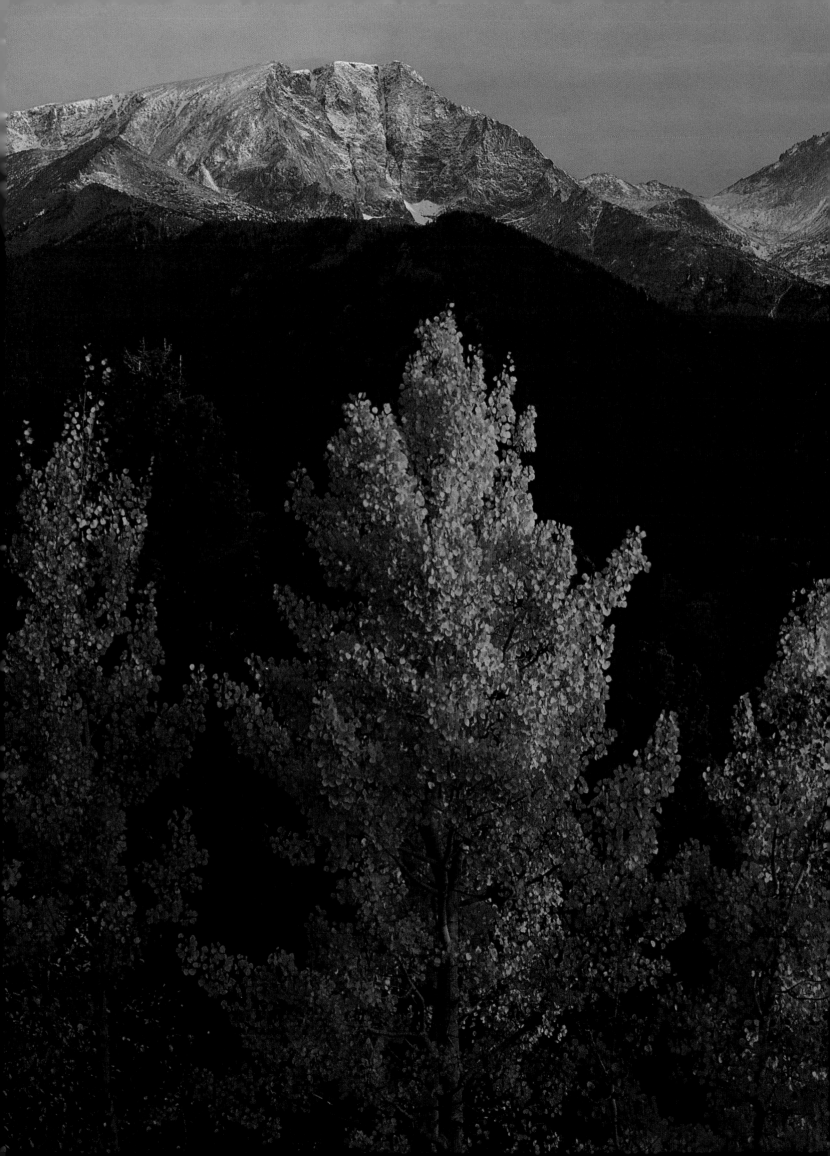

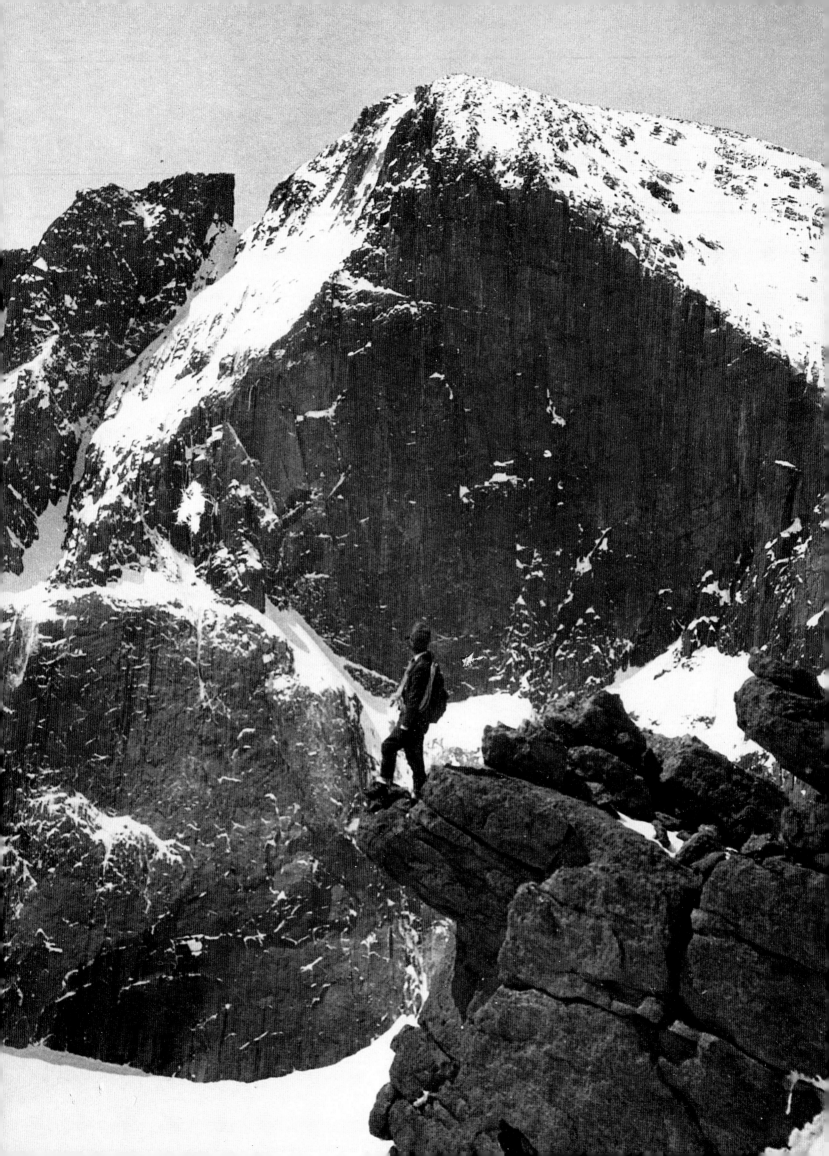

MOUNTAIN MASSIFS *The Ranges*

The Rocky Mountains, which cut through central Colorado from north to south, run from Canada's Yukon Territory all the way down to the Mexican border. The Rockies reach their highest elevation and greatest width in Colorado, where they include more than forty named ranges and countless summits—from the Medicine Bows in the north to the South San Juans straddling the Colorado–New Mexico border, and from the Spanish Peaks in the east to Lone Cone in the west.

After quietly rising nearly a vertical mile in a slow, patient climb from the banks of the Mississippi River to the western edge of the High Plains, the landscape abruptly arches into mountains in one graceful, emphatic leap. There is nothing shy or timid about the way the Front Range springs from the long, rolling plains. Travelers from the east can see the Rocky Mountain Front for better than a hundred miles; what first appear on the western horizon as storm clouds, no more substantial than shadows or dreams, gradually materialize and stretch southward as the very backbone of the continent.

Millions of people first view the Colorado Rockies this way, from the east. On November 15, 1806, after four months' trek across Missouri and Kansas with his small exploring party, Lieutenant Zebulon M. Pike first sighted the mountain that would come to bear his name, looking like a "small, blue cloud" on the distant western horizon. Since that time, explorers and surveyors, prospectors and mountain men, waves of settlers and the tourists that followed have seen that same darkening on the horizon as they reached the precincts of the Rocky Mountains.

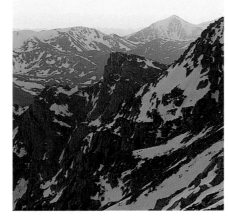

Roughly seventy million years ago, the continent of North America buckled along a zone of structural weakness as it drifted away from Europe, and thus began the rise of the Rockies. This uplift, bringing igneous and metamorphic rock from far beneath the surface, upended horizontal sedimentary layers that washed onto the plains. About forty million years ago, during a particularly active period of faulting, volcanoes broke to the surface over much of present-day Colorado. From deep within the earth, gold, silver, and many other valuable minerals were carried to the surface.

This fiery altering of the Colorado landscape continued for nearly thirty million years, and its effects can be seen in many areas, including the volcanic Never Summer Range located just west of the Front Range, in Rocky Mountain National Park. As the mountains rose, wind and moisture began the inevitable process of erosion. Rushing water attacked the mountains. Trickling water penetrated cracks, alternately freezing and thawing, wedging off bits of rock as ice expanded and contracted. Working slowly but inexorably, these forces had essentially outlined the shape of the Rockies by about three million years ago.

LEFT *A mountaineer contemplates the Diamond Route, East Face of Longs Peak, Rocky Mountain National Park, about 1920.*
ABOVE *The Sawtooth Ridge is a jagged crest that connects 14,060-foot Mount Bierstadt with neighboring Mount Evans.*

Then, between twenty-five and sixty thousand years ago, glaciers crafted the finishing touches. Though the great ice sheet that covered most of eastern North America stopped short of the Rockies, a separate system of glaciers formed at higher altitudes in the mountains. More snow accumulated in the winter at the tops of mountains than could melt in the summer. After a hundred feet or more of packed snow and ice accumulated, the ice underneath all of this weight became flexible and began to move downhill. As glaciers slowly flowed like rivers from their headwall birthplaces, winter snows accumulated at the top, replenishing the ice. Glaciers flowed down V-shaped valleys already carved by water erosion, broadening the valley floors into a U-shape. As the ice moved, the rock frozen to it was torn from the mountain walls.

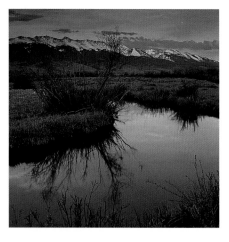

Glaciers formed cliffs, and basins (known as cirques) at the heads of valleys. Lakes were often created in cirques where glaciers dug holes on the basin floors, and in the valleys below the cirques; lakes also may lie behind the natural dams of glacial moraines, the ridges of rock and earth dumped by glaciers where they melted. Mountains once surrounded by glaciers on all sides were worn away until the tops of the glaciers merged, and the peaks became islands of rock surrounded by ice. Colorado's glaciers long ago receded into obscurity, and today these mountains are cliff-sided towers such as Longs Peak in the Front Range. In other areas, broad ridges remained above the ice line, and a fascinating ecosystem of tiny, ground-hugging plants, the alpine tundra, can be found on these unglaciated summits.

The Colorado Rockies were once considered a major deterrent to western development; the mountain ranges were simply a huge, solid obstacle in the path of western movement. In time, however, they became the very object of western movement. In the mid-nineteenth century, the Rockies were the destination for untold thousands of adventurers seeking their fortunes in gold and silver, extracting more metal and mineral wealth than from almost any other state. Although mining is now a smaller portion of the state's overall economy, the mountains remain the basis of Colorado's prosperity, through tourism. Colorado is often called "The Switzerland of America," and many regard it as the ski capital of the world. And, of course, the mountains are celebrated and visited for their sheer beauty.

The many ranges that combine to form the Colorado Rockies are daunting in their majesty. I have walked many miles in their shadows and stood atop many of their peaks in search of beauty and in search of myself. Whether climbing in the San Juans or skiing in the Gores, I marvel at and worship beneath the ever-changing faces of these giants. Can anyone help but be awed and humbled by them, and changed by their grandeur and power?

ABOVE *Spring runoff fills the winding Canadian River below Medicine Bow Mountains, near Colorado State Forest, North Park.*
RIGHT *Sleeping Indian Rock is dwarfed by 14,110-foot Pikes Peak, Garden of the Gods Park, near Colorado Springs.*

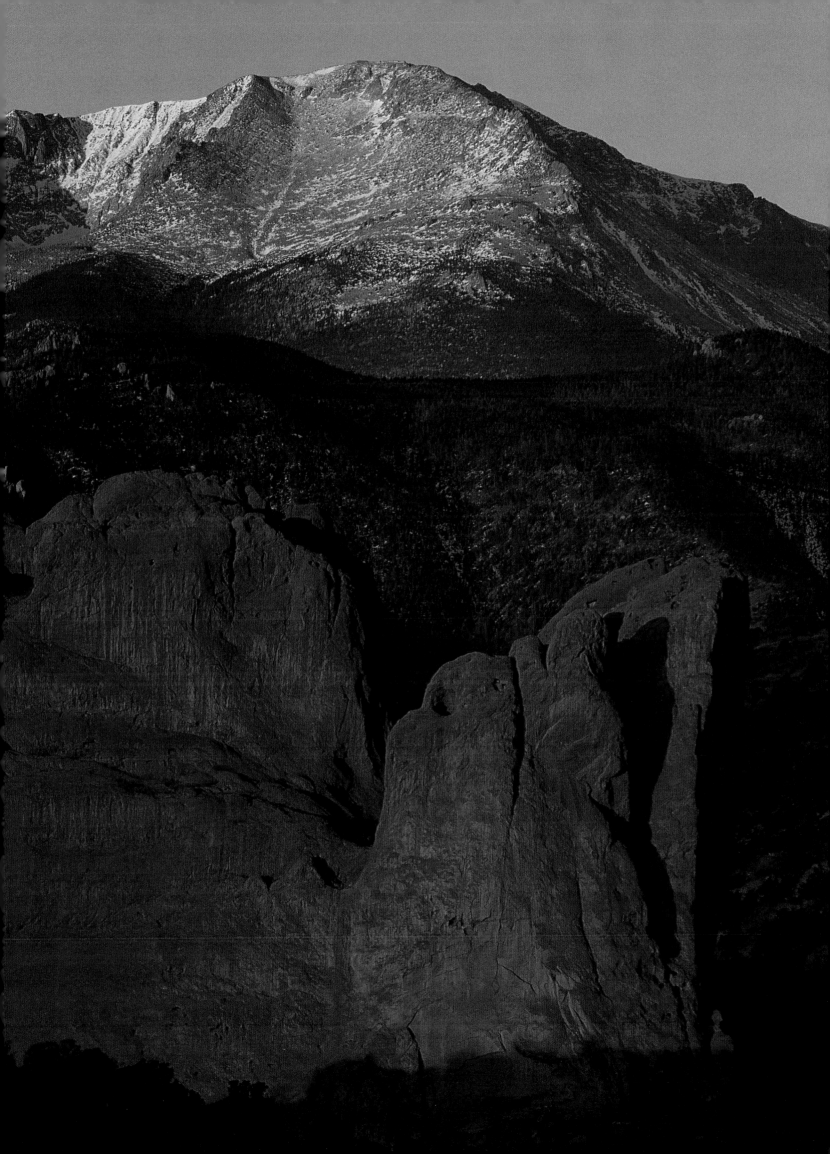

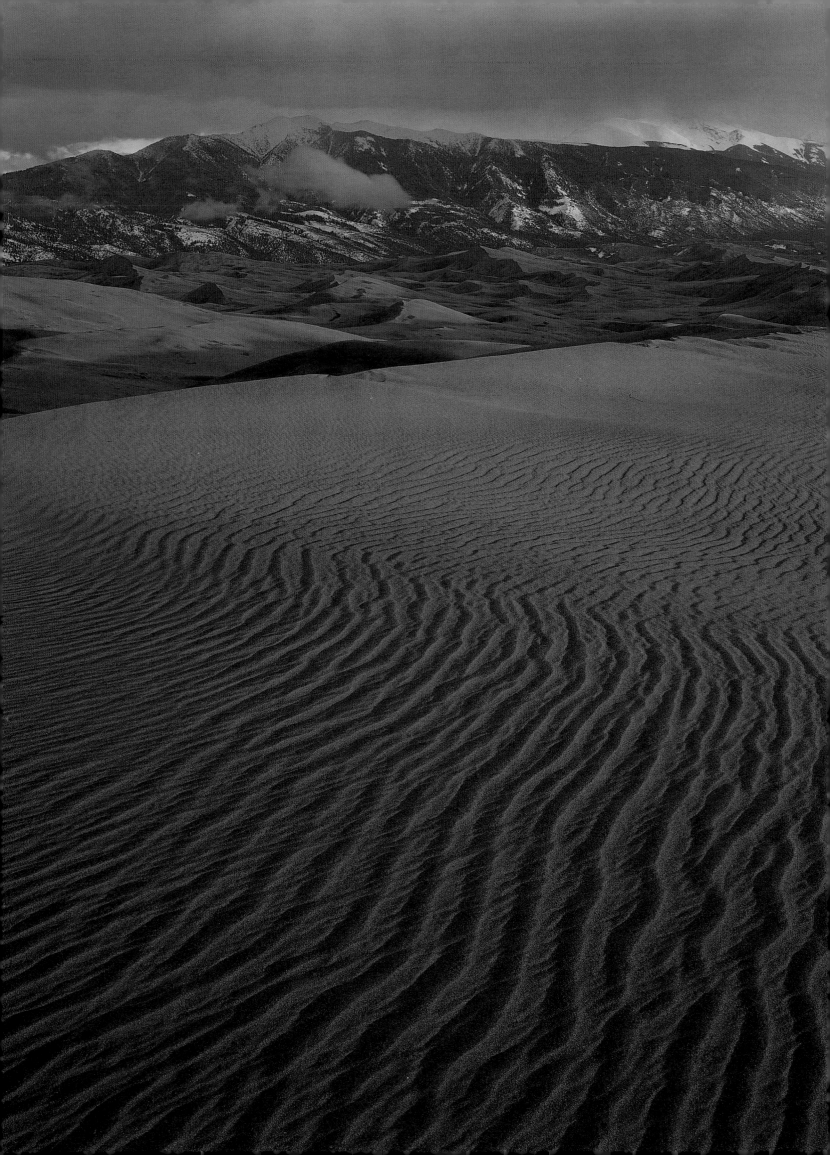

SANGRE DE CRISTO

Probably bestowed by Spanish explorers as much as four hundred years ago, the romantic name of this range translates to "Blood of Christ," a reverent nod to the fiery sunsets that pour across the San Luis Valley. The Sangres catapult 6,500 feet from their base without the softening of foothills, bringing to mind the Tetons or the Sierra Nevada.

Highest of the range's nine fourteeners, Blanca Peak's north face shades the southernmost glacier in the United States and tops a huge mass of granite, a rock formed underground by errant magma. Just twenty-three miles away, 14,197-foot Crestone Needle is composed of sedimentary cobblestones pressure-bonded to gravel.

Due in part to the thirsty San Juan Mountains to the west, the San Luis Valley is Colorado's only true desert. This expansive valley slowly gives way to the Sangres' western alluvial fans. As the valley ascends, so too the Great Sand Dunes rise from the flats to bury the lower flanks of Mount Herard. A tongue of sand climbs Little Medano Creek to 9,600 feet, a full 2,000 feet above the lowest dunes. Stranded within the mountains of Colorado, the dunes seem almost surreal.

–EW

LEFT *For untold eons, sand has drifted across the rain-starved San Luis Valley to build these seven-hundred-foot-high mountains of sand, the highest dunes in the United States, Great Sand Dunes National Monument.*

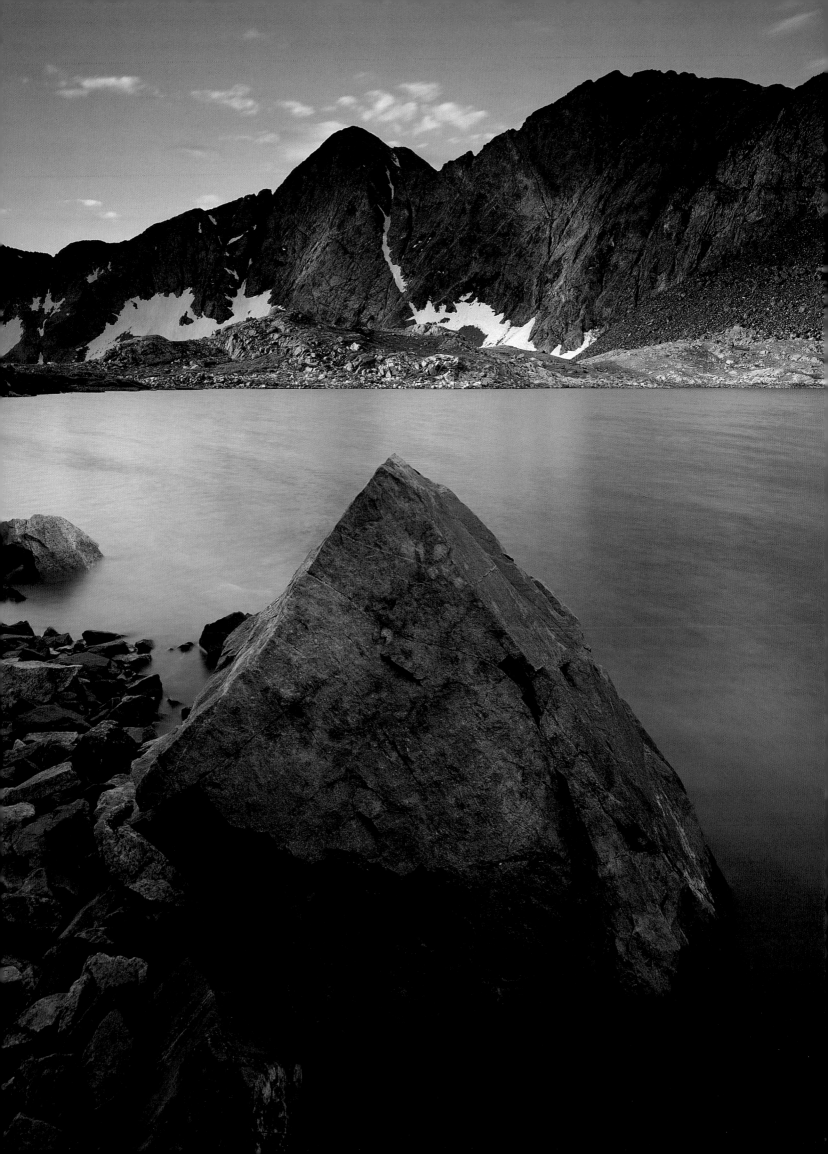

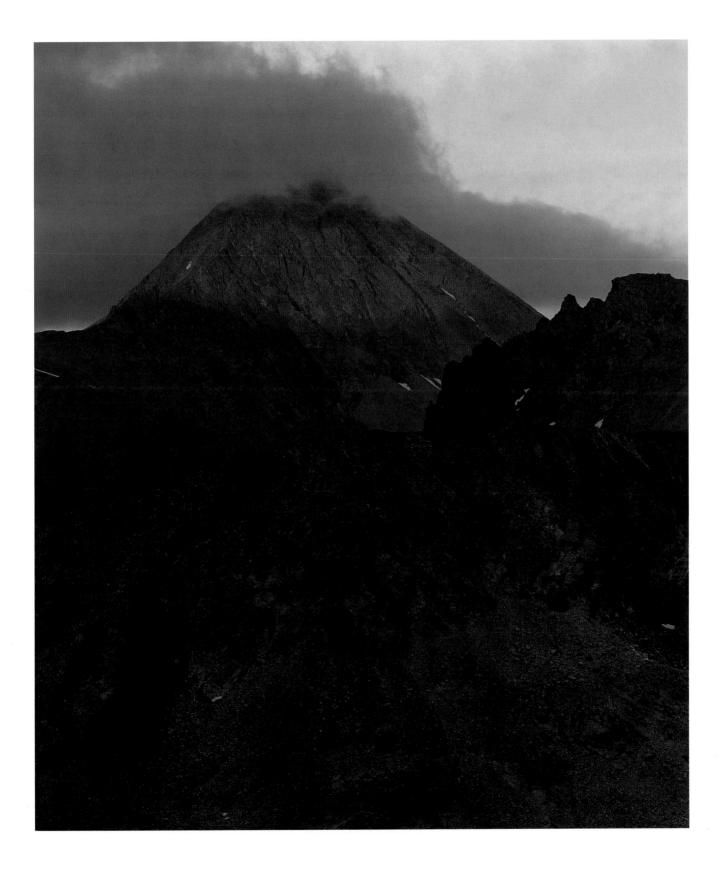

LEFT *Rocks are scattered like toys in Lily Lake beneath fourteeners Blanca Peak and Ellingwood Point, Sierra Blanca.*
ABOVE *Once called Old Baldy, Mount Lindsey was renamed for Colorado Mountain Club leader Malcolm Lindsey.*

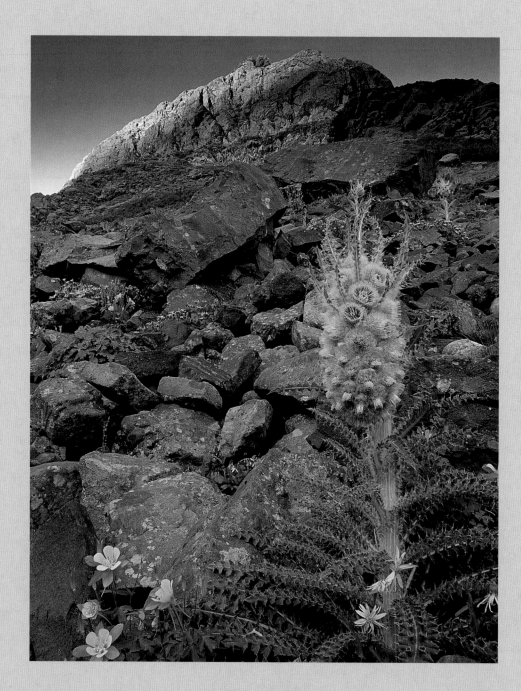

ABOVE *Rocks allow giant yellow thistle and blue columbine to flourish, San Isabel Creek.*
BELOW *Giant yellow thistle thrives at Rito Alto Creek, Sangre de Cristo Wilderness.*
RIGHT *Rock, plants, and lichen become true art, San Isabel Creek.*

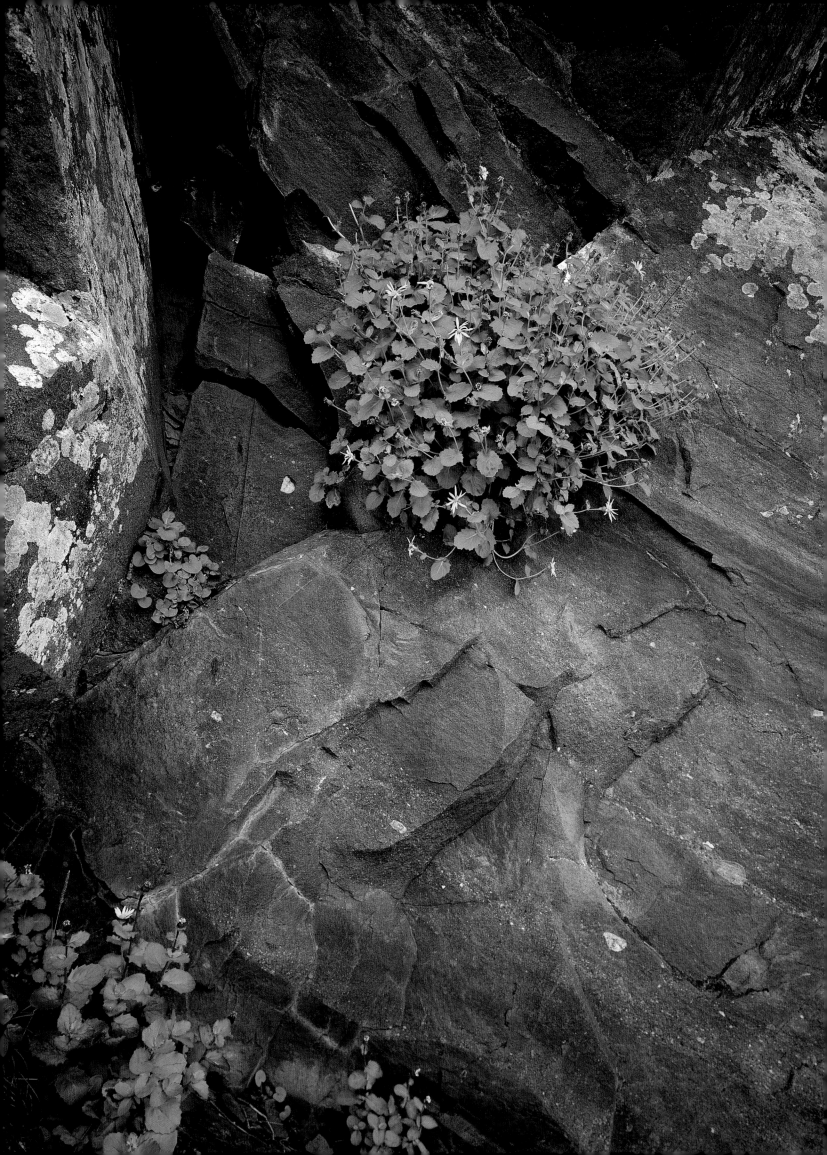

Crestone Peak *14,294 feet*

Unnamed Peak *13,541 feet*

Humboldt Peak *14,064 feet*

Colony Baldy *13,707 feet*

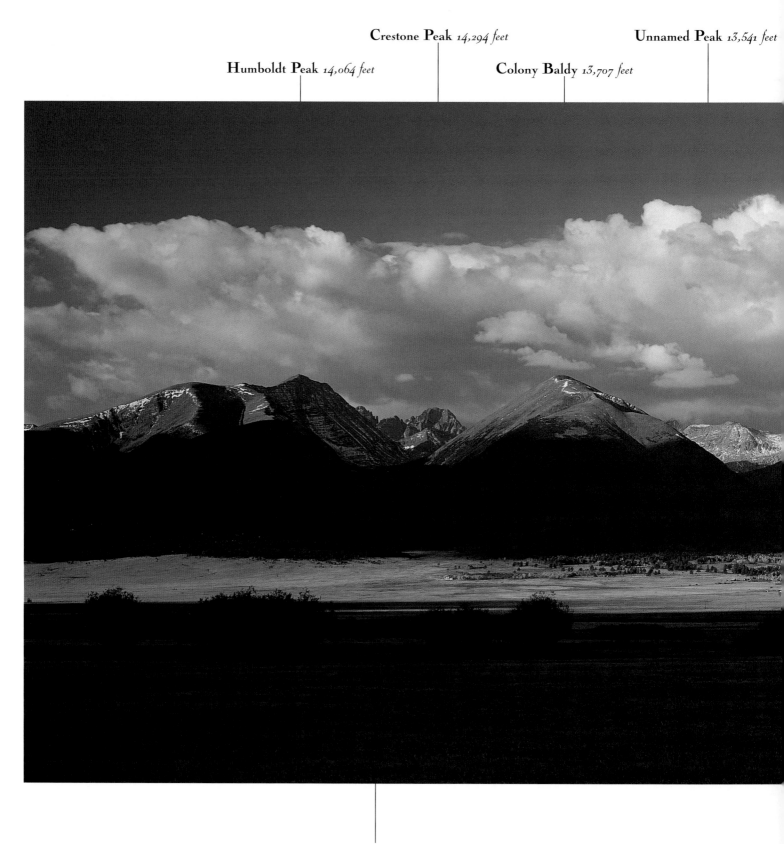

Wet Mountain Valley *7,950 feet*

Little Baldy Mountain *12,982 feet*

Mount Adams *13,931 feet*

Little Horn Peak *13,143 feet*

Fluted Peak *13,554 feet*

Horn Peak *13,450 feet*

Spring Mountain *13,244 feet*

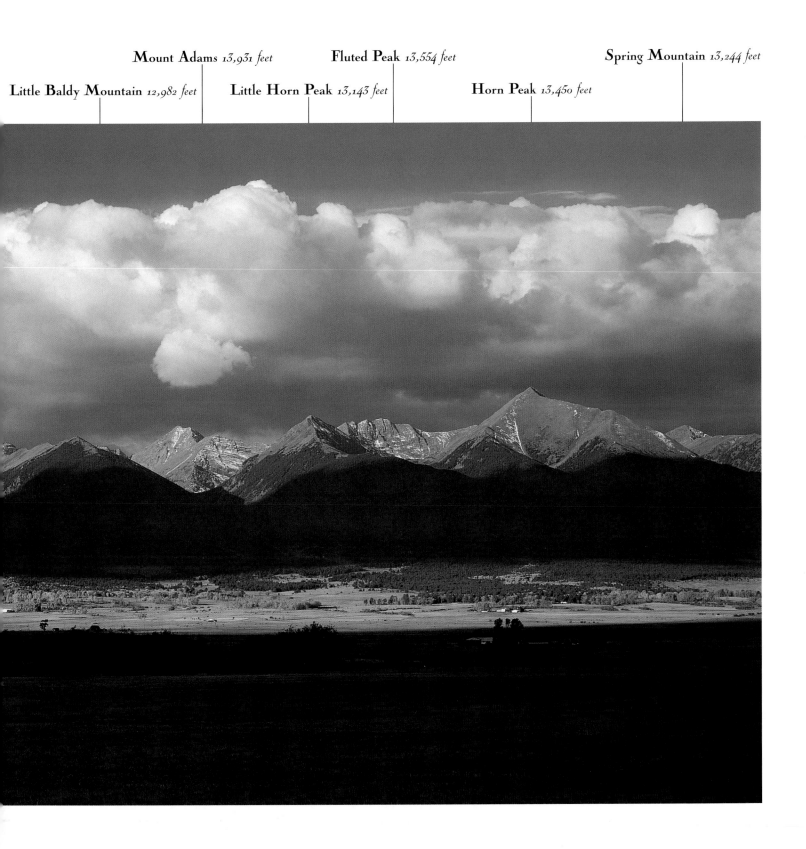

The central peaks of the Sangre de Cristo Range tower above verdant ranchland of Wet Mountain Valley, near the town of Westcliffe.

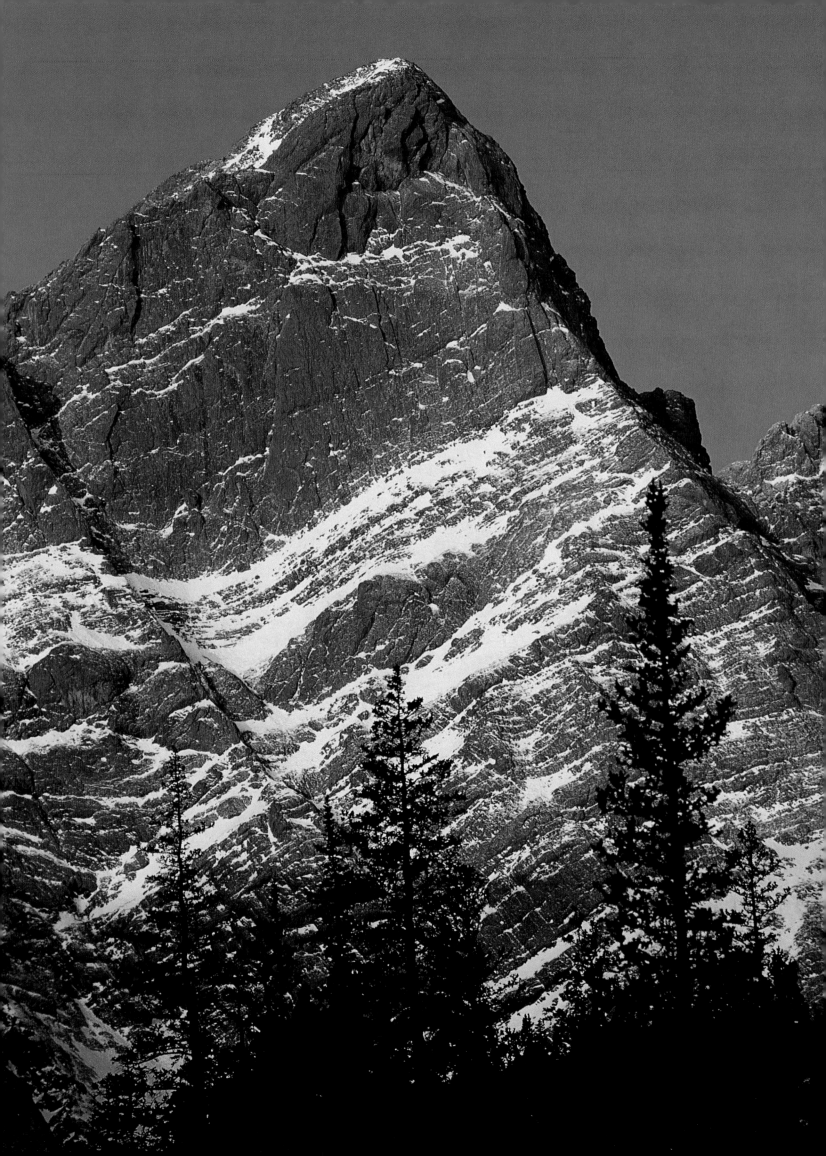

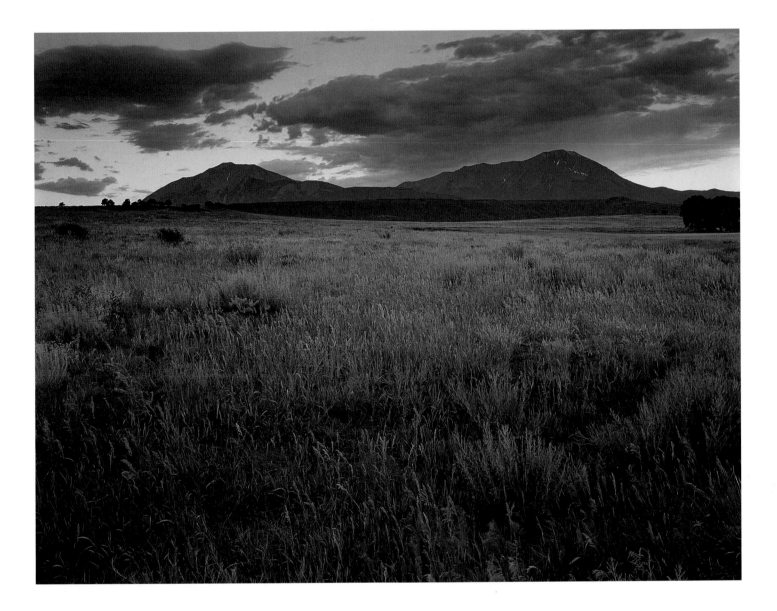

LEFT *The northeast ridge of the 14,197-foot Crestone Needle is known as the Ellingwood Arête, Sangre de Cristo Wilderness.*
ABOVE *Colorado's easternmost high mountains are East Spanish Peak (left, 12,683 feet) and West Spanish Peak (13,626 feet).*

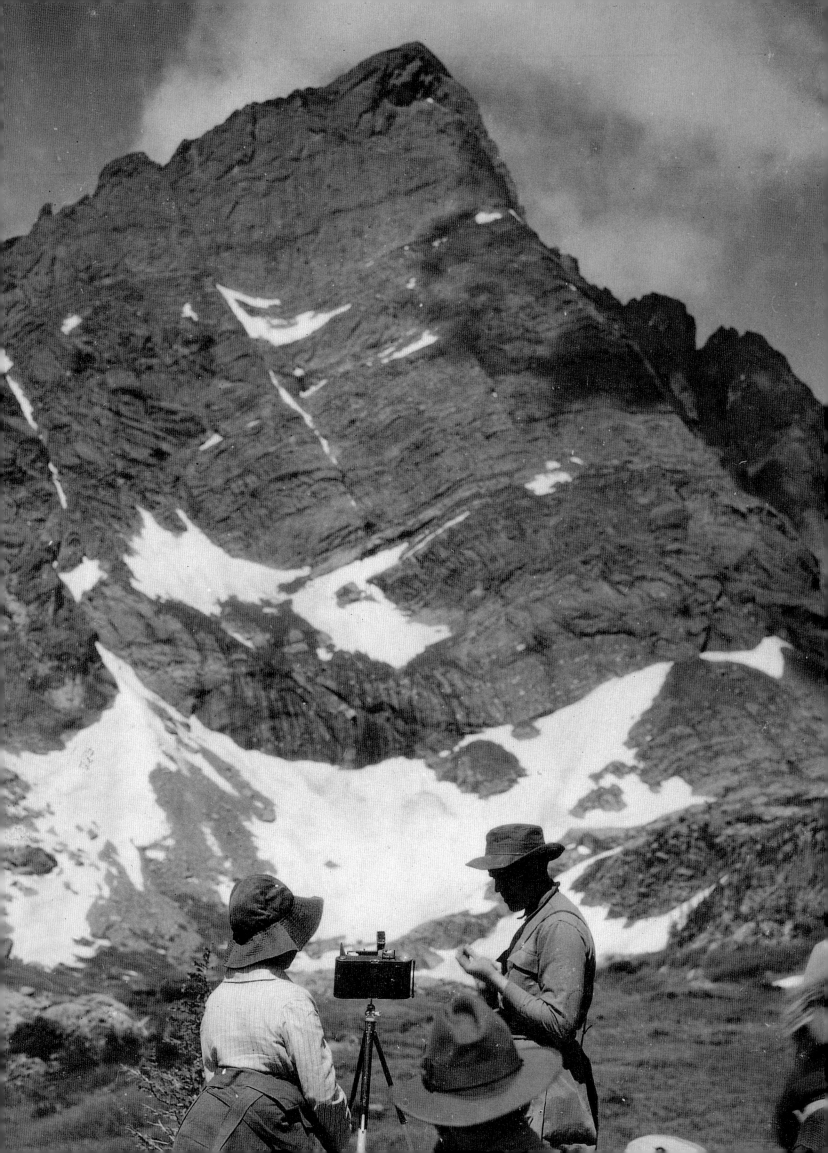

EARTH & SKY *The Elements*

One late June, several friends and I were back-packing through the Holy Cross Wilderness, near the resort town of Vail. We had been hiking above the timberline most of the day, which was warm and peaceful; though the sky was slightly overcast, it seemed no cause for concern. While we were traversing an exposed ridge, small, round "corn-snow" began to fall in light flurries: that was our first warning.

Moments after it began to snow, we heard a nerve-wracking sound: the metal ice-axes strapped to our packs were literally humming, vibrating from the electricity in the air. That was our second warning. The overcast sky had condensed into an ominous thunderhead, and we were standing in the very midst of it, with several pounds of metal on each of our backs. Immediately our situation became crystal clear, and we were not about to wait for a third warning!

With a shout, my companions and I quickly slipped out of our backpacks and abandoned them, beating a hasty retreat down the mountainside; we ran, slid, and fell toward the relative safety of the valley below. No sooner had our flight begun than the lightning started to strike. Flashes of violet light bounced from the rocks around us as the thunder exploded, seemingly inside our heads. Reaching the treeline, we huddled within the meager protection afforded by a few boulders and trees, and waited for the storm to pass. Squatting on our rubber boot soles to reduce conductivity, soaked to the skin and truly frightened, we counted the minutes.

As quickly as it had appeared, the storm subsided. Within half an hour, the fury ceased, the clouds parted, and we were rewarded with the startling aspect of a perfectly clear, blue sky. We returned to the ridge somewhat shaken, the cacophonous raging still echoing in our ears, but ready to retrieve our backpacks and move on. The biggest "jolt" of all awaited us there. We found two of the packs where we had dropped them, but the third had been literally incinerated, its aluminum frame twisted and melted beyond recognition. I shudder to think what could have happened had we not reacted quickly enough. At that moment, I gained the full measure of respect for the power of the mountains.

Typically, the seasons in the Rockies are relatively mild, but storms can appear in minutes. Winds batter the mountaintops with hurricane force. Rain washes away entire mountainsides, and snows bury the landscape in drifts that remain until summer. The elements can prove to be as much of a challenge as the rugged land itself.

The mountains and the elements have a reciprocal relationship. The snow has literally shaped the mountains, packed into glaciers carving broad valleys, or melting to form creeks that join into rivers, cutting deep canyons in the stone. Yet the very shape of the mountains predetermines where the snow shall fall, where it shall melt,

LEFT *A photographer prepares to shoot Crestone Needle, near Lower South Colony Lake, Sangre de Cristo Wilderness, 1920.*
ABOVE *An approaching evening storm sweeps over the Cochetopa Hills and the San Luis Valley, early autumn.*

where the creeks and rivers shall flow. The Rocky Mountains form a high and broad rocky wall, along, over, and around which winds the Continental Divide. In many ways, this invisible line controls the character and destiny of the entire Rocky Mountain region.

It is a poetic thought: You stand on some high, knife-edged ridge along the Divide and watch the rain fall. You face north, holding your arms outspread, and picture the rain falling off your left hand and flowing west to meet the Pacific Ocean. At the same time, you imagine the drops falling off your right hand have begun their journey to the Gulf of Mexico. The Continental Divide is actually somewhat less dramatic. In places it is little more than a slight rise in the landscape. Nor is it a straight line; while running generally north-south, it tends to wander, switch back on itself, and even run from east to west. In places it is simply a line drawn arbitrarily on a map. Yet its effects are profound.

Prevailing wind currents in the Rockies blow from west to east. Clouds laden with moisture carry their burden from the Pacific to the western edge of the Continental Divide—a substantial obstacle. The clouds begin to rise, and massive amounts of air and moisture are pushed upward toward the peaks. As the air mass gains altitude, the temperature drops, and condensation occurs within the clouds. As the water vapor condenses it grows heavier and falls as rain or snow (or virga, rain

which dissipates before reaching land). Few clouds reach the highest limits of the Divide before shedding their moist ballast, and seventy-five percent of Colorado's precipitation falls to the west of it, leaving the eastern plains dry.

The result is an interesting situation, in which the large majority of Colorado's water resides on the western side of the Continental Divide, while the large majority of Colorado's population resides to the east. Recreation and tourism—two of the state's richest sources of revenue— are also governed by this unequal distribution of water. With most of the snow falling on the western side, it is only logical that most of the major ski resorts have sprouted there as well. Thus it is necessary to transport skiers from east to west (to the snow), while transporting melted snow from west to east, where most of the state's agriculture and population awaits with a never-ending thirst.

There are other signs of this complex interrelationship of land and water. More precipitation means lusher vegetation on the west slope; hikers are rewarded with profuse fields of wildflowers, and are likely to encounter more deer, elk, bighorn sheep, and other wild species that dine on the abundant flora. The late snow on west slopes accents the scenic summer vistas. Likewise the clear, rushing mountain streams live to rush a little longer where there is more snowpack to nourish them. All life in the Colorado region is subject, then, to the shifting moods of the elements and the terrain.

ABOVE *The 14,197-foot Crestone Needle is reflected in the waters of Lower South Colony Lake, Sangre de Cristo Wilderness.*
RIGHT *Summer rains wash lichen-covered boulders below North Crestone Creek, Sangre de Cristo Wilderness.*

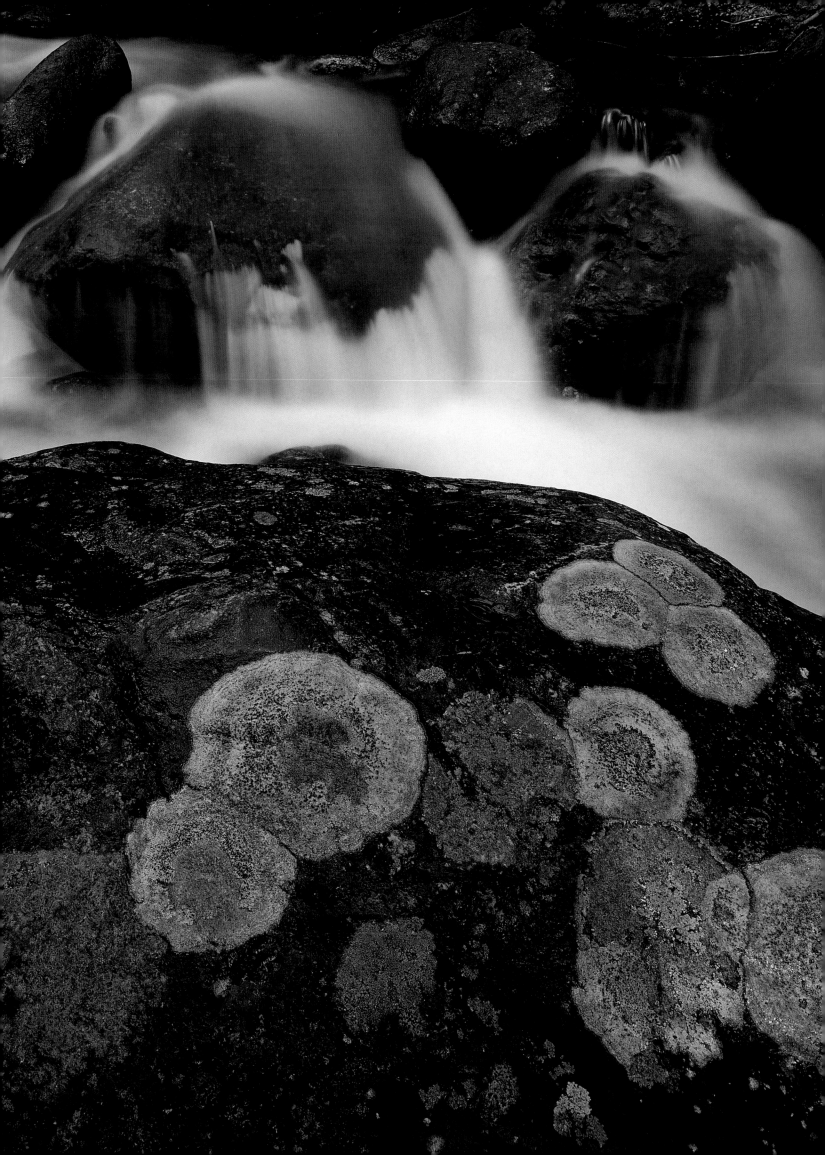

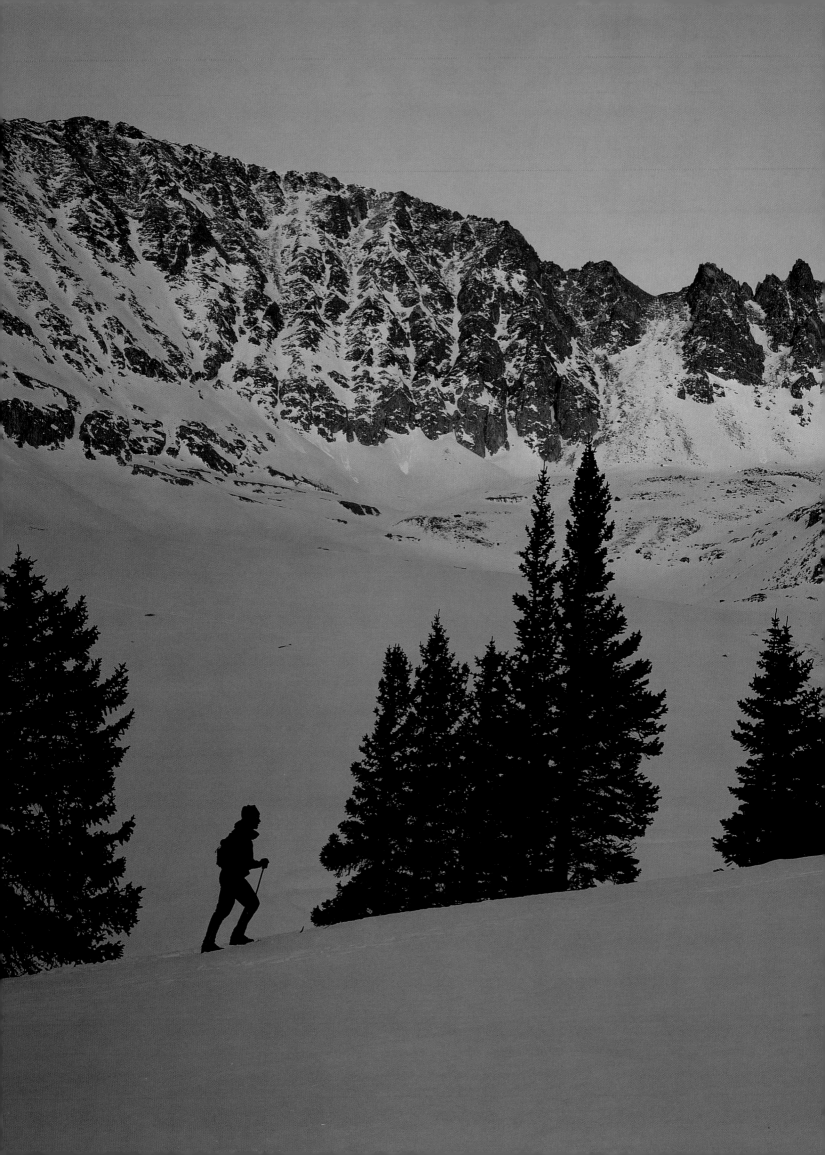

PARK & PLATEAU

The Park Range is a long stretch of mountains named after the many parks, or mountain flats, that rest at the range's foot. Starting at the Wyoming border, the Sierra Madre is the northernmost of the Park's many subranges. The Park Range then rises southward, and includes the Sawtooth Range, the Park's own Front Range, the offshoot Rabbit Ears Range, the Gore and Tenmile Ranges, ending with the Mosquito Range. The Park Range is also home to several of the world-renowned Summit County ski areas near the town of Breckenridge.

The often overlooked plateau area comprises two small ranges—the Williams Fork Mountains and the Elkhead Mountains, which are unconnected to any of Colorado's six major ranges—and several separate mountain plateau regions. These mesa-like plateau regions include the Flat Tops Wilderness near Glenwood Springs, the deep Black Canyon of the Gunnison, and giant Grand Mesa above Grand Junction. Other plateaus in western Colorado fit the geology of the Colorado Plateau canyons more than they do the mountainous Rockies.

—EW

LEFT *A backcountry skier enjoys the crimson alpenglow of a winter sunset illuminating high pinnacles and the summit of 13,690-foot Wheeler Mountain, upper Clinton Creek, Tenmile Range, near Copper Mountain.*

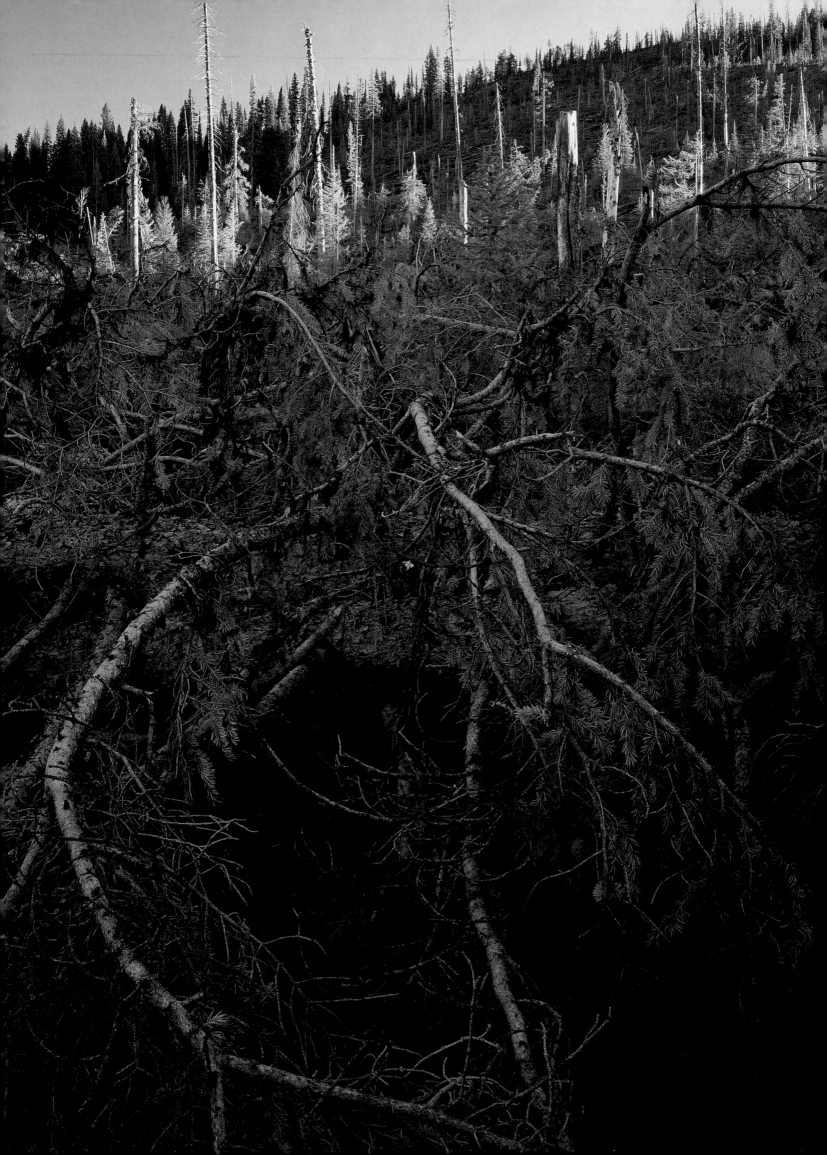

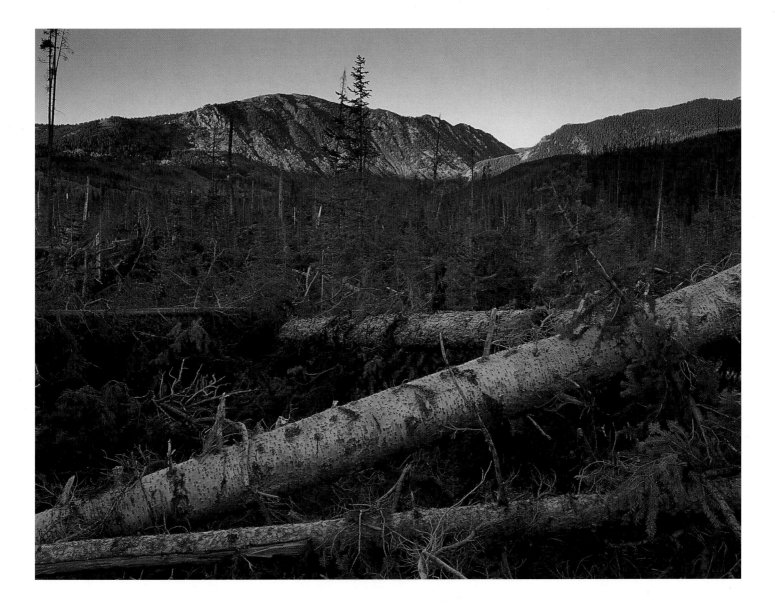

LEFT *In late 1997, 120-mile-per-hour winds leveled twenty thousand acres of parkland, including this forested area near the North Fork.*
ABOVE *The Sierra Madre rises above a fallen forest, Medicine Bow–Routt National Forests, near Steamboat Springs.*
BELOW *A blue columbine, the state flower of Colorado, flourishes among lavender.*

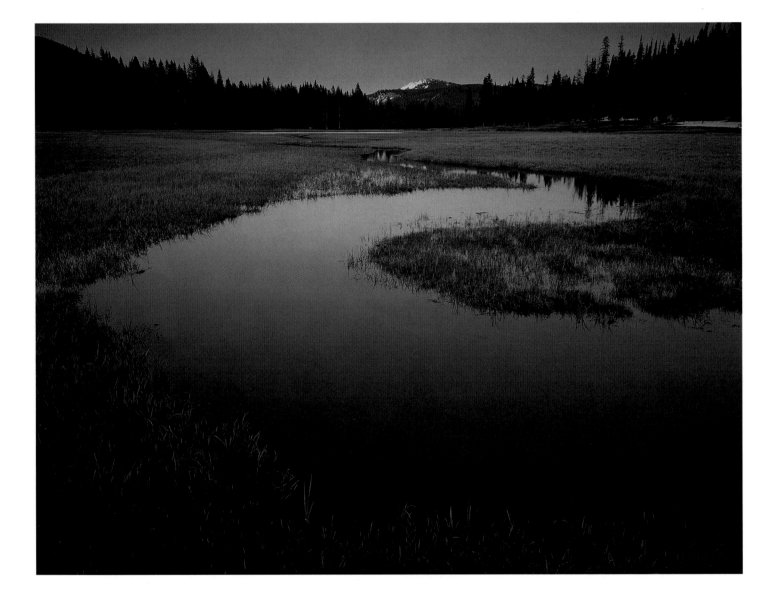

ABOVE *The waters of West Fork meander toward their confluence with Encampment River, Sierra Madre, Mount Zirkel Wilderness.*
RIGHT *At 13,213 feet, Peak L towers above aspens and blue-pod lupines, Slate Creek, Eagles Nest Wilderness.*

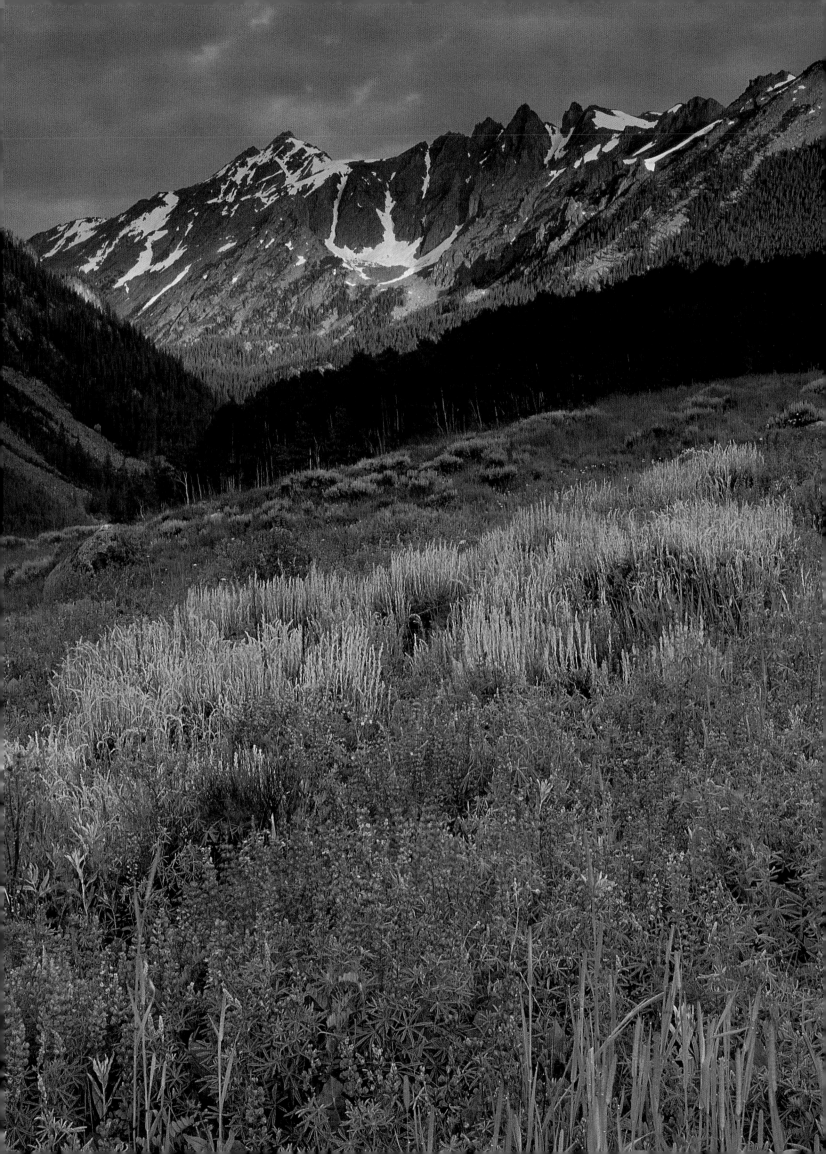

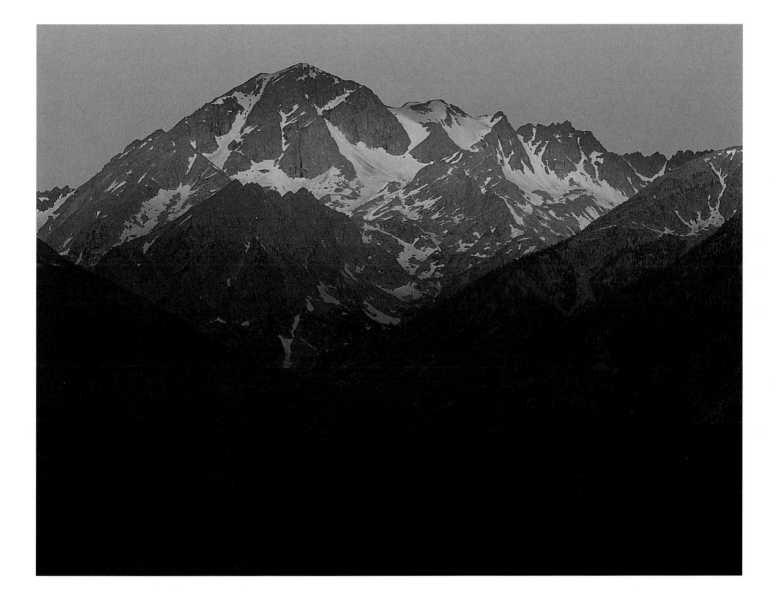

LEFT *Blue ice crystallizes on Salmon Lake following a cold early spring night, Eagles Nest Wilderness, near the town of Silverthorne.*

ABOVE *Seen here from the Williams Fork Mountains, Mount Powell, at 13,534 feet, is the highest peak of the Gore Range.*

OVERLEAF *Windy Ridge warriors for a millennium, bristlecone pines are among earth's oldest life, Mosquito Range.*

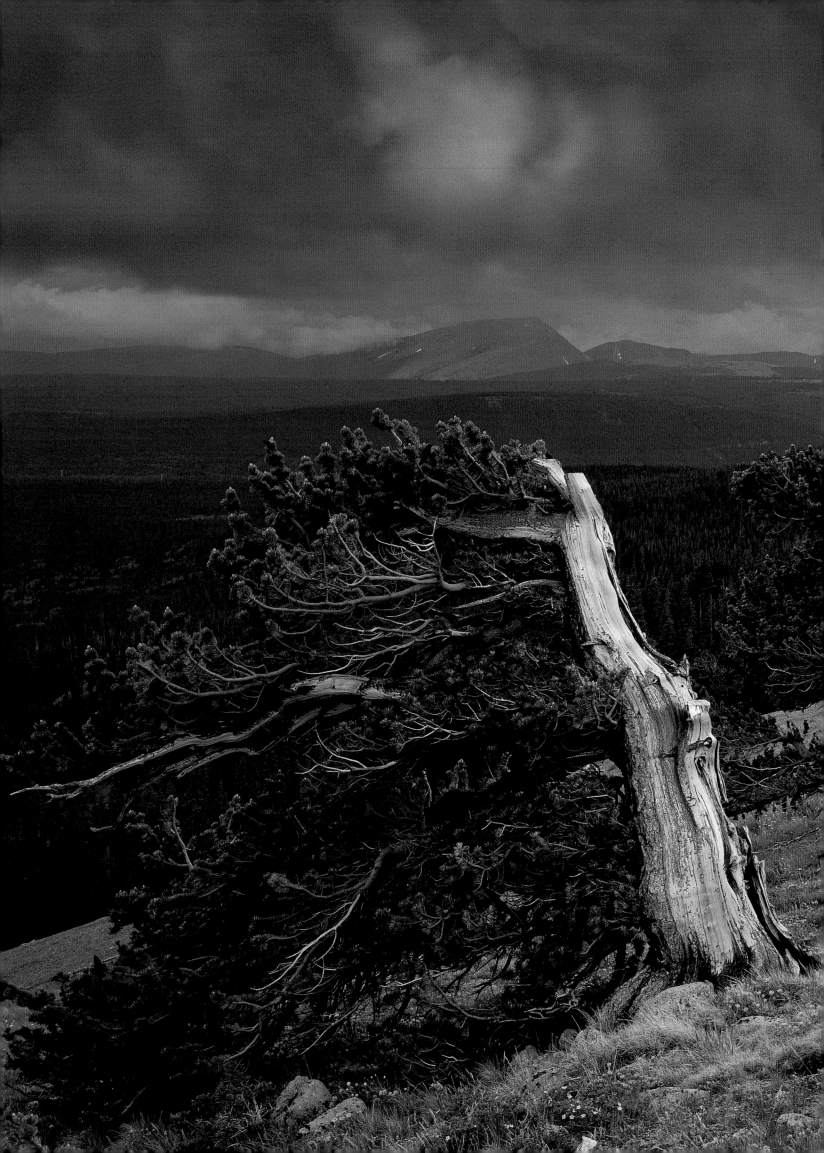

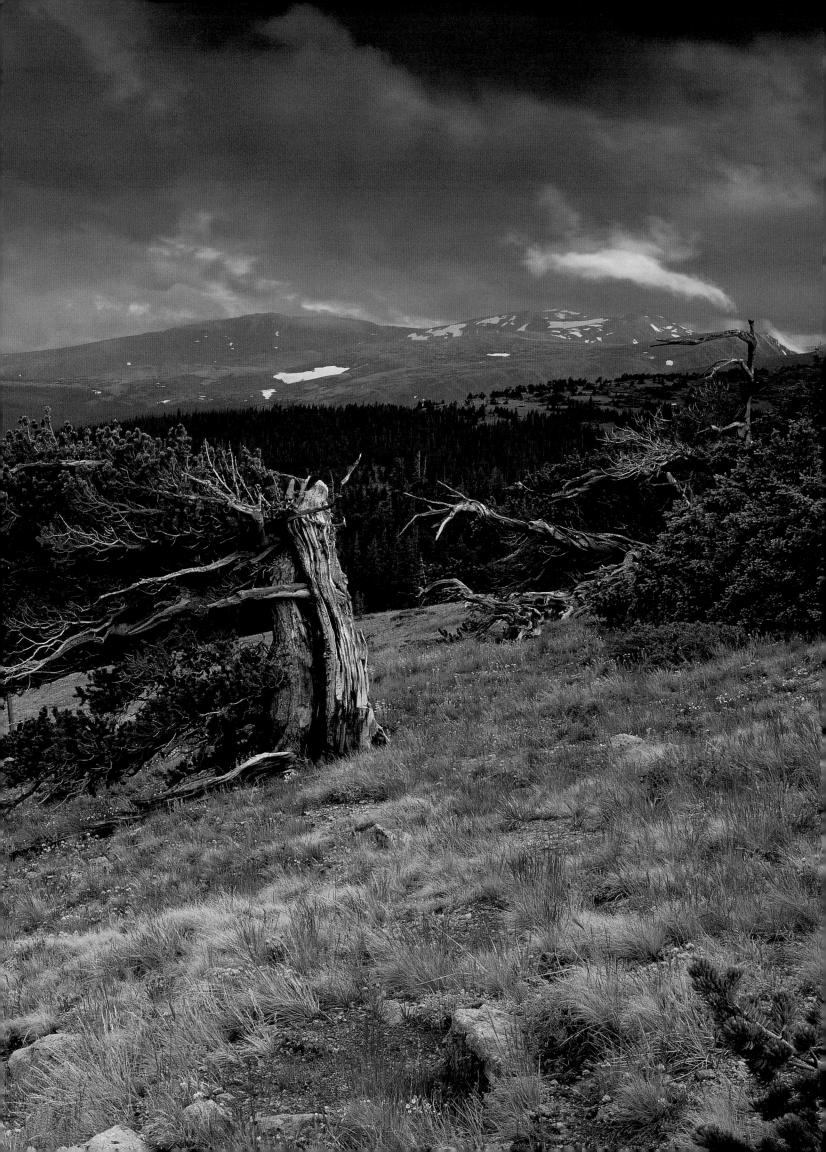

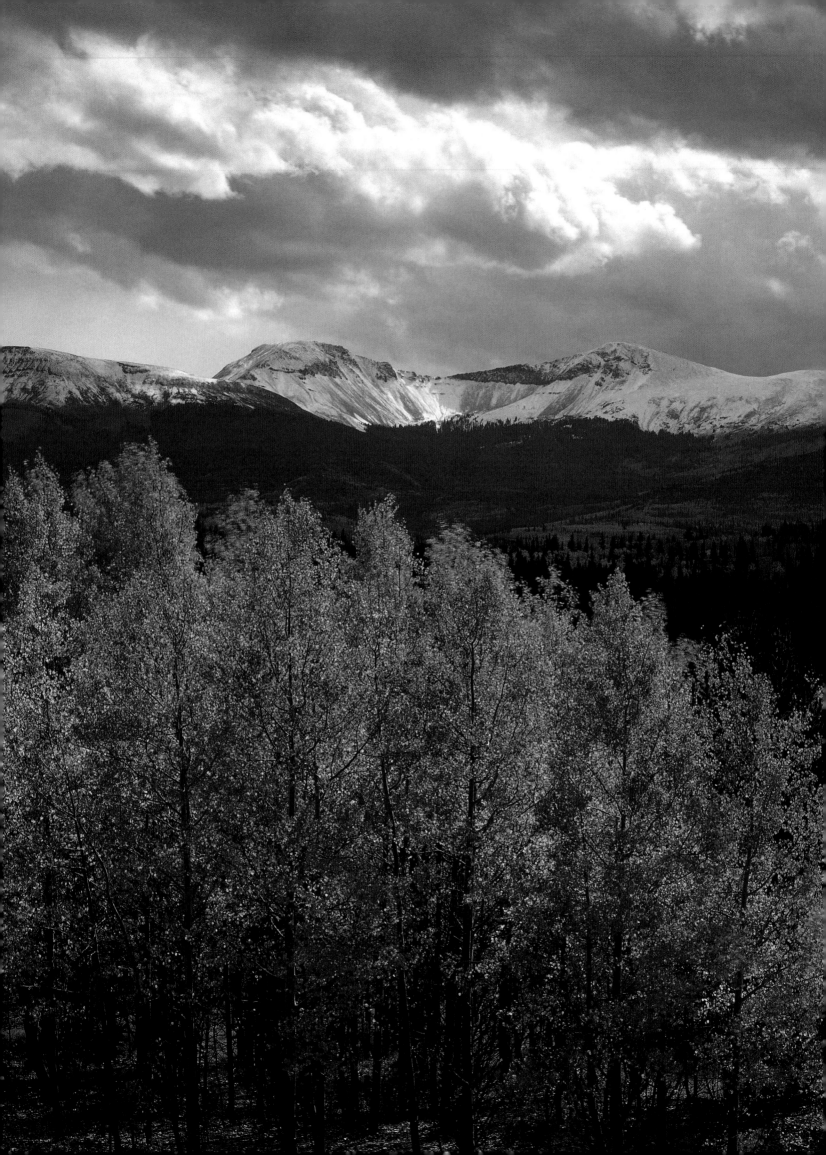

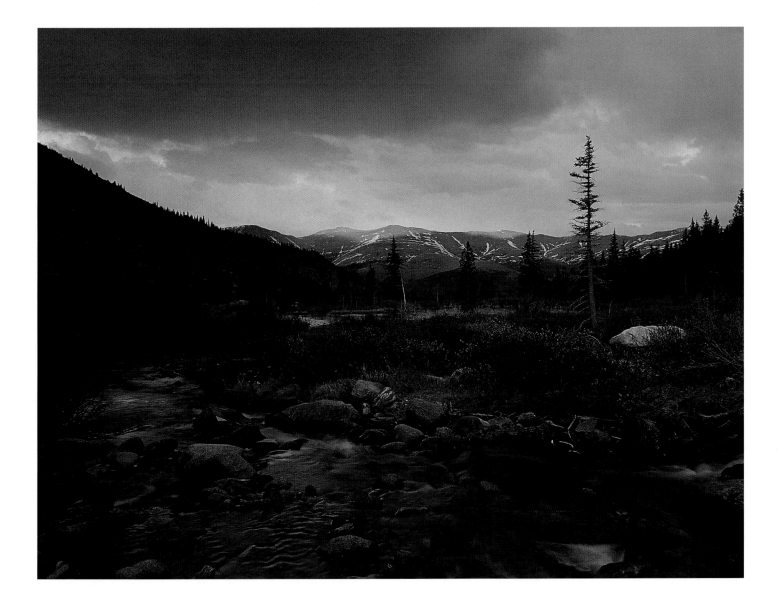

LEFT *An autumn storm hovers over East Buffalo Peak (left, 13,301 feet) and West Buffalo Peak (13,327 feet), Mosquito Range.*
ABOVE *Mount Silverheels was named for a dancehall girl who nursed minors through a smallpox epidemic, Tenmile Range.*
OVERLEAF *The Chinese Wall cuts through more than six miles of the White River Plateau, Flat Tops Wilderness.*

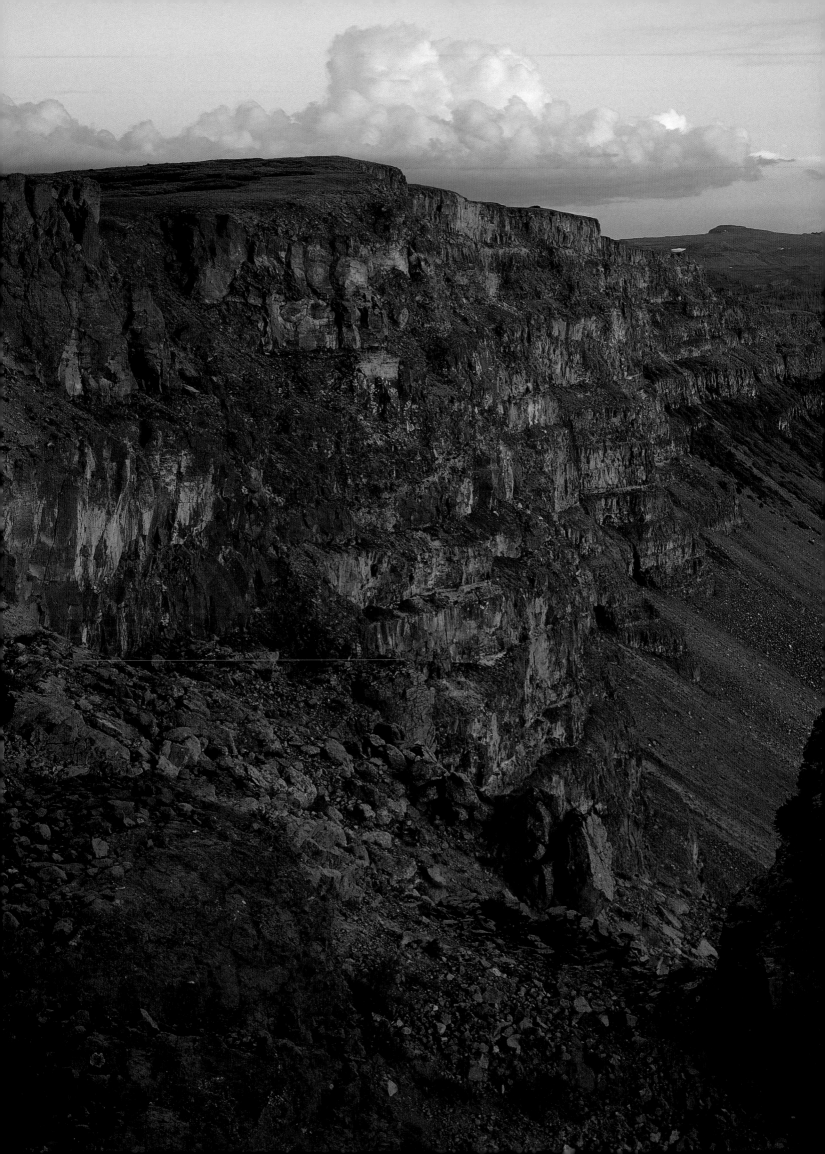

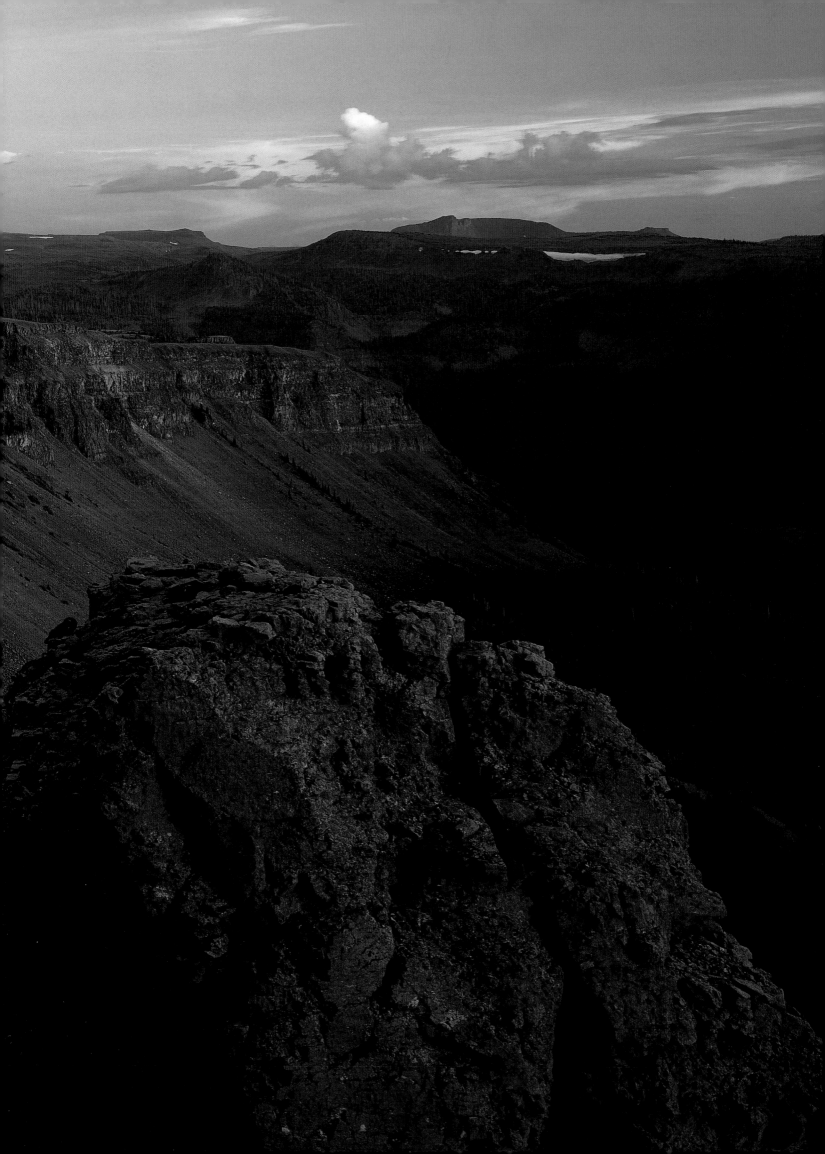

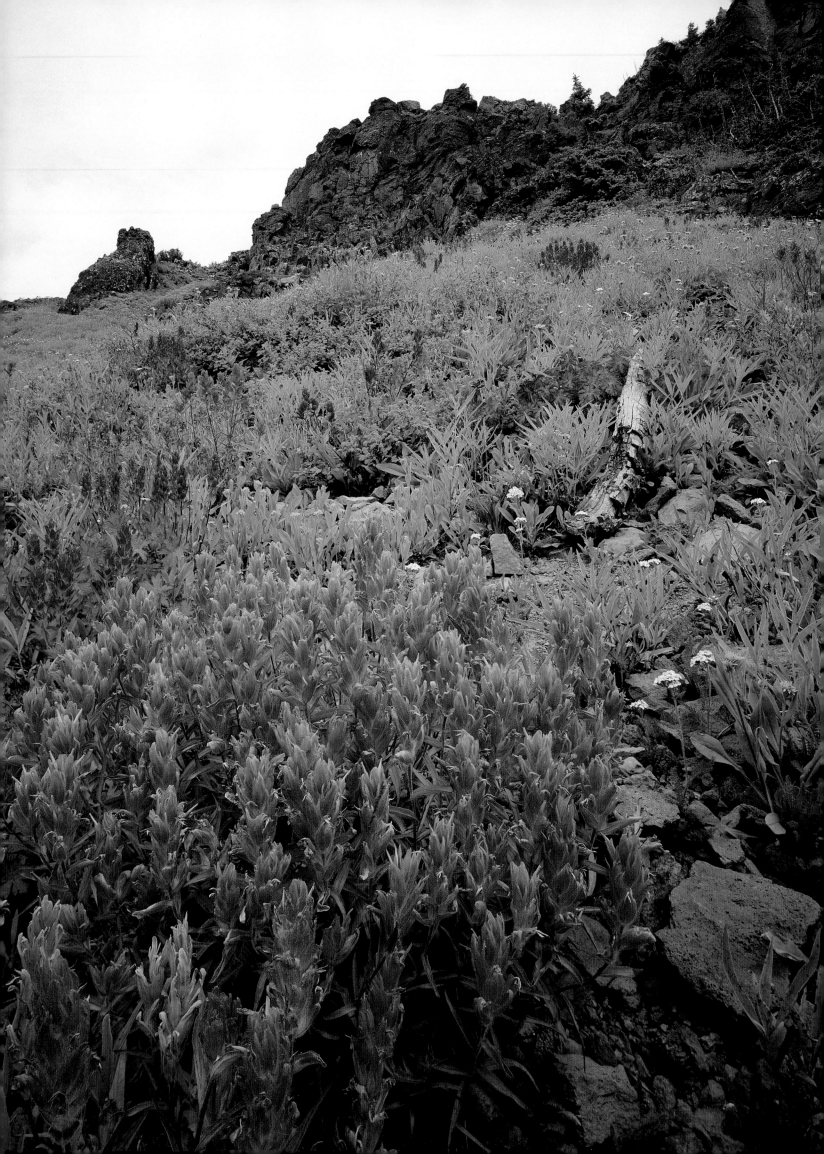

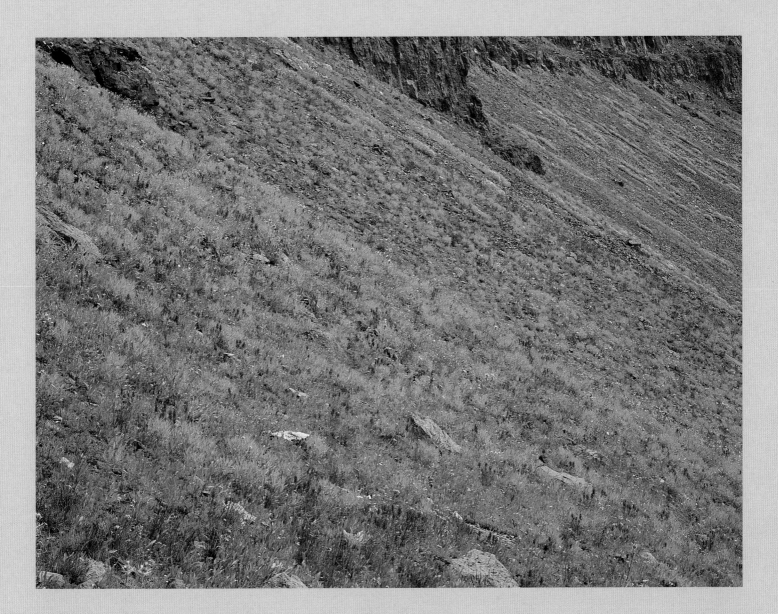

LEFT *Paintbrush grows in profusion, dotting this high alpine vista with its bright color, near Devil's Causeway, Flat Tops Wilderness.*
ABOVE *Flowers paint a slope above Bear Creek near Little Causeway Lake, Flat Tops Wilderness.*
BELOW *The scarlet gilia is also aptly called the skyrocket flower.*

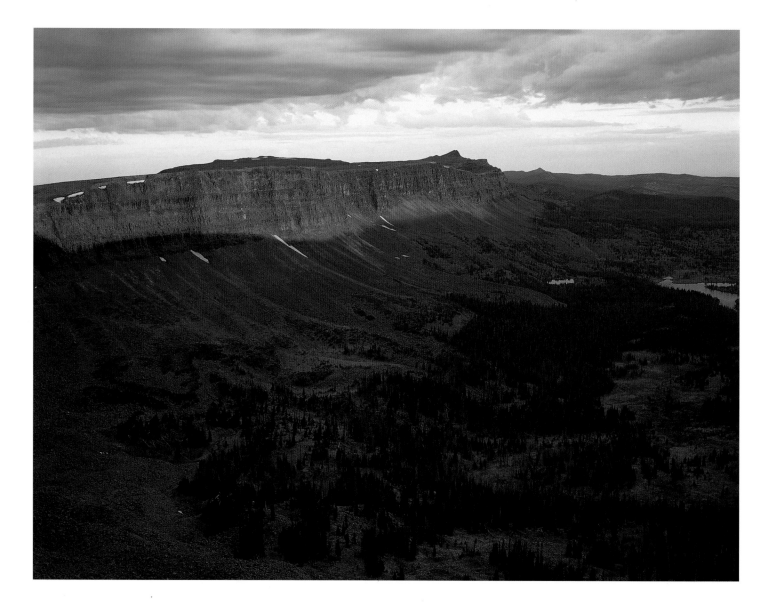

ABOVE *A summer daybreak strikes a typical Flat Tops escarpment while Causeway Lake waits in shadow, Flat Tops Wilderness.*
RIGHT *Morning brings golden light to an 11,000-foot plateau near the Chinese Wall, above Trappers Lake.*

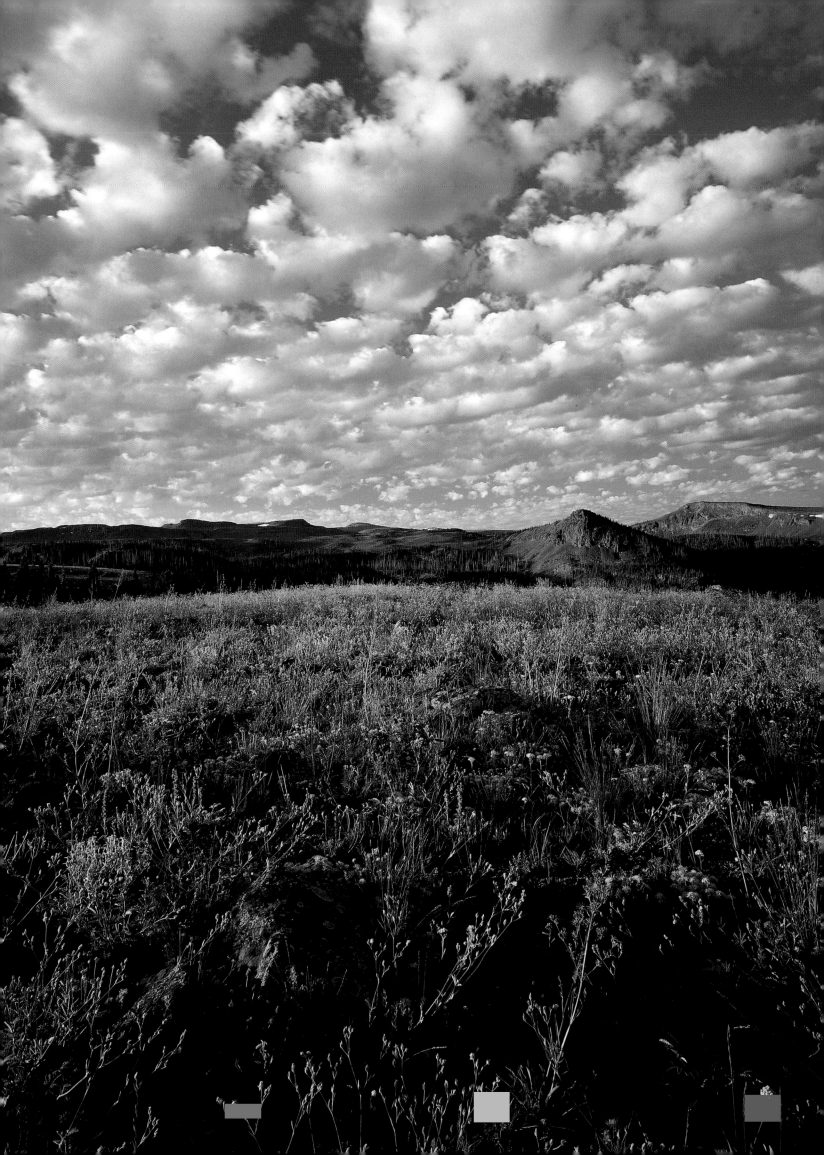

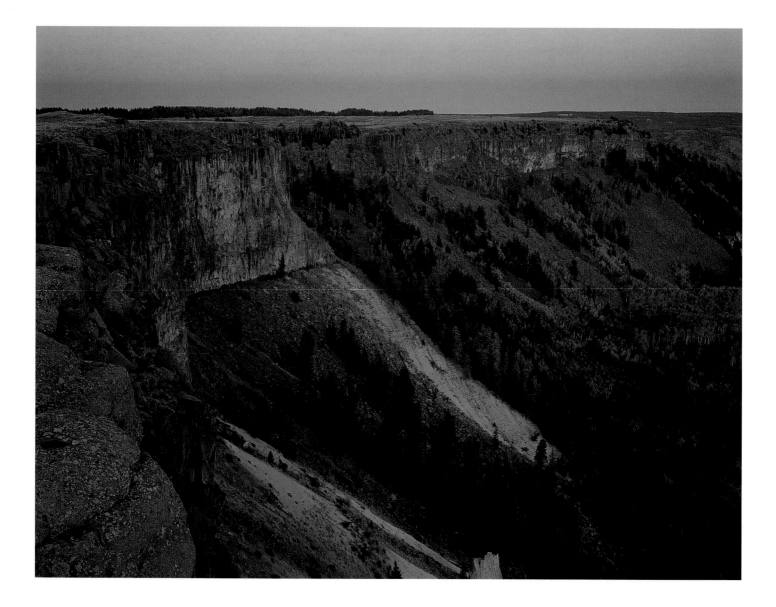

Grand Mesa, a plateau giant, rises nearly one vertical mile above Grand Junction between the Colorado and Gunnison Rivers.

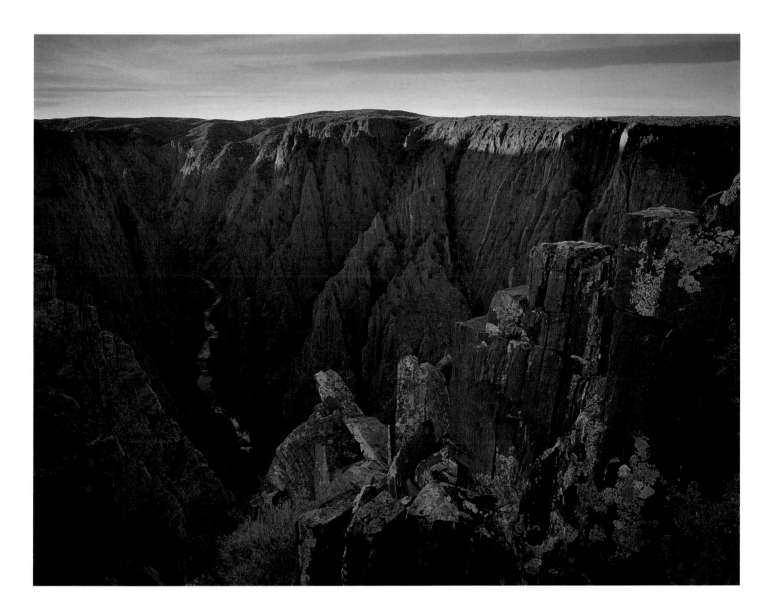

Sunrise strikes the plateau, but requires hours to reach the dark depths of the Black Canyon of the Gunnison National Monument.

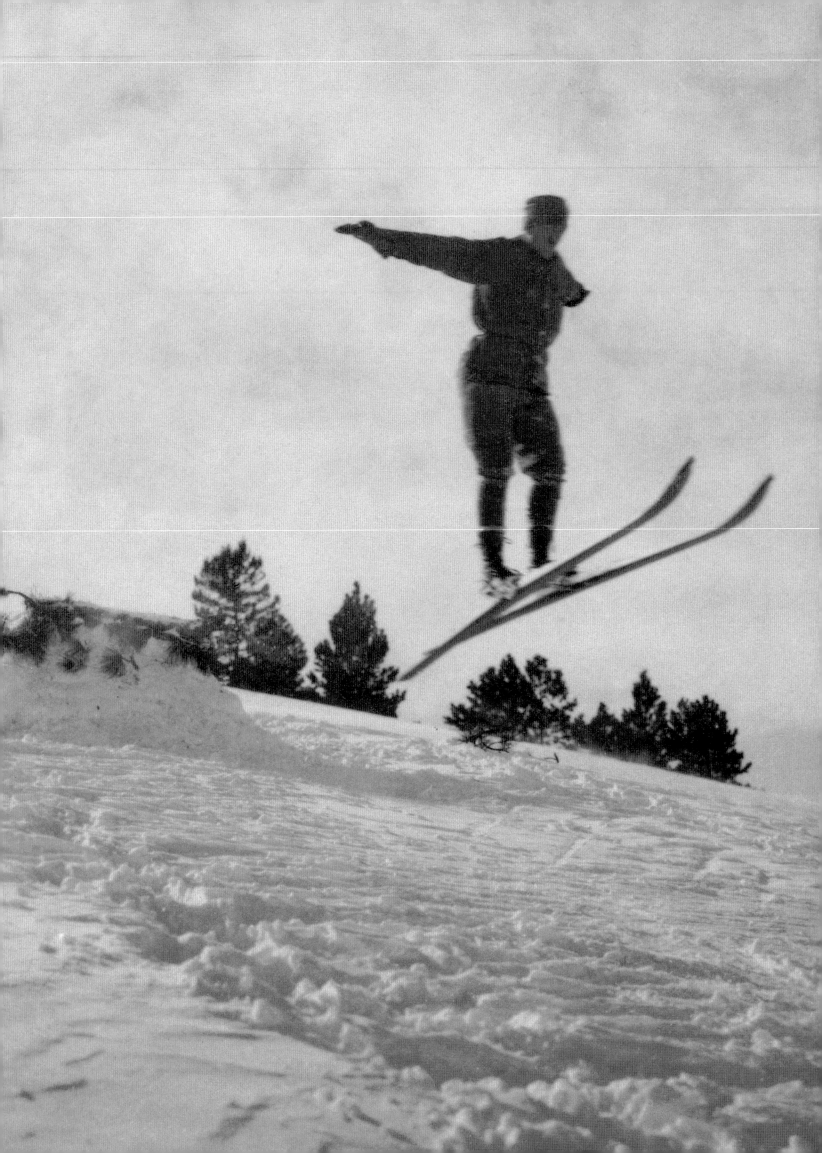

TOP OF THE WORLD *The Alpine Zone*

For generations, the alpine peaks of the Colorado Rockies have drawn artists, poets, adventurers, treasure hunters, dreamers, and the curious. These lofty heights have inspired songs, books, poetry, paintings, and simple reflection. Perhaps more than any other image, the one of a jagged, snow-capped peak brings to mind the spirit and beauty of the state of Colorado.

Among the thousands of summits that rise toward the heavens, fifty-five are members of that elite group of "fourteeners," mountains with an elevation higher than fourteen thousand feet. All of the fourteeners in the Rocky Mountain chain, and nearly three-quarters of all those in North America, are located in the state of Colorado. With the highest average elevation of any state (6,800 feet), and more than fifteen hundred peaks above twelve thousand feet, Colorado is truly a land of giants. It is perhaps no surprise that such lofty heights have been celebrated in poem and song ("America the Beautiful" being only the best-known representative), and have inspired the imaginations of countless visitors and residents alike.

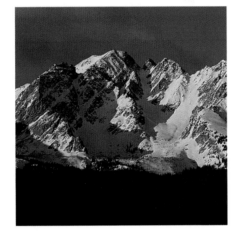

Living in the shadows of these giants, it is difficult to think of actually descending to live anywhere else. The spirit of the mountains captures the hearts and minds of its denizens, preventing them from leaving. In many cultures, mountains have been revered as holy sites, natural temples—literally, the homes of the gods (as the Ute Indians considered the Rockies). I remember clearly the first time that I stood upon the summit of Longs Peak—a Rocky Mountain National Park giant that, at 14,255 feet, is the highest in northern Colorado. The grandeur and scale opened my mind to the limitlessness of nature; I was forced to acknowledge a planet so large and ancient that all human endeavors seemed insignificant in comparison. In that moment, my world became larger, and my place in it changed.

Having since more thoroughly explored many of these lofty and dramatic places, I can say without hesitation that the peaks of the Colorado Rockies truly do have the power to change a person, to broaden one's ways of thinking. Few who witness the majesty of these lonely, windswept heights walk away unaffected. Always stunning, sometimes violently dangerous, Colorado's alpine peaks are emblematic of the state's imagination and of its heart.

The alpine zone lies above timberline. It is a unique and fragile ecosystem that is constantly battered with punishing extremes. The alpine zone is alternately baked in the sun and frozen in solid ice. Brutal storms can consume a mountain with deadly fury; howling winds scour the surfaces, and oxygen becomes a rare and valuable commodity. Even the most tenacious forms of life are routinely beaten back down to altitudes that are more hospitable.

LEFT *Bundled in heavy woolen clothes, a skier challenges gravity while relying on wooden skis in this portrait from the early 1900s.*
ABOVE *Little Powell, often confused with Mount Powell, towers high above the west fork of Brush Creek.*

One cannot help but be awed and humbled by the destructive forces of nature in the alpine zone. Witness, for instance, the forest blowdown that occurred early on the morning of October 25, 1997, along the west slope of the Park Range (inside and adjacent to the Mount Zirkel Wilderness, Medicine Bow–Routt National Forests). Wind estimated at 120 miles per hour blew down a swath of twenty thousand acres, five miles wide and thirty miles long. In one breath, nature flattened four million spruce and fir trees, scattering them like a box of matches. It will take centuries for nature to rebuild these forests, but it is all part of the endless cycle of growth, destruction, and renewal.

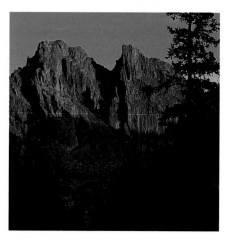

Yet, for all of their harshness and occasional fury, these peaks continually draw people who endure great difficulty and risk to stand upon them and gaze down upon the world as if from heaven. Among the altitudinal extremes of the Rockies, men and women have attempted and performed physical feats that border on the superhuman. Some of the world's great mountaineers have learned or polished their skills in the Rockies. And the rocks and snow attract many for more modest pursuits: Colorado's twenty-six ski resorts draw eleven million skiers and snowboarders annually, and millions more come to hike and climb for pleasure.

In the rarified air of the alpine zone, sunlight can do strange and wondrous things. Those who witness the magic of alpenglow on a winter evening are typically at a loss for words. The sun and the snow combine to ignite an otherworldly conflagration among the peaks; the whole world, for a few brief minutes, burns with a bright, spectral fire, and comes alight with such shocking beauty that one is propelled into a new way of seeing. Entire mountainsides burn in warm bright hues; the white snow turns a thousand shades of red, pink, and orange; shadows turn purple and deep blue, while distant hillsides appear to be aflame. A sudden fiesta of light and color illuminates an entire horizon.

Then, in seconds, it all fades away. Twilight falls and the blaze is extinguished. Deeper, cooler colors dominate the flames until the black and silver symphony of night enshrouds the land.

On my first visit to Colorado in 1955, I was deeply impressed by many things. The people were open and friendly. The air was fresh and clean. Countless swiftly flowing rivers, turquoise lakes, and pristine forests waited to be explored. Rolling plains and harsh deserts fed my sense of adventure.

But it was the vision of the mountains, the tallest monuments of rock and ice, that stayed with me, and that beckoned to me again and again. From first sight, it was the alpine peaks that defined the state in my imagination, and it is those peaks that will always sing to me in my dreams.

ABOVE *Alpenglow of an autumn evening lights remote northern pinnacles of the Sawtooth Range, Mount Zirkel Wilderness.*
RIGHT *The spring thaw progresses nicely on Big Agnes Mountain while Gilpin Lake seems immune, near Mount Zirkel.*

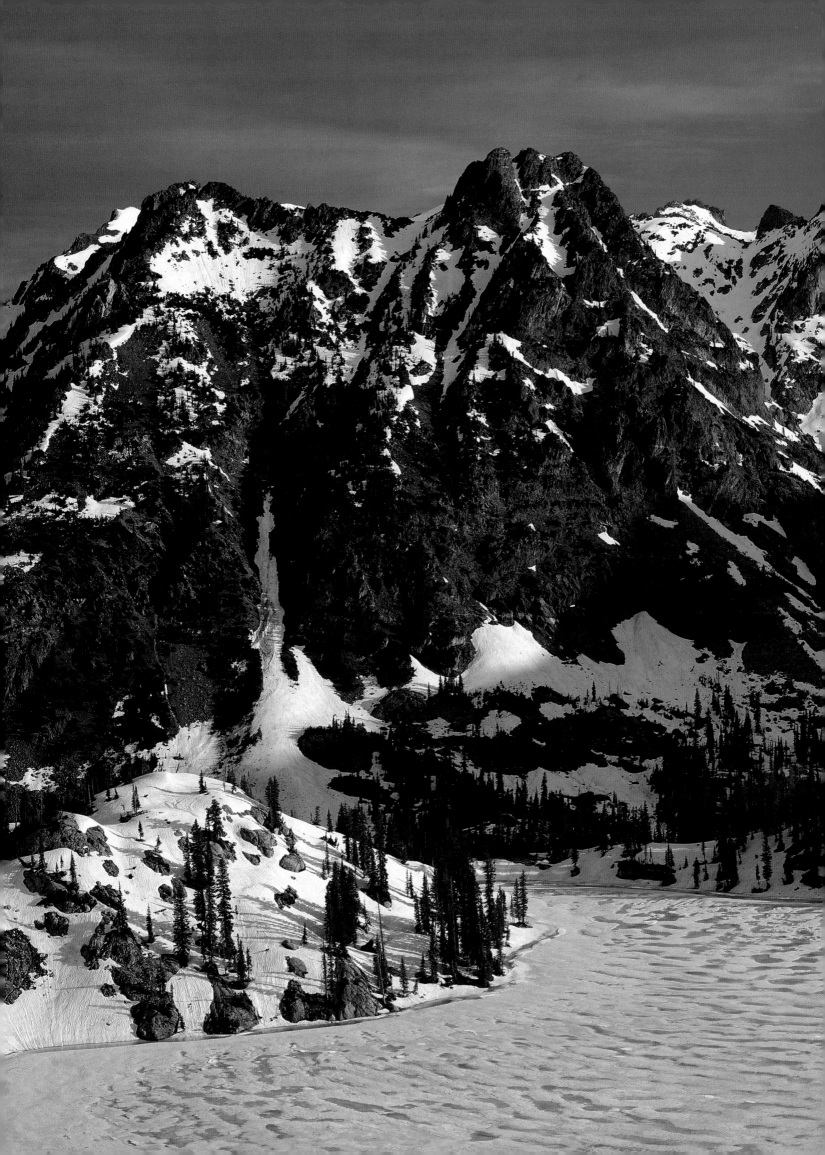

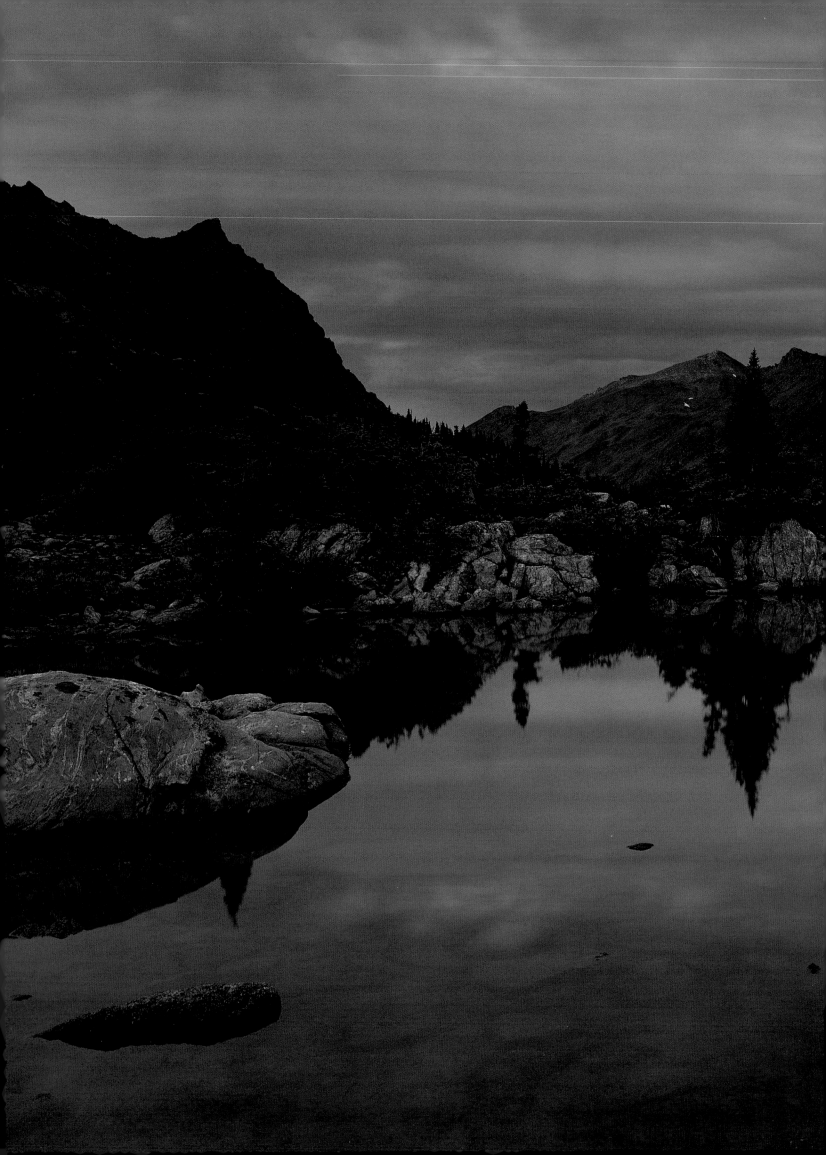

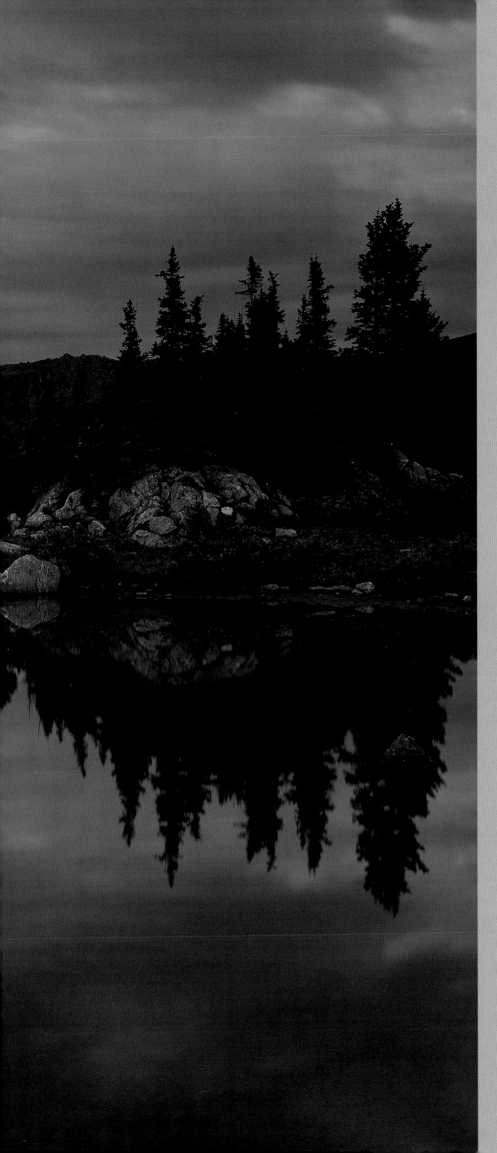

SAWATCH RANGE

Embracing the three highest mountains in Colorado, and four out of the eight highest peaks in the continental United States, the Sawatch Range is the monarch of the Rockies.

Despite the fact that the Sawatch contains such high peaks, it is actually a fairly small range. In fact, in overall area, it is one of the smallest of the major ranges in Colorado.

Topped by Mount Elbert at 14,433 feet, the Sawatch Range is composed of a single faulted anticline created during the Laramide Orogeny, a geological uplift that formed much of the Rockies about sixty million years ago, during the Paleocene period of mountain building. Large alluvial fans rest on the lower slopes of Mount Elbert and neighboring 14,421-foot Mount Massive. Torrential Ice Age rivers caused this outwash, which has been slowly growing since.

Most of the Sawatch Range consists of ancient Precambrian schist and gneiss, which was gradually worn down by glaciation to form characteristic U-shaped valleys. The peaks of this Continental Divide range are famous for their numerous and accessible hiking trails.

—EW

LEFT *A pond above an upper fork of the Fryingpan River reflects the soft palette of a summer sunset over the Williams Mountains, Hunter–Fryingpan Wilderness Area, near the Victorian town of Aspen.*

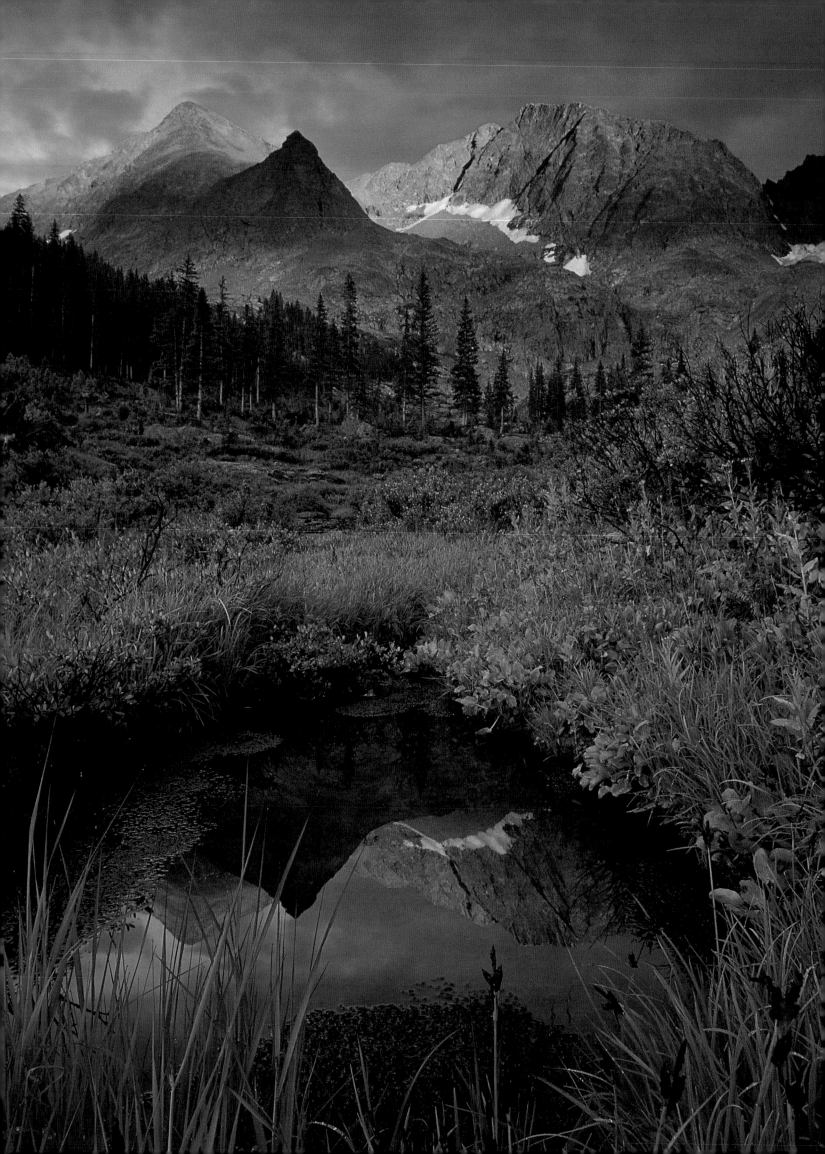

LEFT *A summer rain pool holds reflections of two of the Three Apostles, Apostle North (left, 13,863 feet) and 13,951-foot Ice Mountain.*
ABOVE *An afternoon rainbow encircles 14,336-foot La Plata Peak, the fifth-highest mountain in Colorado.*
OVERLEAF *Cottonwood Pass separates Taylor Park and the Arkansas River Valley, on the Continental Divide.*

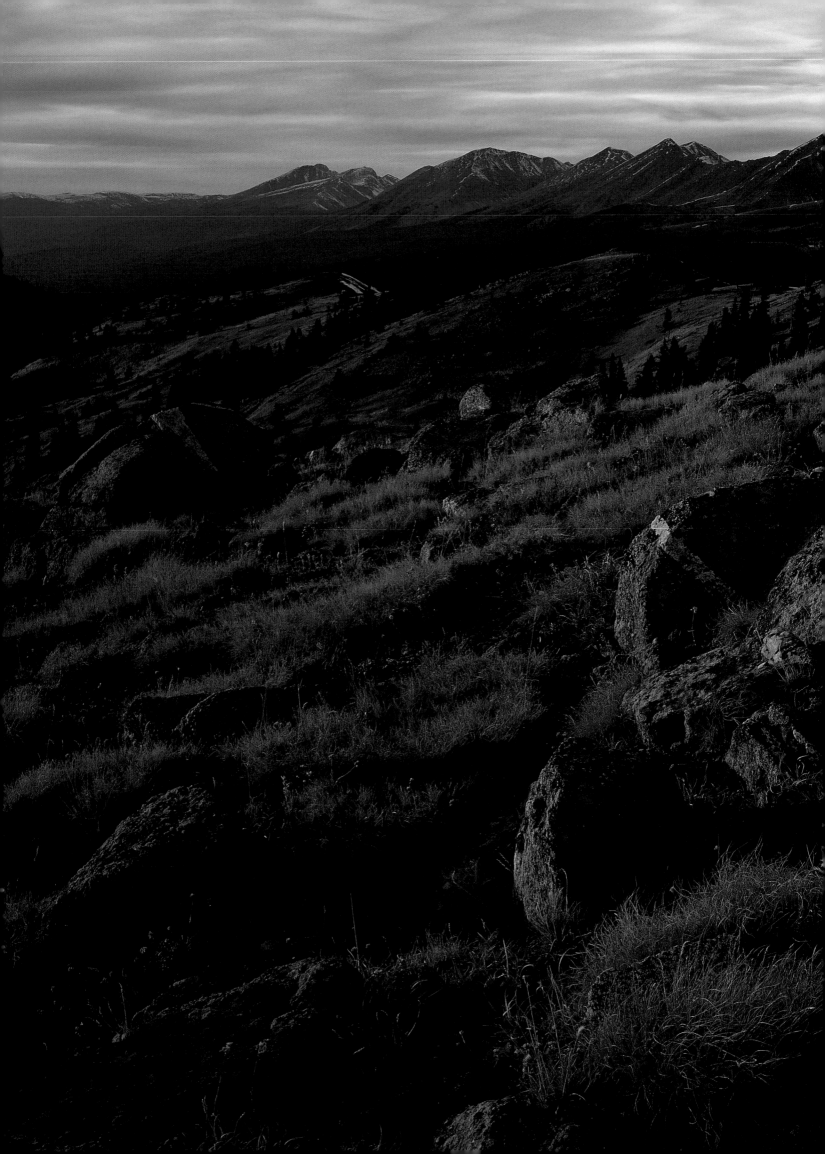

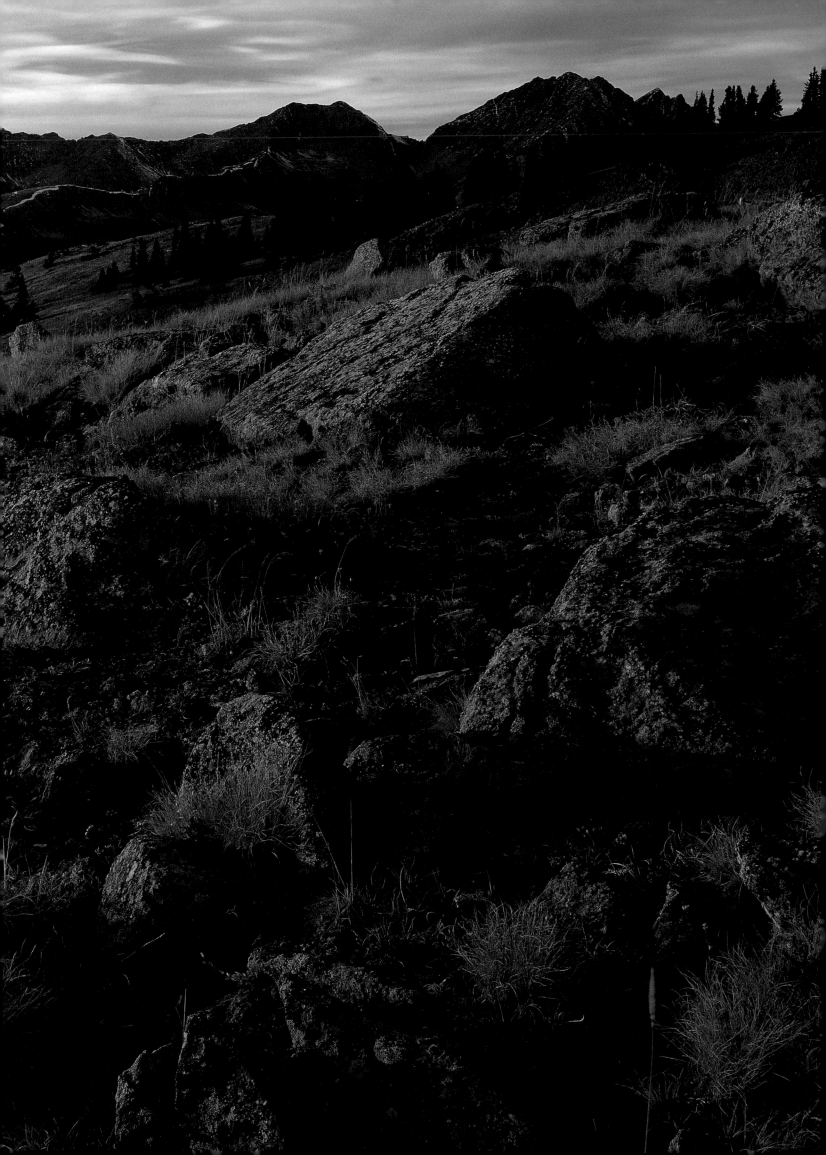

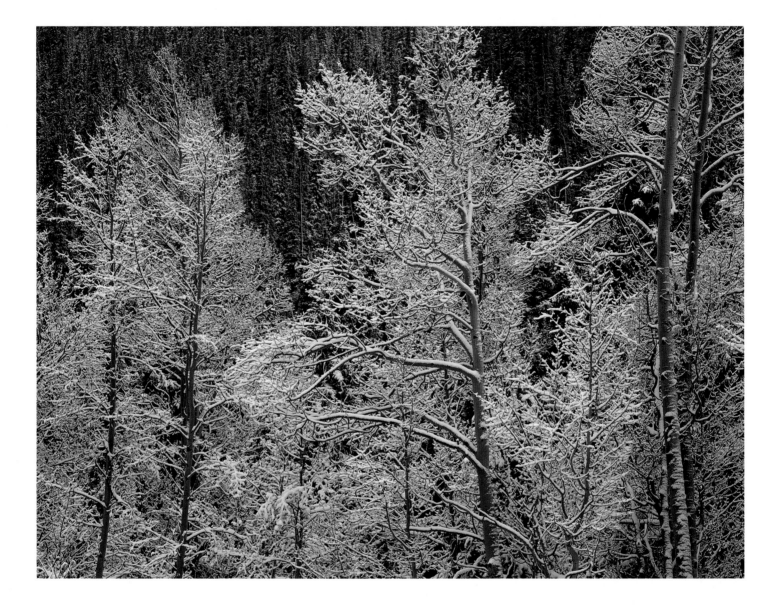

ABOVE *An overnight dusting of snow clings to aspens that still exhibit the last signs of autumn color, upper Cottonwood Creek.*
RIGHT *Aspens sway in an autumn breeze after a snowstorm blanketed Sheep Mountain (11,857 feet), Cottonwood Canyon.*

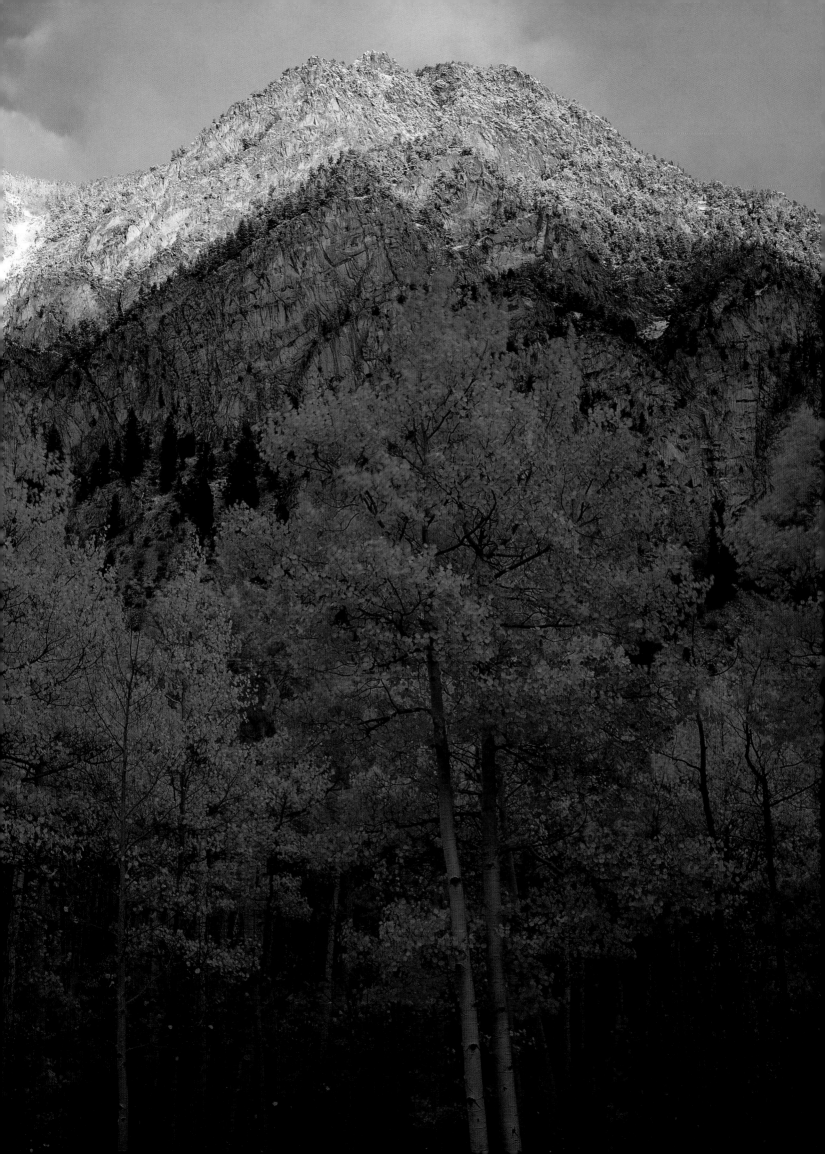

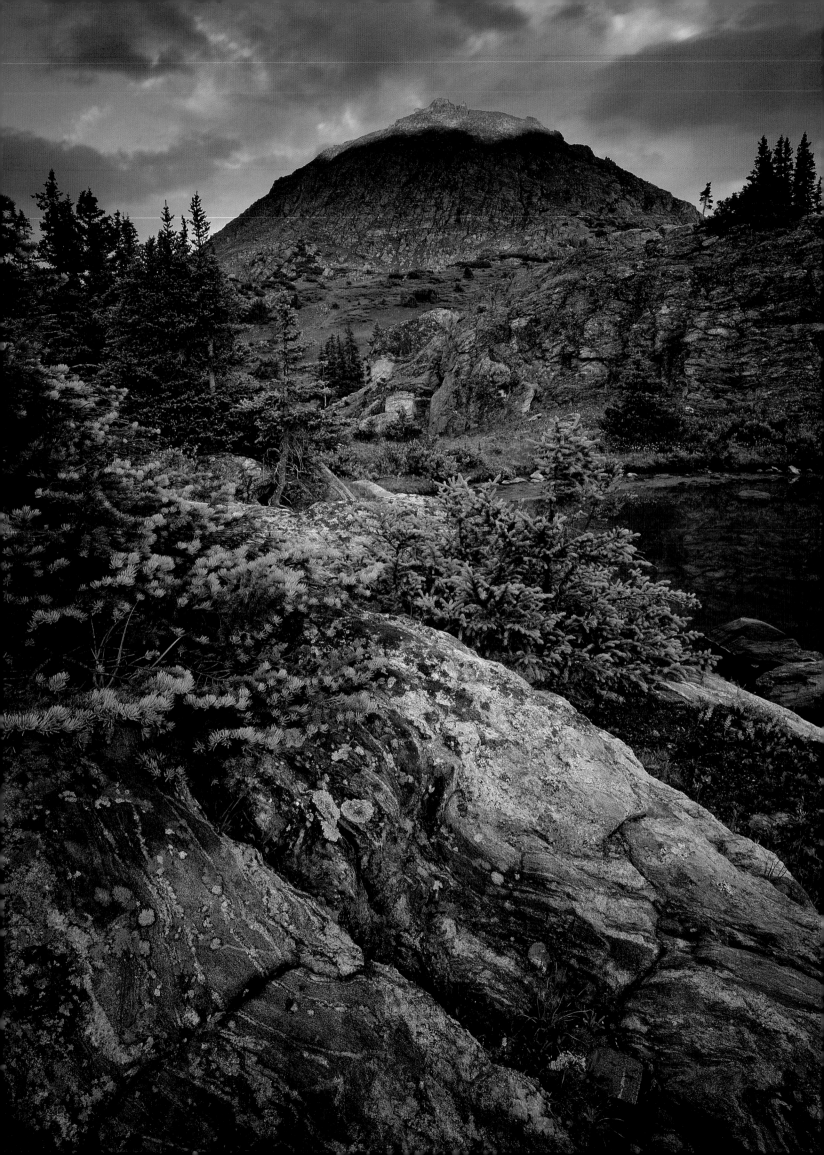

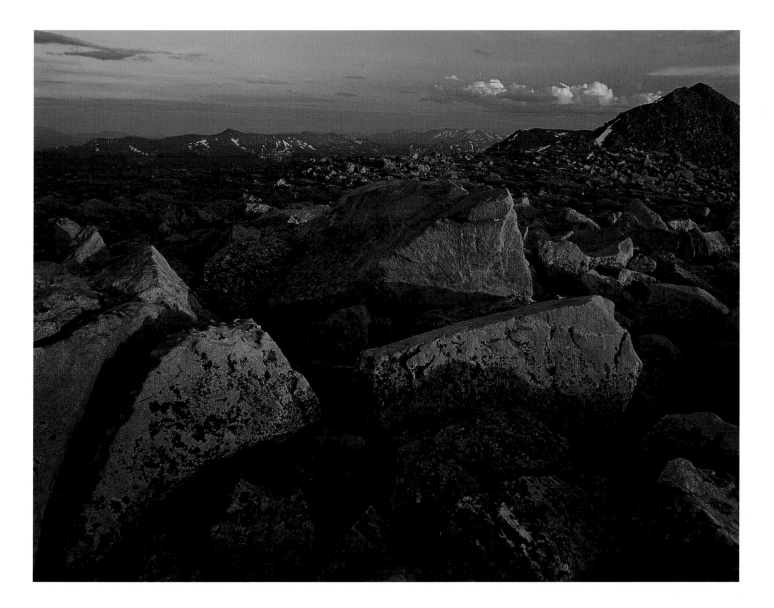

LEFT *A large granitic dome, rising above striated rock and an alpine pond, catches warm sunset light, Hunter–Fryingpan Wilderness.*
ABOVE *Evening light colors granite boulders on Notch Mountain and the distant Mosquito Range, Holy Cross Wilderness.*

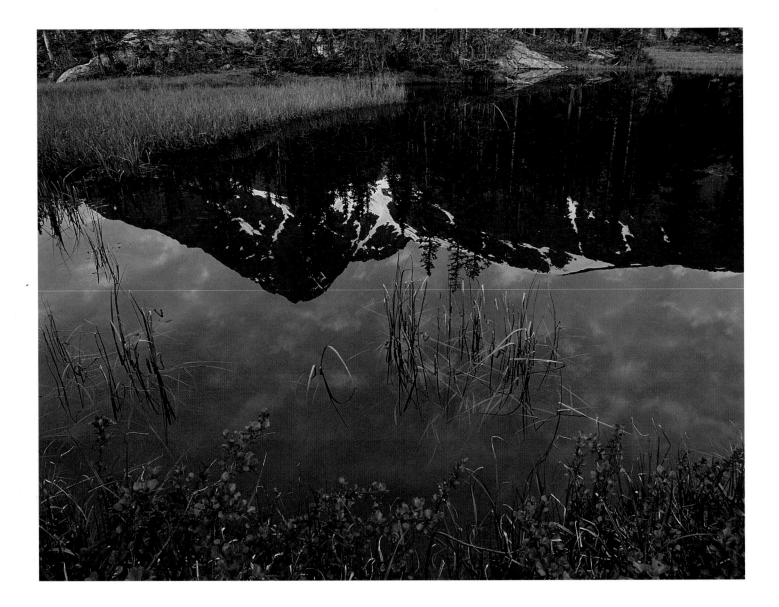

ABOVE *An alpine tarn reflects the 14,005-foot Mount of the Holy Cross, which has become a goal of pilgrims, East Cross Creek.*
RIGHT *Mount of the Holy Cross, shown here from Notch Mountain, was named for the white cross descending from its peak.*

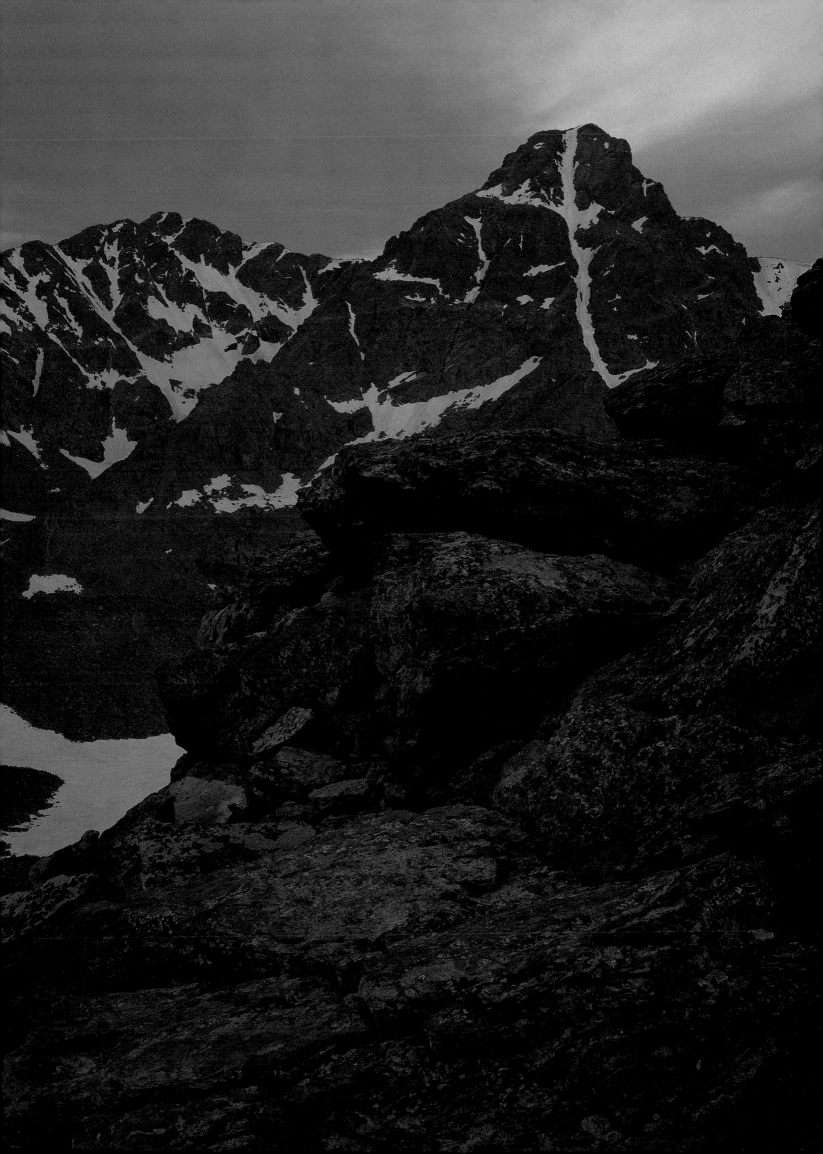

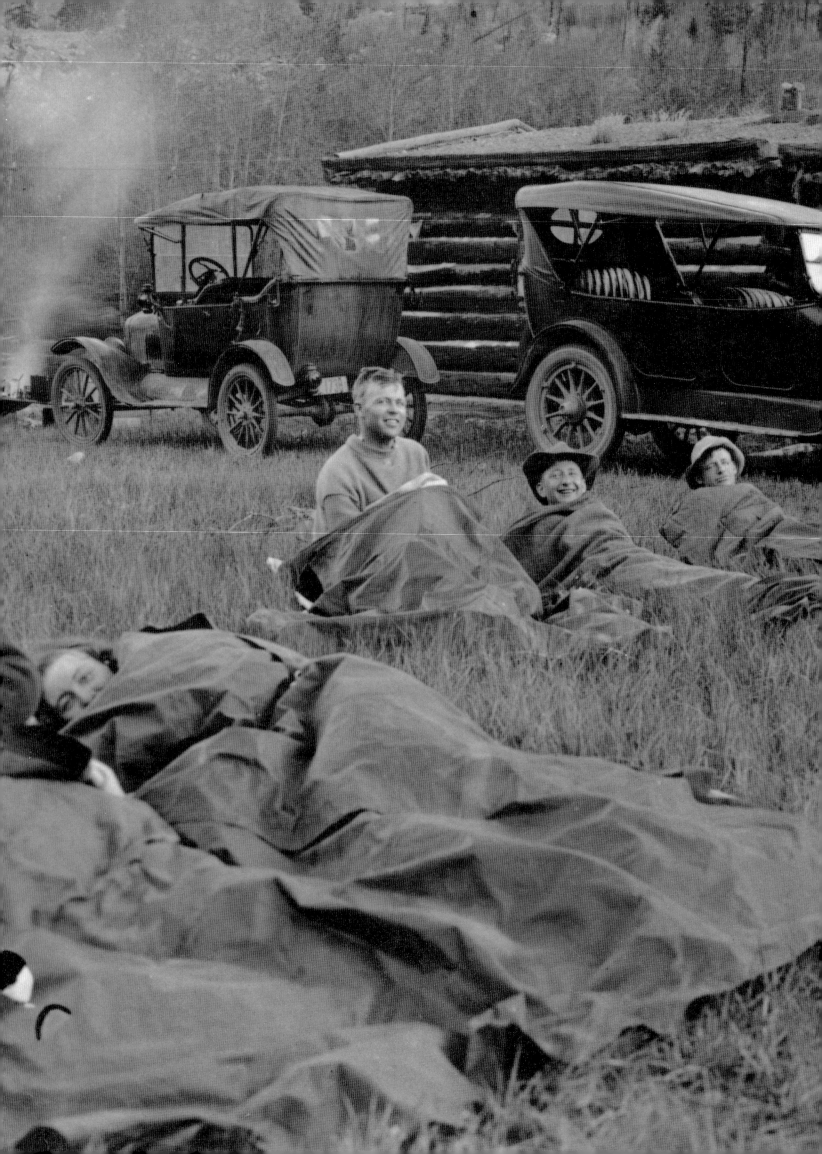

Spring to Winter *The Seasons*

This land is a place of all seasons, for even in winter there is the promise of spring, the foretaste of summer. The white of snow becomes the white of summer clouds; the resonant green of spruce becomes the green head of drake mallard; the gray of rock and lichen endures in the gray of lowering winter skies; the same orange-red of Indian paintbrush bars the blackbird's wing and stains the western tanager's head. Here part of each season is contained in every other. The tight-woven knowledge from all our yesterdays at this land is held in the stern simplicity of tree and sky and flower and rock, a certainty of tomorrow.

–Ann Zwinger
Beyond the Aspen Grove

Colorado's climate is one of its great attractions. Clear, sunny days are the norm rather than the exception, and crisp, starlit nights abound. In most parts of the state, the temperatures are relatively mild, and it is rarely very hot or very cold for long. Humidity is consistently low, which makes even the hottest and coldest times more comfortable.

Of course, high in the mountains, the relative mildness of the climate can be misleading. Winter storms in the Rockies can be killers; with little warning, a pleasant winter afternoon can be transformed by wind and snow that buries roads and punishes the unprepared. On three occasions, I have seen people buried by avalanches (fortunately, in each instance, no one was killed).

In the spring, the snowmelt from the warming alpine peaks can turn narrow mountain streams into raging torrents.

In summer, even relatively light rains can cause flash floods to thunder down previously dry canyons, destroying everything in their path. In the Rockies, every change of season brings new trials, but it also brings new beauty.

For those who build their lives on this land, timing is everything. In the spring and summer the crops must be planted and nurtured. In the mountain regions, farming can be a challenge. The number of days when the weather is warm enough to grow fruits and vegetables is a scant seventy-six days, compared to two hundred days on the eastern plains. Fall is a time of preparation; the days shorten, and the land changes. Summer crops are harvested, and winter wheat is planted. Winter can be a desperate trial or a time of peaceful reflection. Together, the seasons form a whole, an eternal cycle by which all living things in the Rockies are bound together.

It has been said that there are only three seasons in the mountains: winter, summer, and fall. In a sense, this is not far from the truth. Spring in the Rockies can be an ephemeral thing; blink, and you

LEFT *Campers with horseless carriages rise and shine at Twin Lakes before proceeding on a Mount Elbert expedition on July 4, 1919.*
ABOVE *This showy bloom of leafy aster defines alpine summer at over twelve thousand feet, Hunter–Fryingpan Wilderness.*

may miss it. Rather than a gradual return of life it is a sudden explosion. Summer arrives hard on the heels of winter, leaving spring only a week or two to make a cameo appearance.

As the snow begins to melt in the high country, the rivers gather strength, pastures that have been brown for months turn green overnight, and wildflowers appear in profusion. Skeletal aspen trees are suddenly fleshed out in their quaking green finery, and creatures of all description emerge from their winter hiding places in perfect synchronization, hungry and restless, as if the exact moment had been agreed upon in advance.

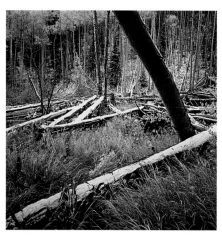

Summer is the long, green season during which the flora thrive and the animals are most active, gaining weight and gathering food in preparation for the changes to come. Summer clouds and rain and sun constantly play upon the land, altering the colors and textures of the mountains; rain falls through the sun like electrified gold, forming colorful rainbows. In summer, the signs of life are everywhere.

With fall, the first snows come to the high country, and the aspens begin to turn. Entire mountainsides come alive with color, as green, red, yellow, and orange run riot over the hills and through the valleys. Autumn sunsets in the mountains burn with hues of silver and gold, blues and reds, pinks and purples. No two days are the same but they are all beautiful. Fall is a perfect season to roam in the Rockies: there are fewer tourists, and the weather is usually dry.

Winter in the Rockies is unpredictable. It can appear overnight, suddenly blanketing the high country in snow and not relenting until June; or it may begin gradually by merely depositing a few tentative flakes from time to time. During Colorado winters, mountain towns were once frequently isolated by severe storms and heavy snows. Whole communities could sometimes be buried for weeks.

In December 1913, Denver itself was hit with a severe storm that blanketed the city with nearly fifty inches of snow in just a few days. The entire community was paralyzed; schools and businesses ground to a halt. An army of men was recruited to work for the daily wage of $2.50, to dig the city out. They shoveled for days, digging through drifts up to twenty feet deep, and loading the snow onto horse-drawn wagons. Some of the piles of dumped snow remained until summer.

Today mountain communities are considerably less isolated in the winter. Telephones, radio, television, and four-wheel drive have done much to ease the trials of the winter months. Yet there is still a sense of pride and shared toughness in the small mountain towns during winter. In a sense, the whole community rises above the challenge of winter and finds its identity and strength in the process.

ABOVE *A surprise fall storm dusts all in its path, including this clearing of downed trees in an aspen forest, Cottonwood Creek.*
RIGHT *Mount Elbert, Colorado's highest mountain at 14,433 feet, backdrops snow-softened boulders along a mountain lake.*

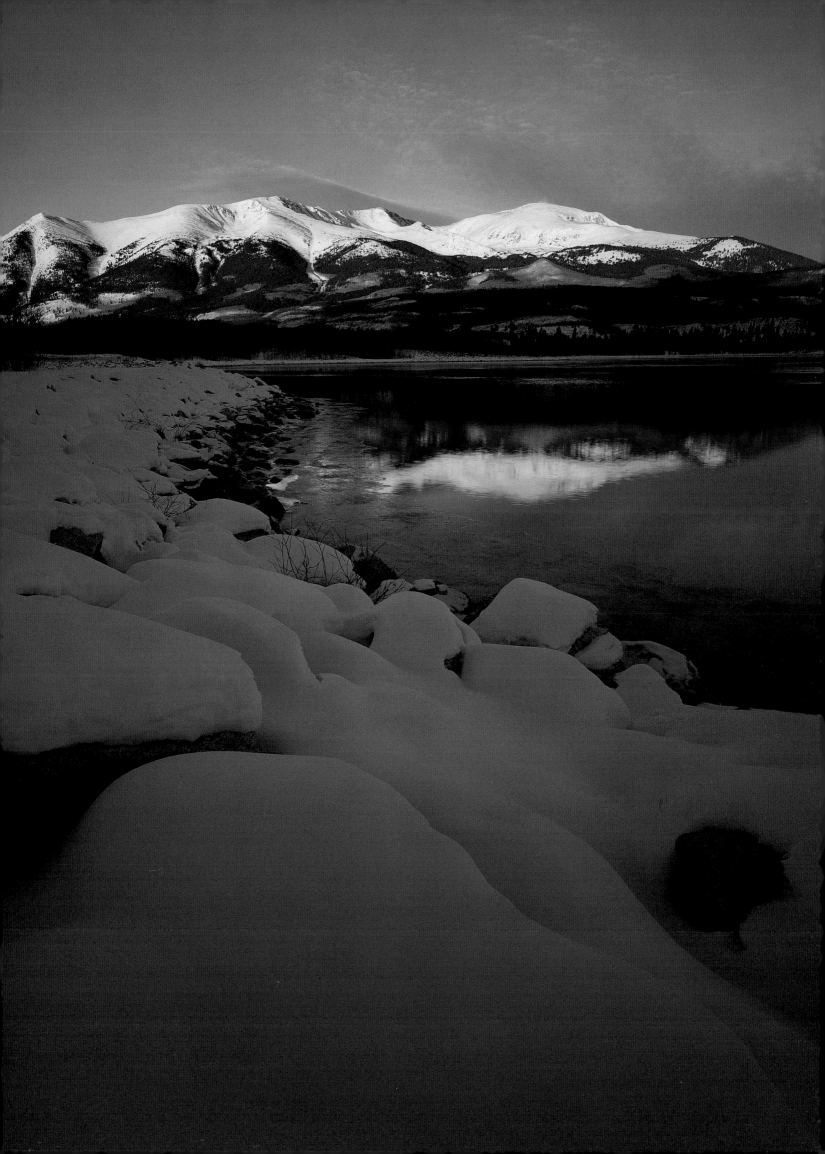

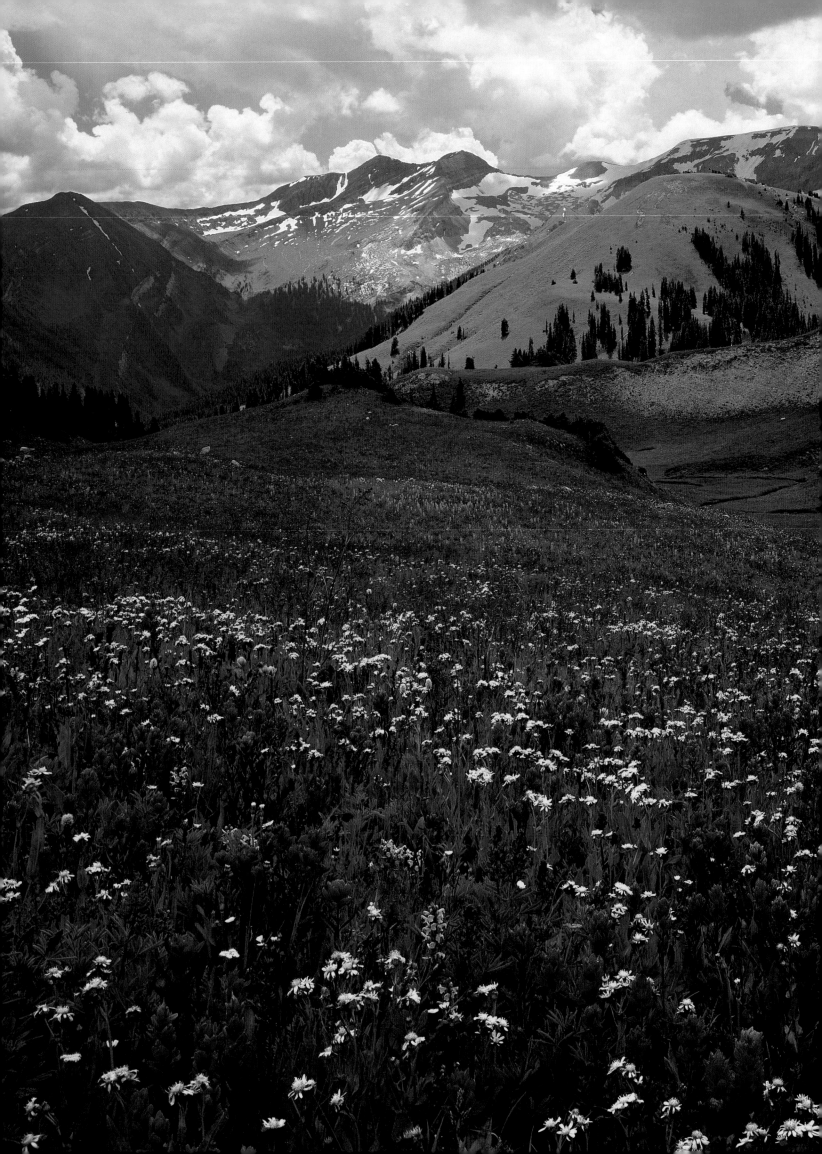

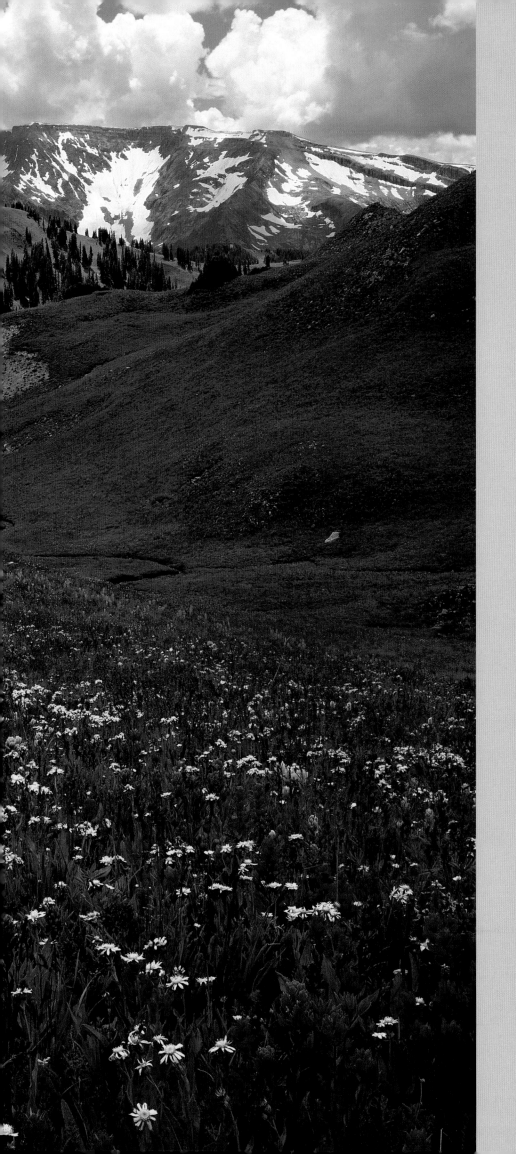

ELKS & WEST ELKS

The Elk and West Elk Ranges form a large, craggy mass of layered, broken rock, richly painted in purples, reds, and rusts. Located southwest of the more prominent Elk Range and with its highest peaks barely reaching 13,000 feet, the West Elks constitute a significant subrange. The two ranges abound with creative names like the Raggeds, the Castles, and Electric Pass; the tranquil Ruby Range glows with its named hue at sunset, replete with Purple Mountain and Oh-Be-Joyful Pass.

Made famous by television, magazines, and advertising, the great Maroon Bells reflected in pristine Maroon Lake is probably the most documented view in all of Colorado. Lofty neighbor Pyramid Peak reaches to the heavens, reminiscent of the Himalaya.

A land blessed with more than 422,000 acres of wilderness areas, the Elks and West Elks contain the resplendent Maroon Bells–Snowmass, the Raggeds, and the lonely West Elk Wildernesses. The early summer colors of vibrant greens splashed with fields of wildflowers against the rusty mountains form a palette unique to these ranges.

—EW

LEFT *Treasury Mountain (left, 13,462-feet) and neighboring Treasure Mountain (13,528 feet) reign over a kaleidoscope of summer wildflowers in full bloom, Maroon Bells–Snowmass Wilderness Area.*

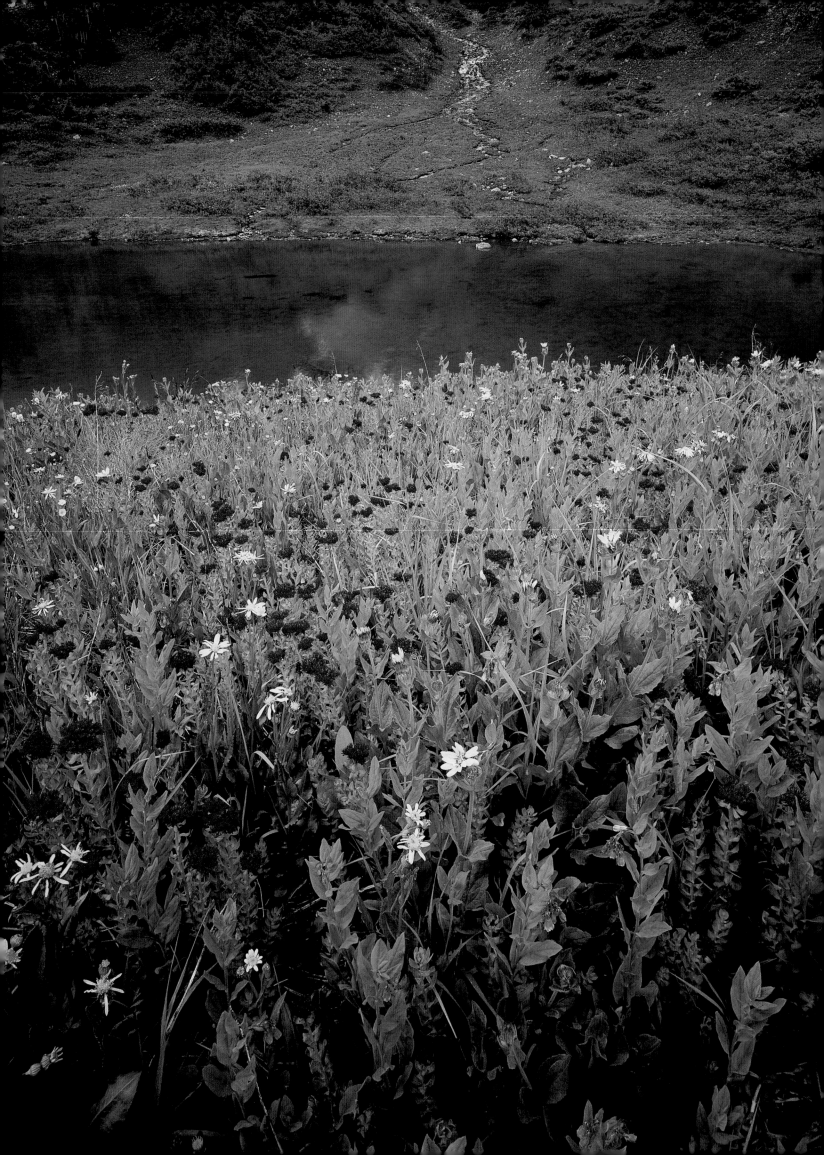

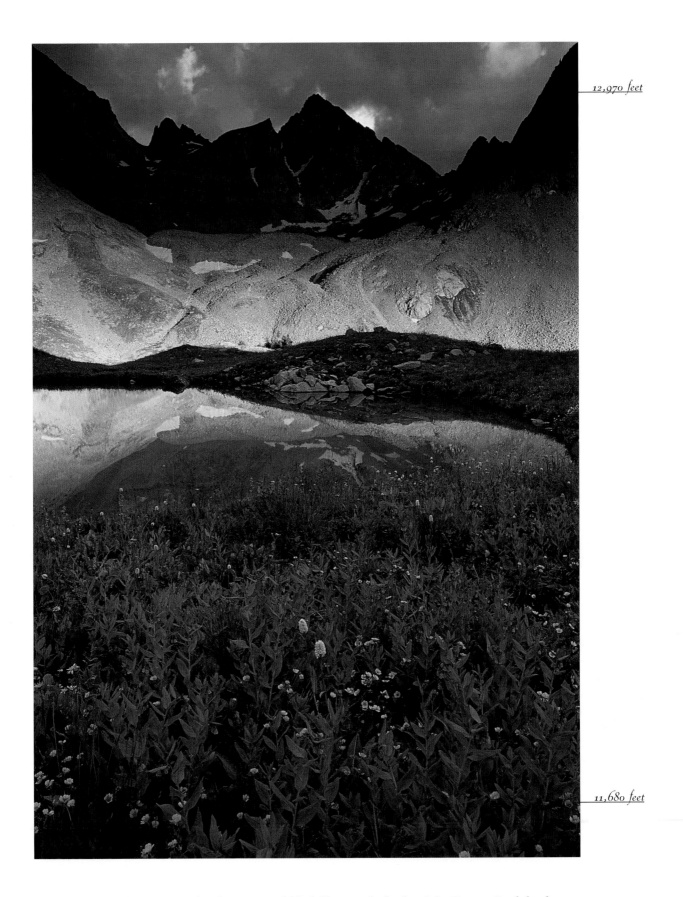

12,970 feet

11,680 feet

LEFT *Arrowleaf balsam root, king's crown, and bluebells paint the banks of the Copper Creek headwaters.*
ABOVE *An unnamed mountain looms over a flower-lined pond above Avalanche Creek.*
OVERLEAF *An alpine tarn mirrors mountains above, Maroon Bells–Snowmass Wilderness.*

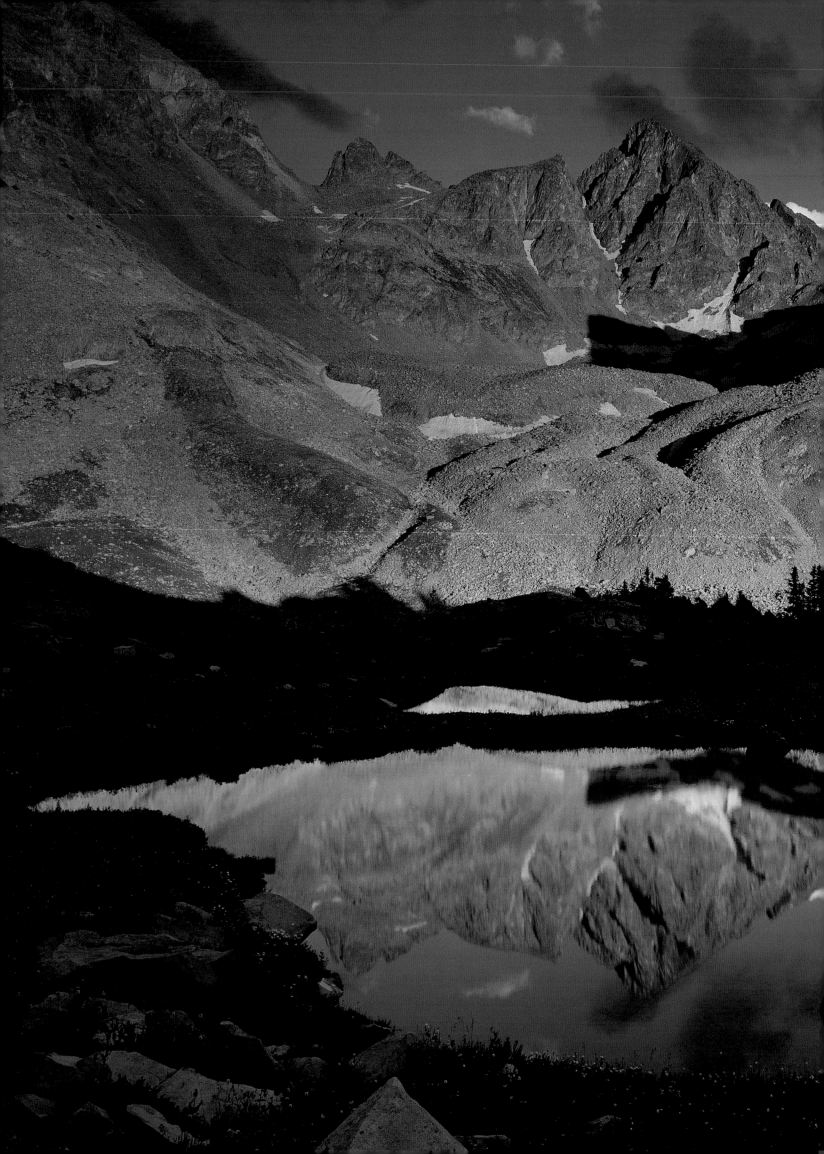

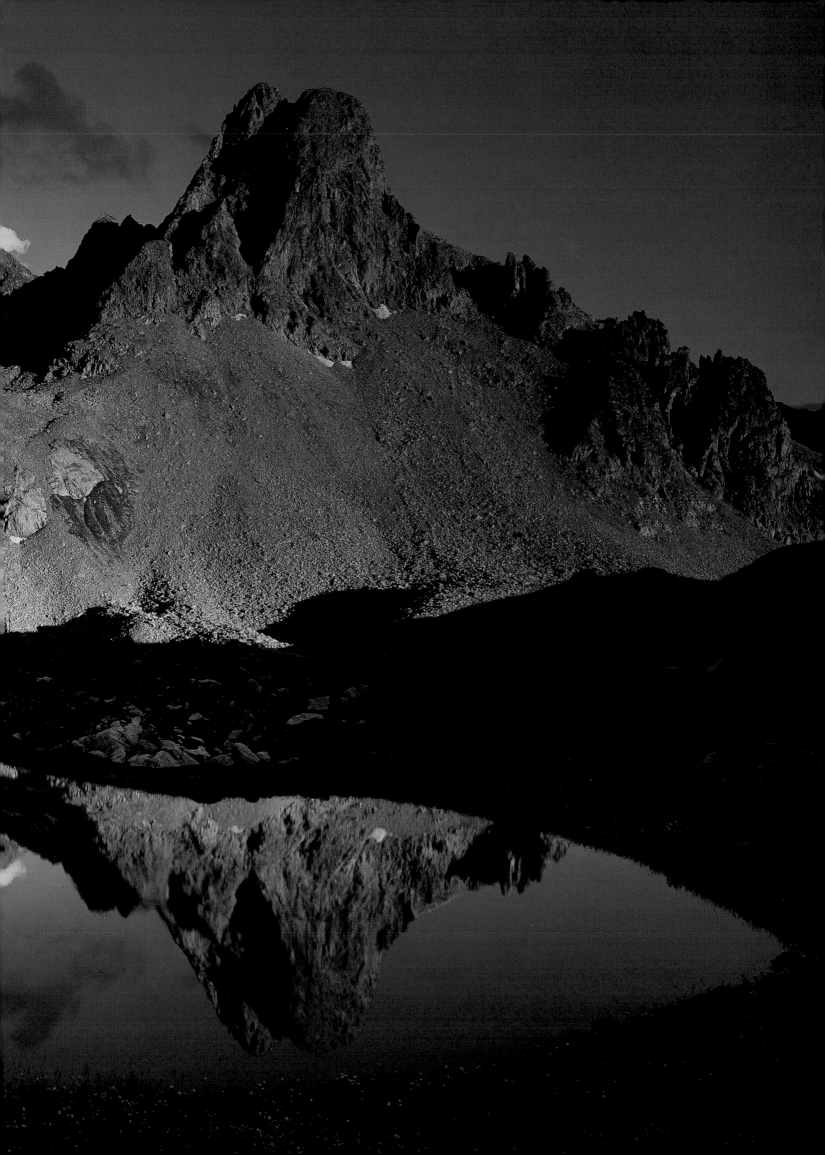

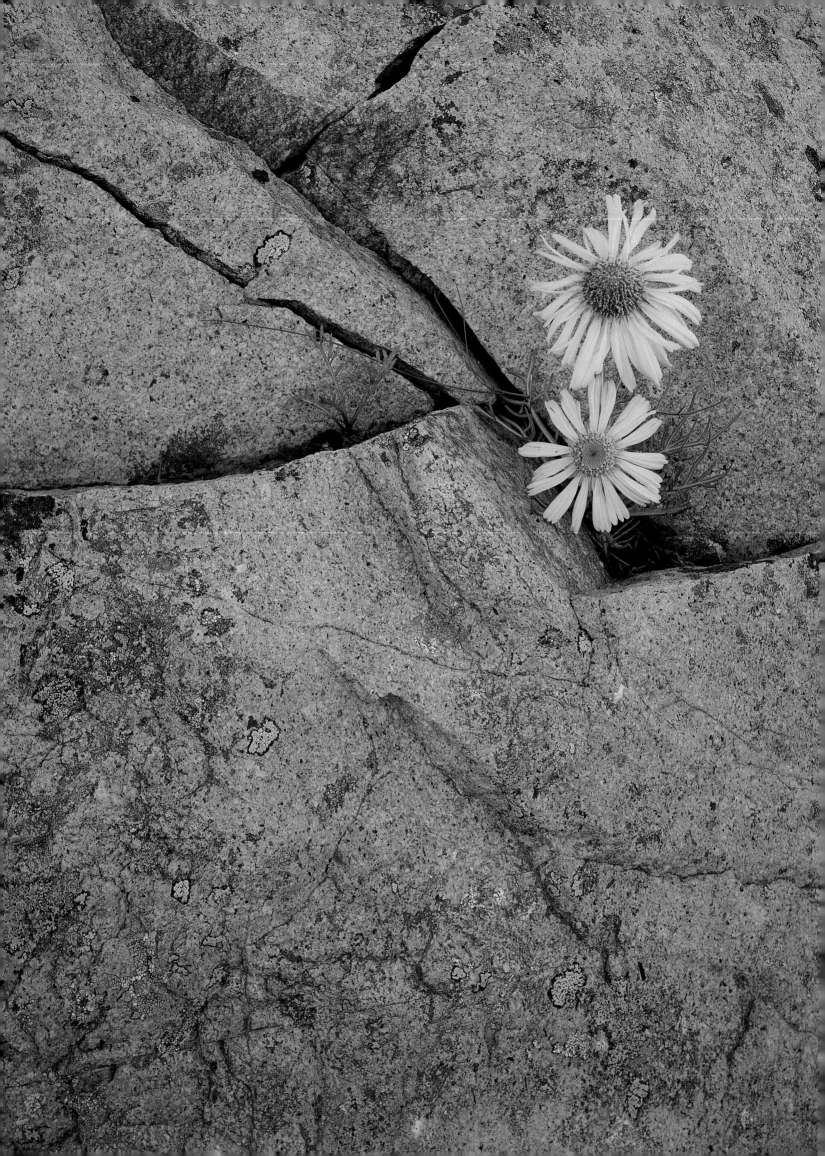

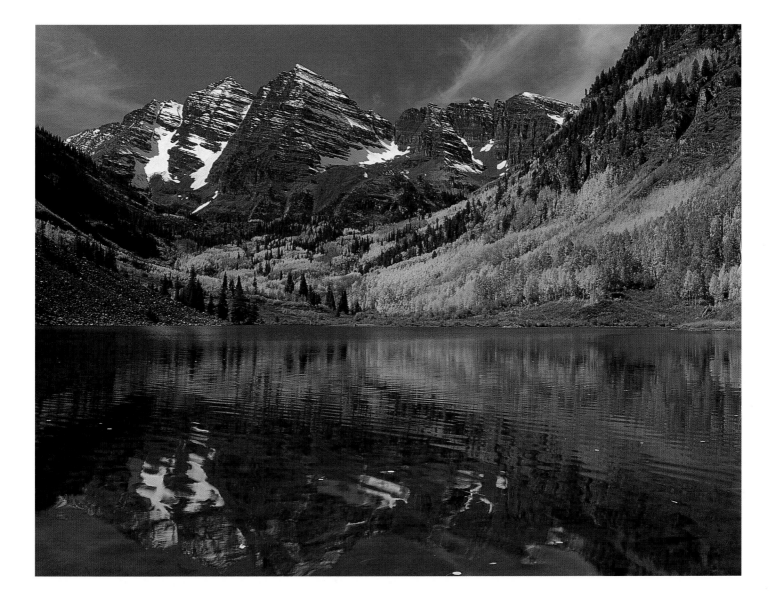

LEFT *Two alpine sunflowers take root in a tiny crack in a boulder near Avalanche Creek, Maroon Bells–Snowmass Wilderness.*
ABOVE *The noble and spectacular Maroon Bells rise over forty-five hundred feet above pristine Maroon Lake.*
BELOW *A backpacker escapes up the Capitol Creek trail in autumn.*

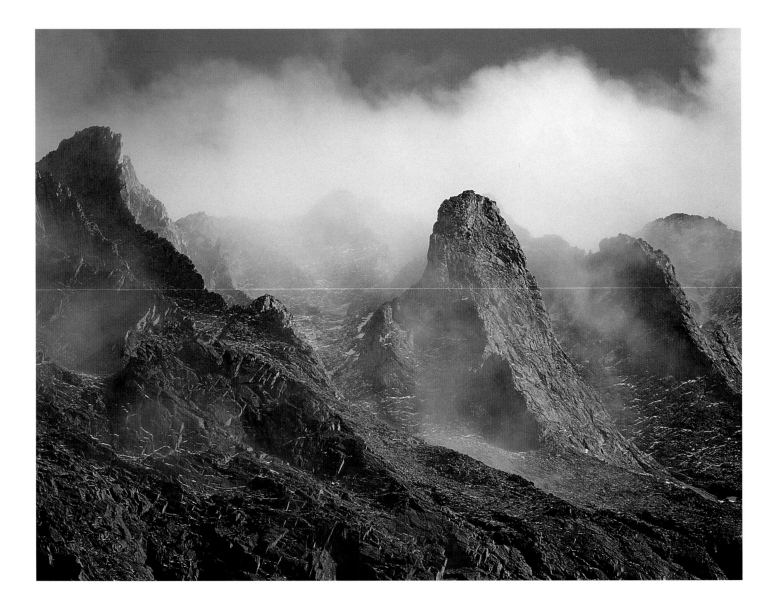

ABOVE *Pinnacles below Knife Edge, a ridge of Capitol Peak, spear through the clouds, Maroon Bells–Snowmass Wilderness.*
RIGHT *A heavy snowfall buries 14,018-foot Pyramid Peak and forested hillsides of Maroon Lake, near Aspen.*

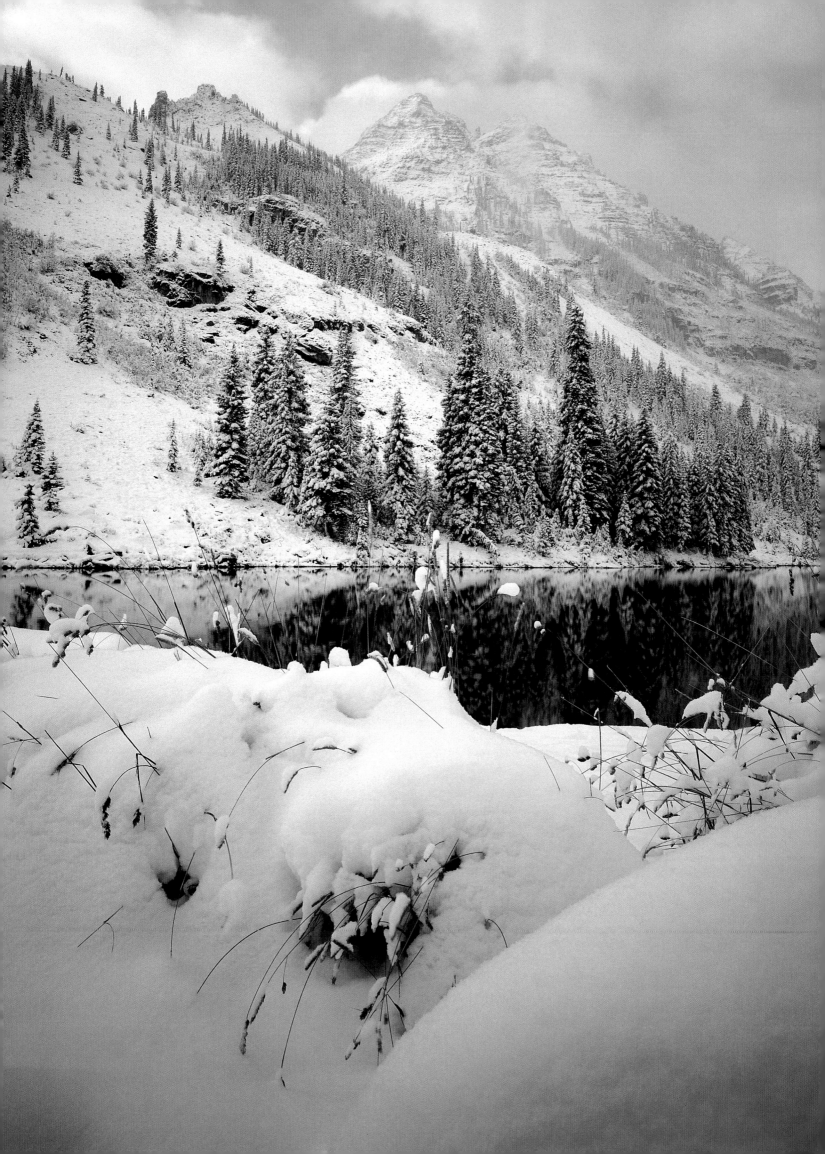

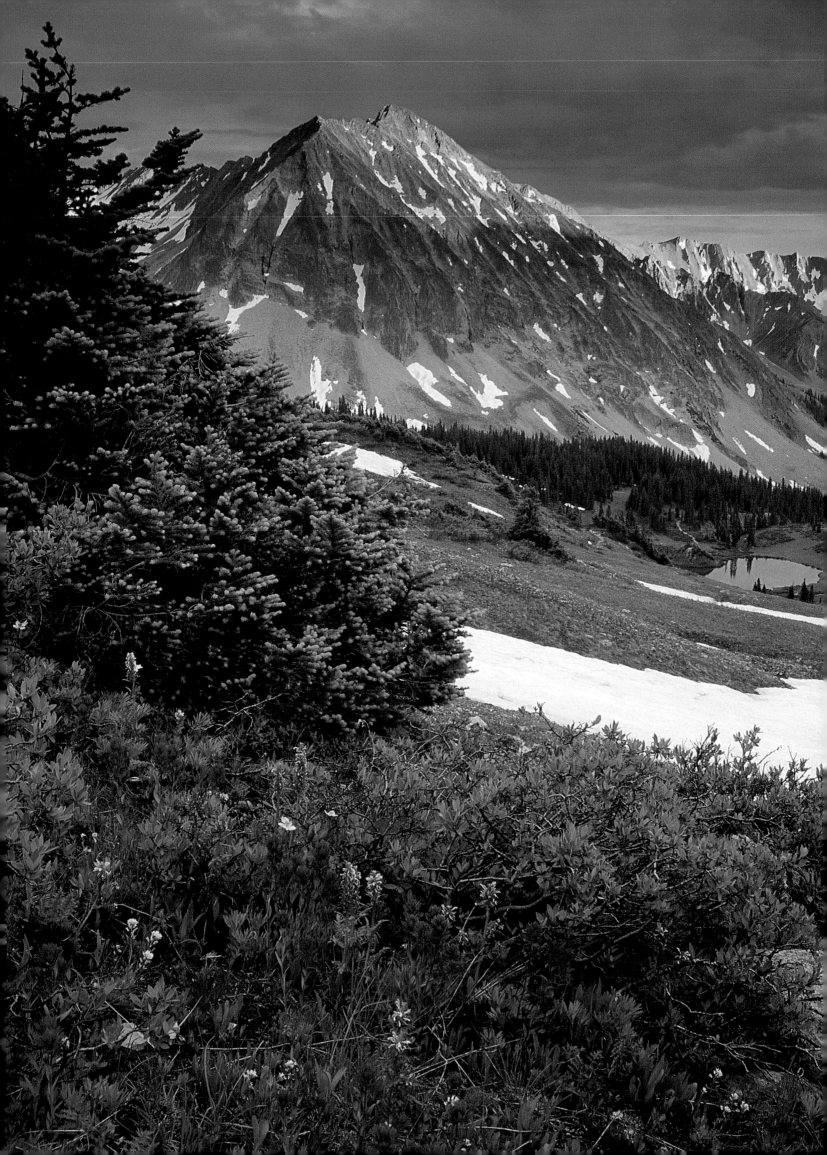

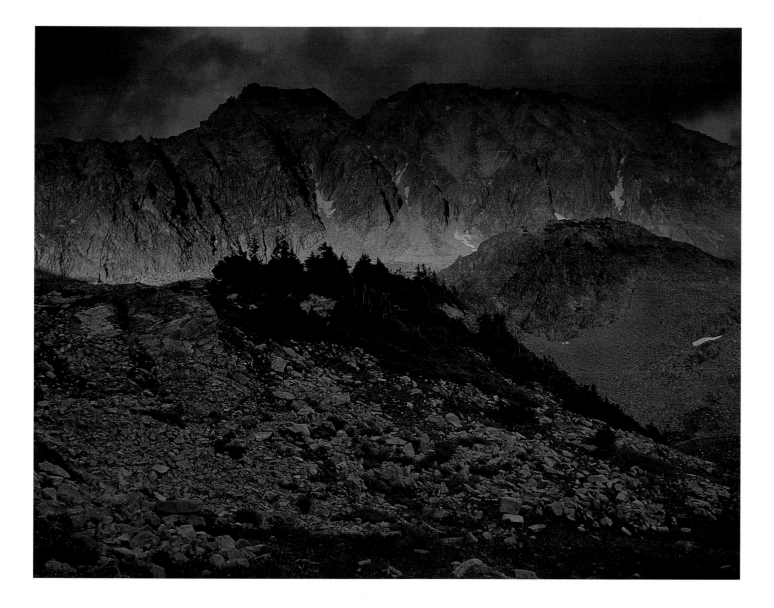

LEFT *Paintbrush dots a hillside above Copper Lake, with 13,253-foot White Rock Mountain rising beyond, near East Maroon Pass.*
ABOVE *Intense alpenglow penetrates a cloud just long enough to tint an unnamed peak above Avalanche Creek.*

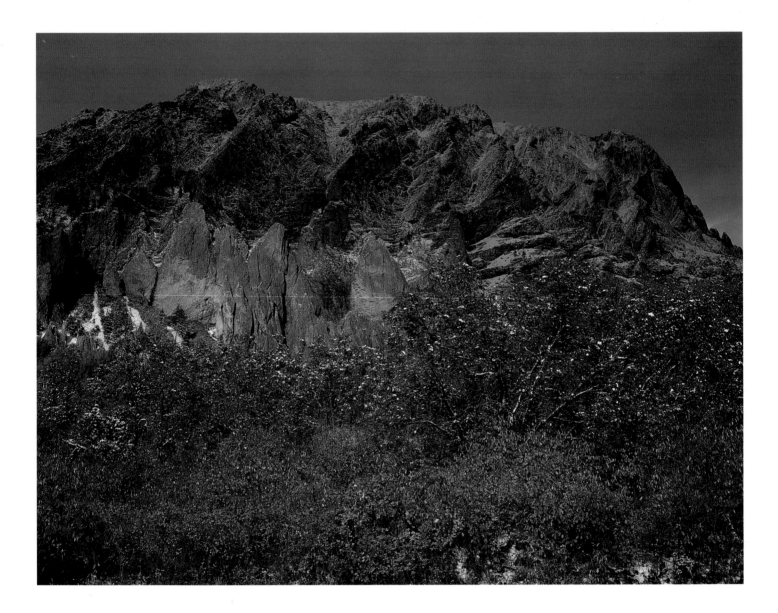

ABOVE *In autumn, a fresh dusting of snow outlines the massive cliffs of 11,348-foot Marcellina Mountain, near Kebler Pass.*
RIGHT *Mount Owen, at 13,058 feet, is the highest peak in the Ruby Range, Raggeds Wilderness.*

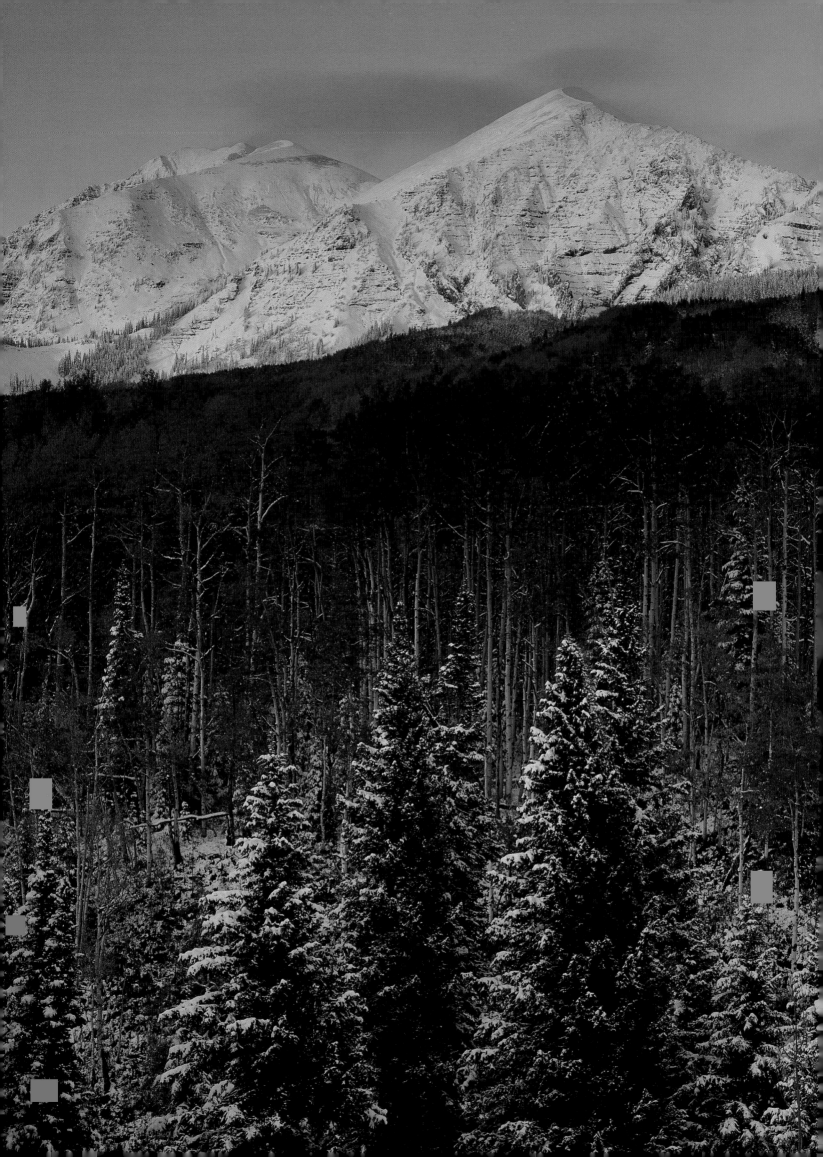

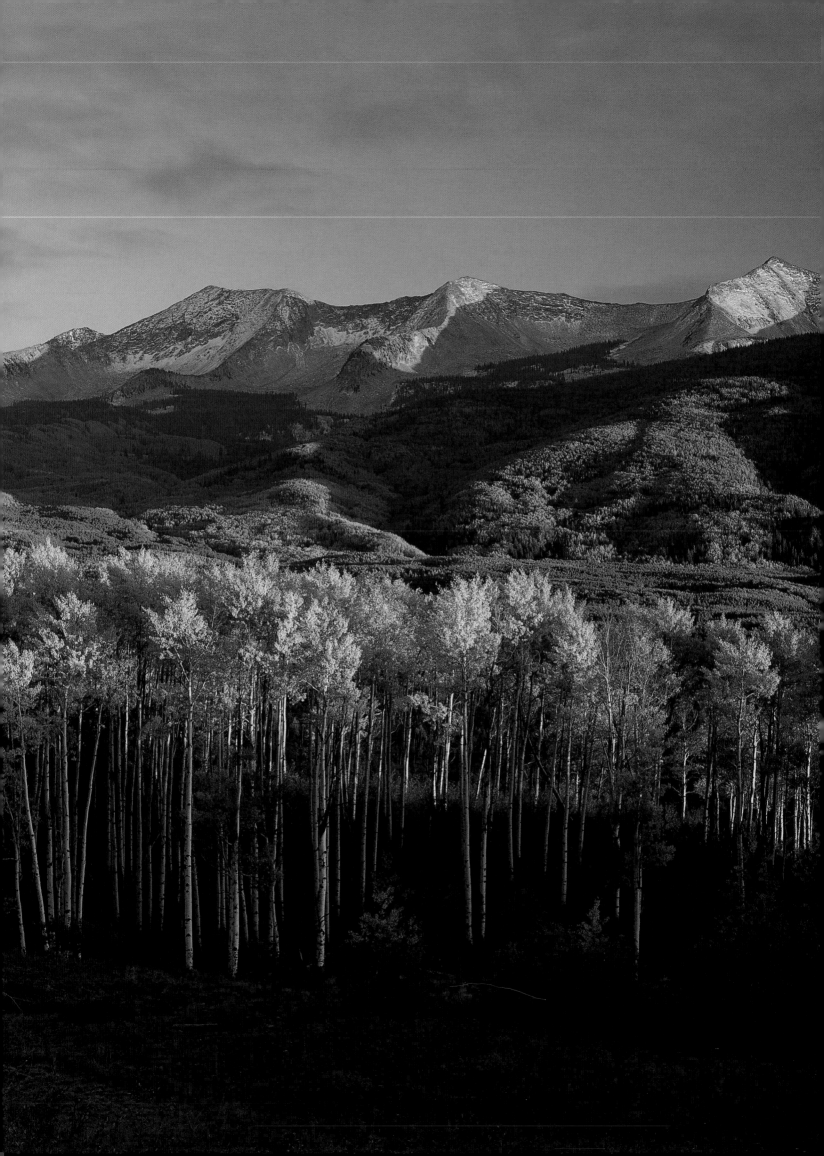

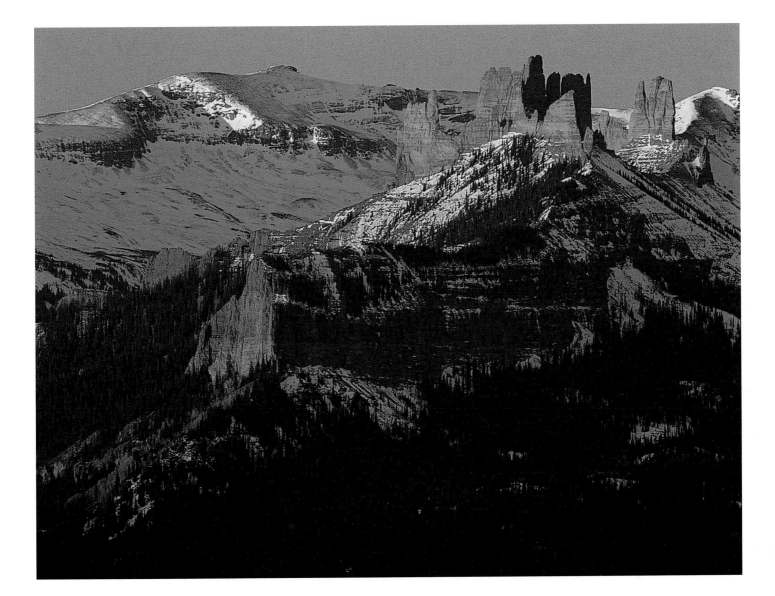

LEFT *Viewed here from near Kebler Pass, 12,432-foot East Beckwith Mountain backdrops a stand of aspens, Gunnison National Forest.*

ABOVE *A fresh snowfall outlines the broken pinnacles of the Castles, shown from near the summit of Ohio Pass.*

BELOW *A golden aspen forest shimmers in translucent light, Kebler Pass.*

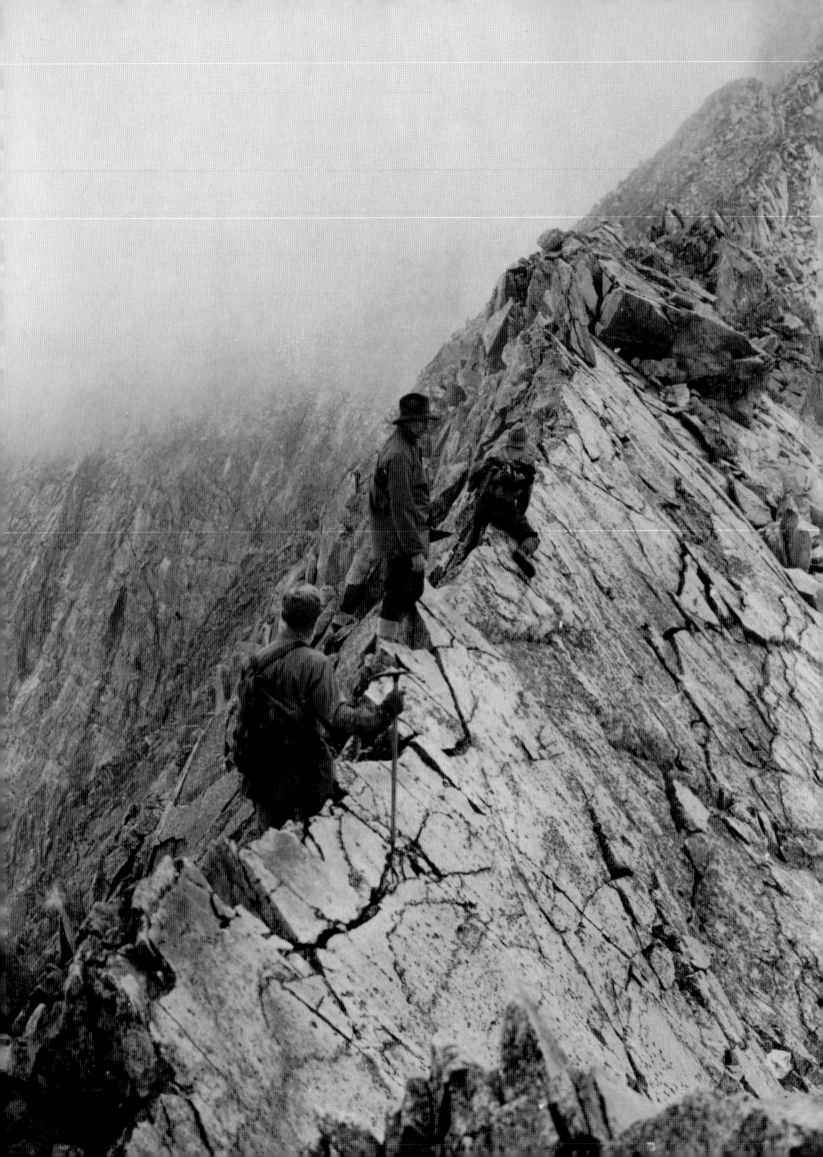

Today the scene looks as if someone once labored long and hard to dig scores of postholes into the rocky banks of the Purgatoire River. But a hundred and fifty million years ago, this dry scrubby canyon was actually a lake, the surrounding landscape was much different, and the local wildlife was a little, well, wilder…. A herd of fifty-ton brontosaurs were pounding down the marshy shoreline in a tight group, adults forming a protective ring around the juveniles, defending them with their sheer size. Out of the underbrush, death charged across the muddy flats, as a pack of allosaurs (large, fast, and vicious) closed in. These marauding, two-legged carnivores were each as long as a city bus. Accelerating through the mud with their powerful clawed feet, they attacked the herd of vegetarians, hoping to pull down a youngster, or one of the old and infirm, amid the tumult.

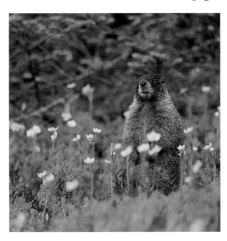

But the allosaur attack went awry when some of the brontosaurs turned to make a stand. They snapped their long tails like whips and kicked with clawed forefeet. A few even reared on their hind legs to crush their attackers. Facing this united front, the allosaurs retreated, realizing that it might be better to go hungry than to be squashed.

This grand battle is not mere fantasy, nor a Hollywood script. Scientists who have studied the site say just such a clash of giants probably occurred on this remote stretch of land, a little south of La Junta. They base their conjectures on the footprints that the monsters left behind: both banks of the Purgatoire are dotted with these hardened impressions, making up the world's longest fossilized dinosaur highway.

Sadly, there are also other, more recent denizens who no longer tread the mountains and valleys of Colorado. The grizzly bear is not yet extinct but it is under heavy pressure. This massive and sublime creature roamed Colorado until very recently. Although its name came from its grizzled coat and not its fearsome temper, the grizzly has often been portrayed as a bloodthirsty killer who attacks without provocation. Though this is an exaggeration, it is certainly true that grizzlies fear no other animal in the wild. The grizzly is listed by the federal government as "threatened" in the United States outside of Alaska; and it is classified as "endangered" in Colorado. The last documented grizzly in Colorado was killed in 1979, and there is little chance that any grizzly bears remain in the state.

Two types of wolves once roamed Colorado, but pressure from civilization also resulted in their disappearance. Wolves were trapped for their fur during the nineteenth and the first quarter of the twentieth century; subsequently, intensive private and governmental poisoning further decimated them. The last remnants of Colorado's native wolf population were probably eliminated in the

LEFT *Climbers in fedoras and hobnail boots assemble for the first known photograph of Knife Edge Ridge on Capitol Peak, 1925.*
ABOVE *A yellow-bellied marmot peers above spring wildflowers, Minnehaha Gulch, Maroon Bells–Snowmass Wilderness.*

1940s. The Division of Wildlife receives reports of sightings every year, but there is no strong evidence to show that wolves have survived in Colorado.

Happily, some species that were seriously threatened have rebounded in Colorado. The mountain lion once enjoyed extensive distribution throughout the continent. Today the only viable populations exist in the remote western reaches of the United States and Canada. The Colorado Rockies is one of the few areas in which these magnificent cats still manage to thrive. Two of the habitat factors most important for their survival are prey availability and stalking cover. Therefore, lions are most abundant in the woodlands, mountain shrub, lower montane forest, and short-grass habitats on the prairie. The single most predictive feature of a viable lion habitat is the presence of mule deer. Lions are most active at night and are extremely secretive, solitary animals. It is easy to live one's entire life in lion country and never be lucky enough to see one. In my long residence in this state, much of it spent outdoors, there has only been one occasion when I have been fortunate enough to witness a great cat in its natural habitat. It was just a momentary glimpse at sunrise, when I was camped along the Front Range, but it left an indelible impression of wildness.

There are other success stories as well. Along with the mountain lion, the bald eagle has remained as

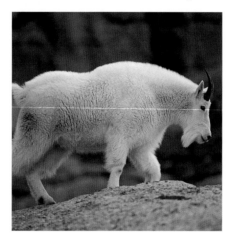

an inspiration. I remember well the first time that I saw a bald eagle in Colorado. More years ago than I care to recall, I was driving down Highway 36 between Boulder and Denver on a cold winter day. Traffic was slow and I had time to look around a little. I gazed out across the shoulder of the road, scanning the wintry fields and subdivisions, ditches and train tracks. This was a relatively urban area and I certainly wasn't expecting to see spectacular wildlife, but out of the corner of my eye, I noticed some very large birds perched in several old cottonwood trees. I nearly dismissed them as the omnipresent ravens that come to the highway to dine on flattened squirrels. However, a quick second glance revealed that these birds were no common ravens but real, live bald eagles. Here I was in my car, on the edge of a major city, and not one hundred yards from where I and thousands of others drove our cars, sat several very wild, very beautiful creatures, without an apparent concern in the world.

At that moment, I realized just what a truly wild and untamed place Colorado remains, even in the face of the modern age. I was reminded of my reasons for coming to the region in the first place. There is still a sense of the wild here, a connection between humanity and nature that is present even in the midst of a hectic rush-hour commute.

ABOVE *The lovable and elusive mountain goat defies gravitational logic by climbing routes that require a rope for most mountaineers.*
RIGHT *Afternoon thunderheads build over the massive Capitol Peak (14,130 feet), Maroon Bells–Snowmass Wilderness.*

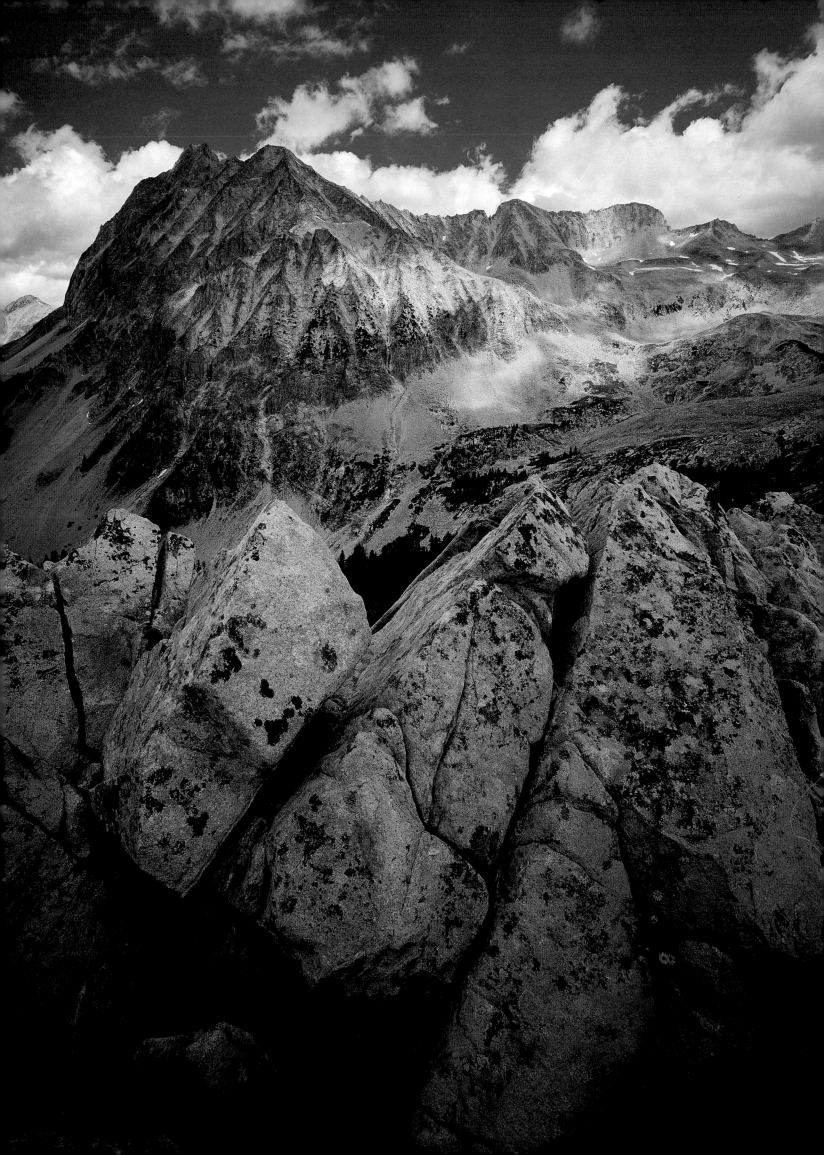

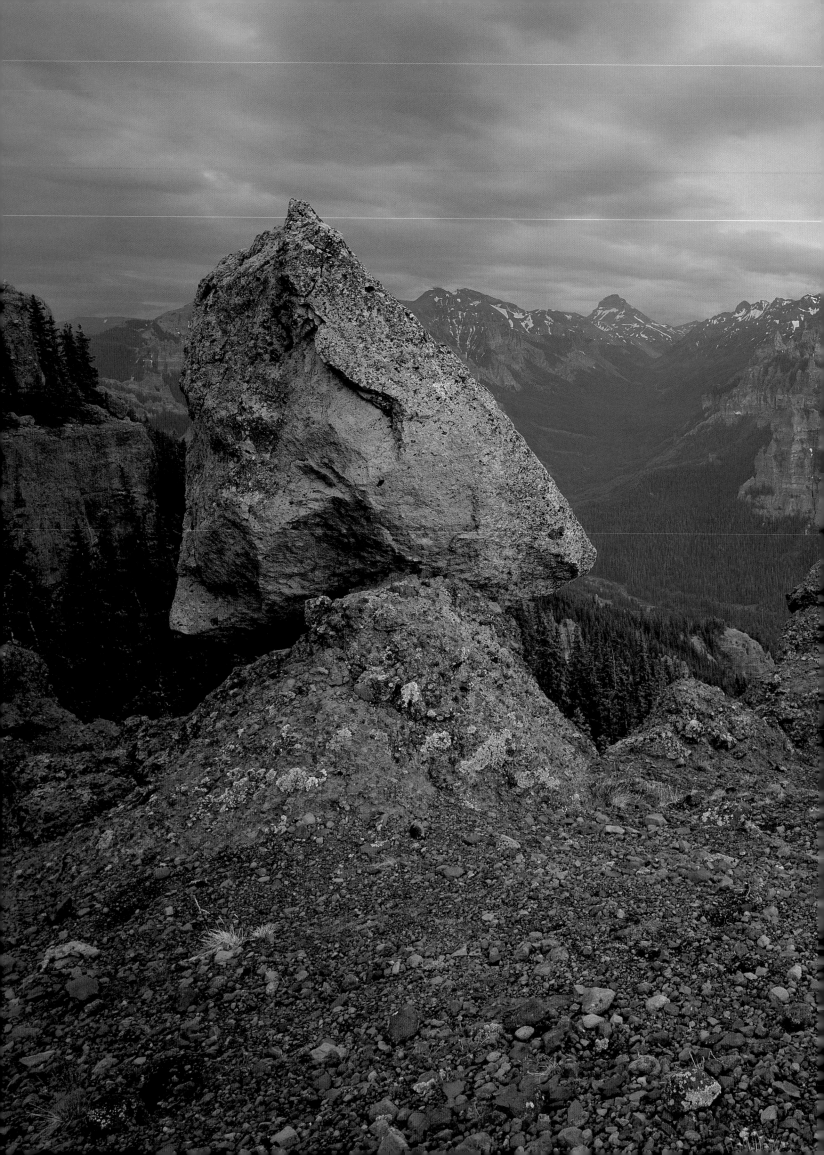

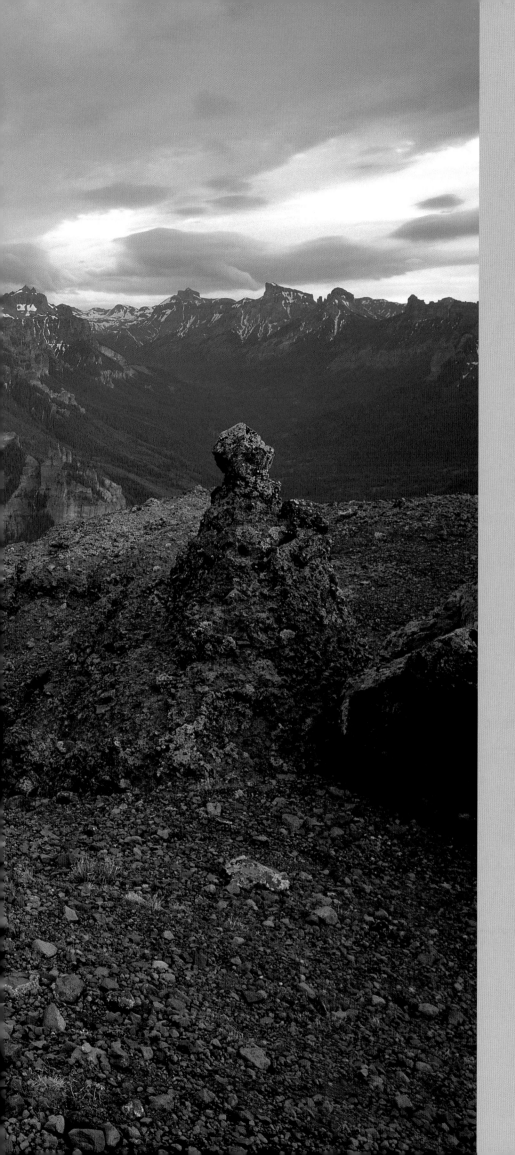

SAN JUANS

A seemingly endless ocean of peaks, pinnacles, and magnificent rock faces, the San Juan Range contains more land above 10,000 feet than any other mountain range in the continental United States.

Great wilderness areas abound in the San Juans: the Weminuche, La Garita, Mount Sneffels, Uncompahgre, Lizard Head, Powderhorn, and South San Juan. Nine stately subranges rise here as well, elegant tracts like the Needle and West Needle Ranges, and the San Miguel, Grenadier, and the Sneffels Mountains, to name a few. The distinctive slopes of red and orange rock are remnants of heavy mineral staining and a violent volcanic heritage.

Thirteen fourteeners push upward here, mammoths of ragged proportions, beckoning scores of climbers to their ledges and gullies. Thankfully, most of the vistas from the highest San Juan summits are as uncluttered as they were in days gone by. A ride on the Durango-Silverton Narrow Gauge Railroad is truly a journey into the past; passing thus below the Needles and Grenadiers is perhaps the greatest wilderness experience one can have in Colorado without hiking.

—EW

LEFT *A huge granite "mushroom" balances precariously before a vast panorama of peaks of the San Juan Range in the Uncompahgre Wilderness, also known as the "Land of the Big Blue."*

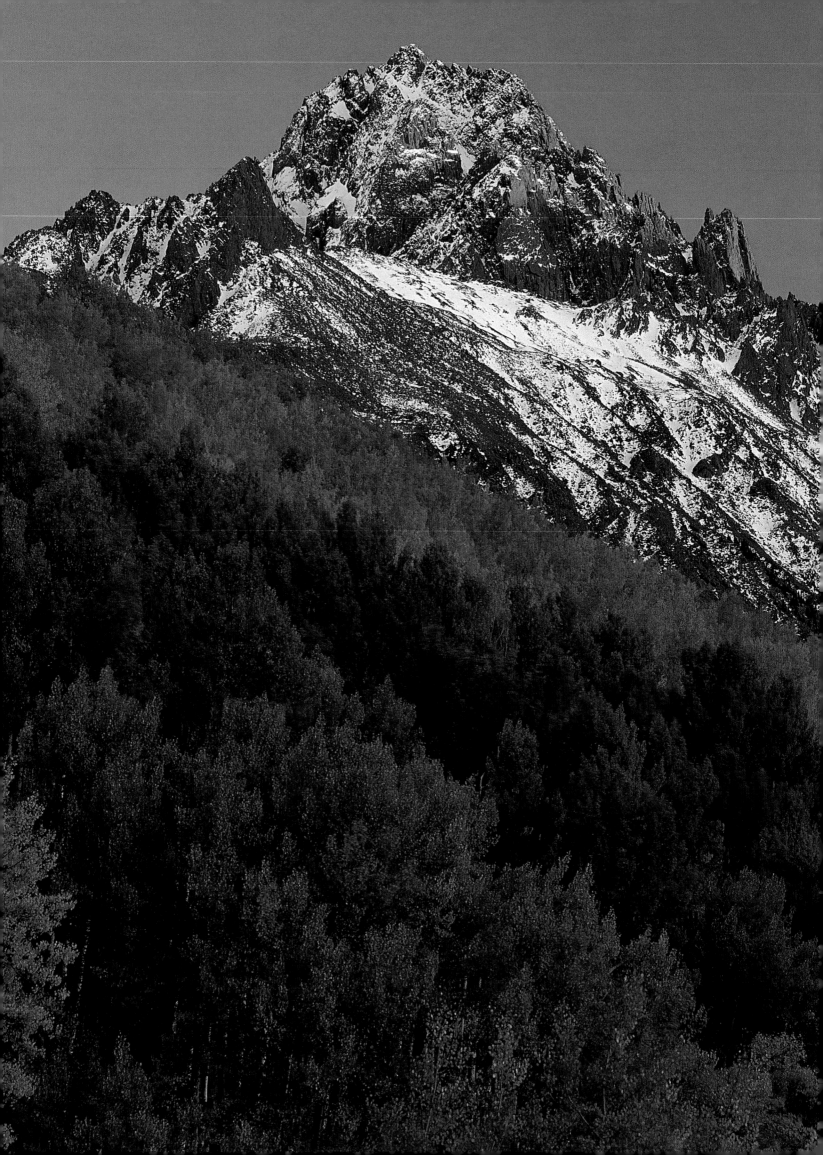

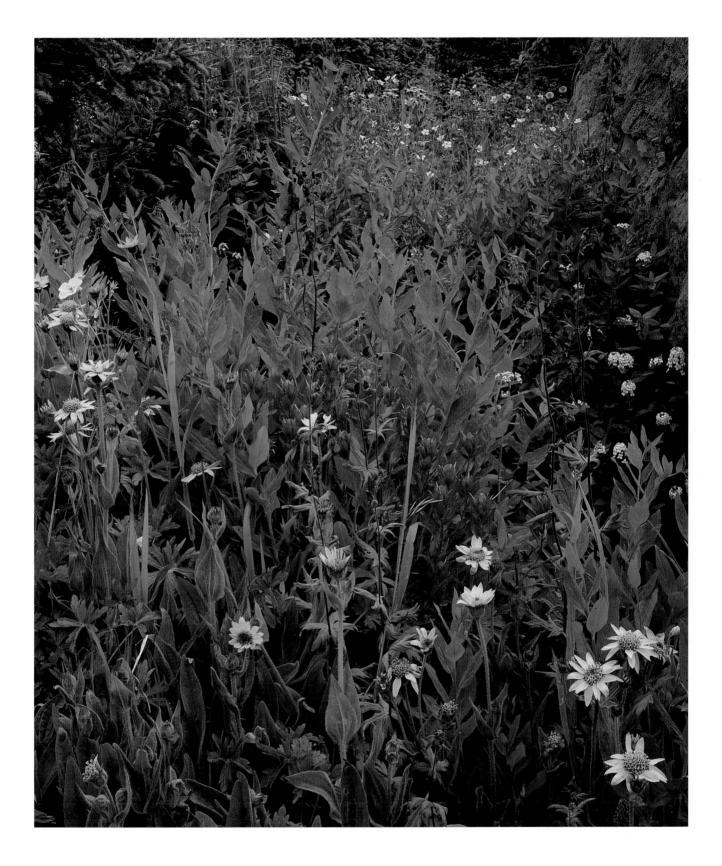

LEFT *Mount Sneffels (14,150 feet) is the centerpiece of the 16,505-acre Mount Sneffels Wilderness, a popular day-trip area.*
ABOVE *Arrowleaf balsam root and giant red paintbrush dot hillsides along the Little Cimarron River.*

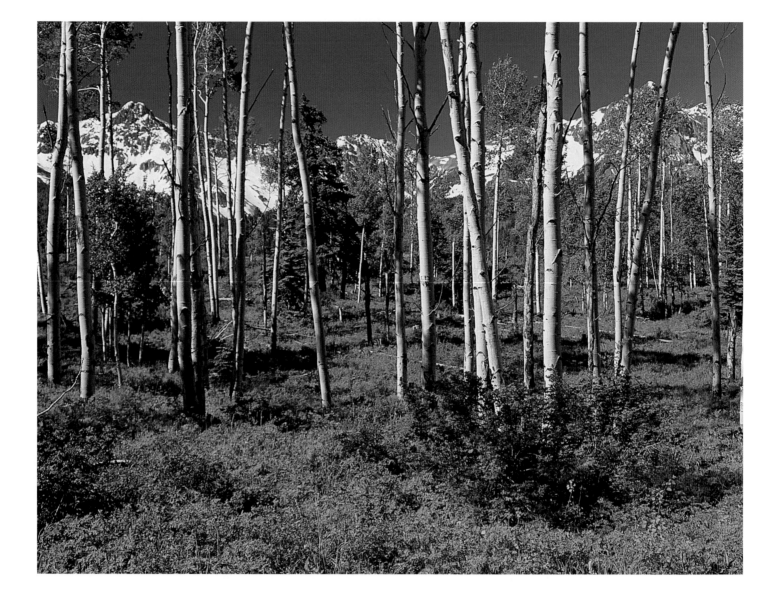

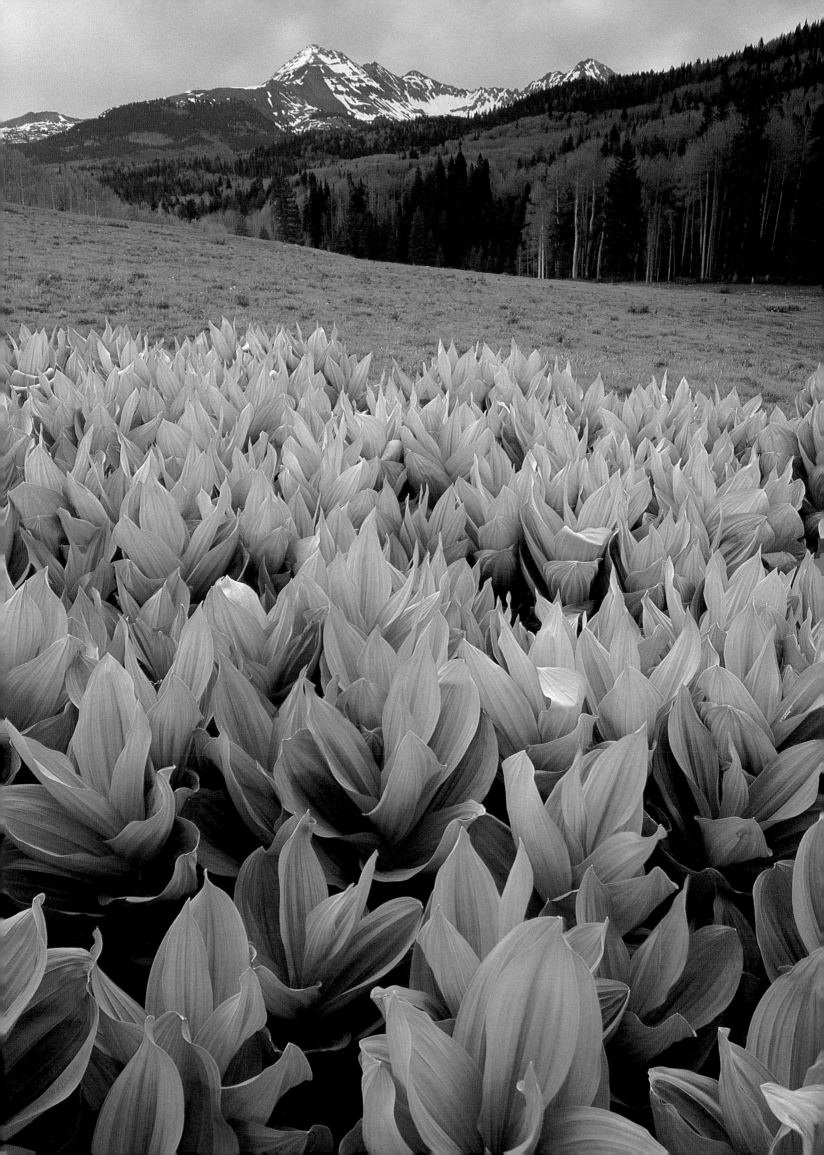

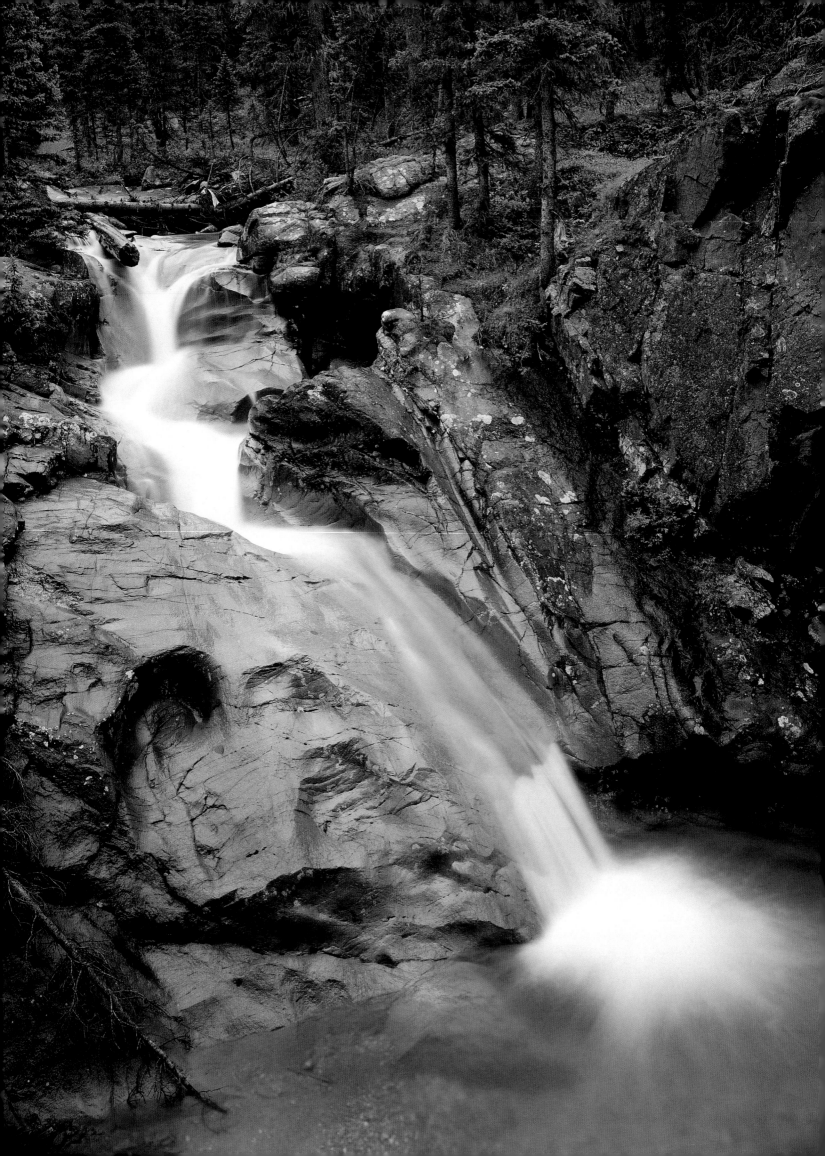

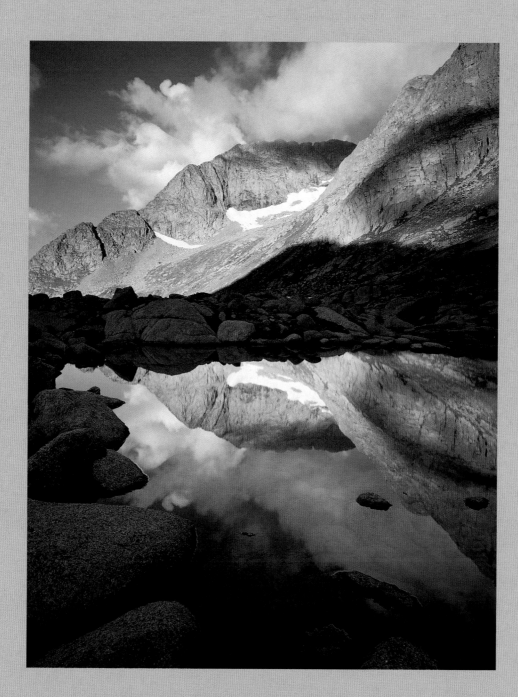

LEFT *A Chicago Creek waterfall plunges through verdant forest, Weminuche Wilderness.*
ABOVE *Mount Eolus, at 14,083 feet, is the highest peak in the Needle Range.*
BELOW *The fly agaric, Amanita muscaria, thrives at Vallecito Creek.*

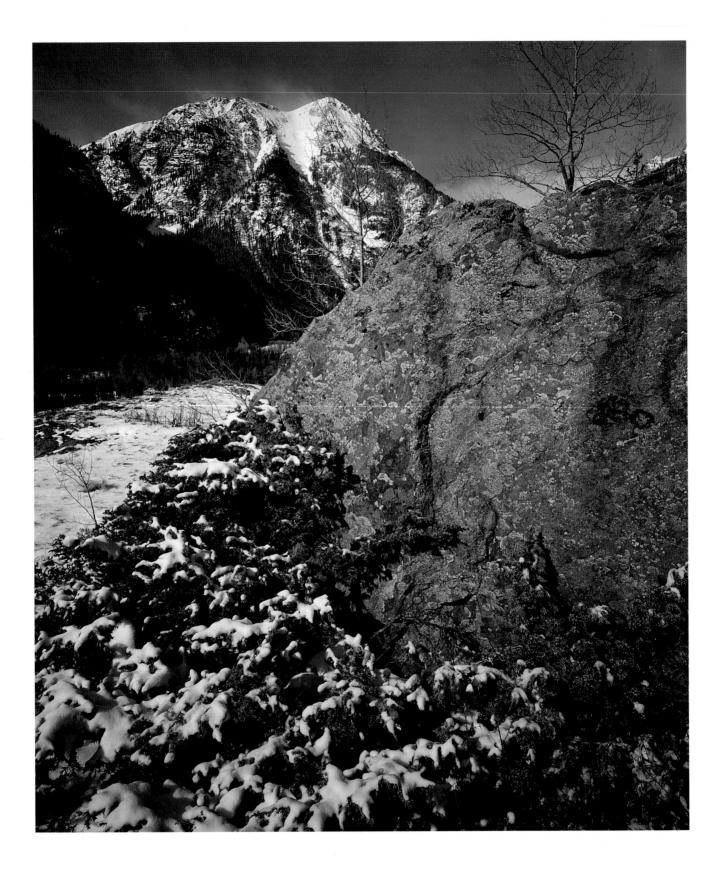

ABOVE *Snow plumes rise above 13,841-foot Half Peak following a spring storm, near the Lake Fork Gunnison River.*
RIGHT *The deepest snow of the year buries 13,113-foot Lizard Head Peak, Lizard Head Pass, San Miguel Mountains.*

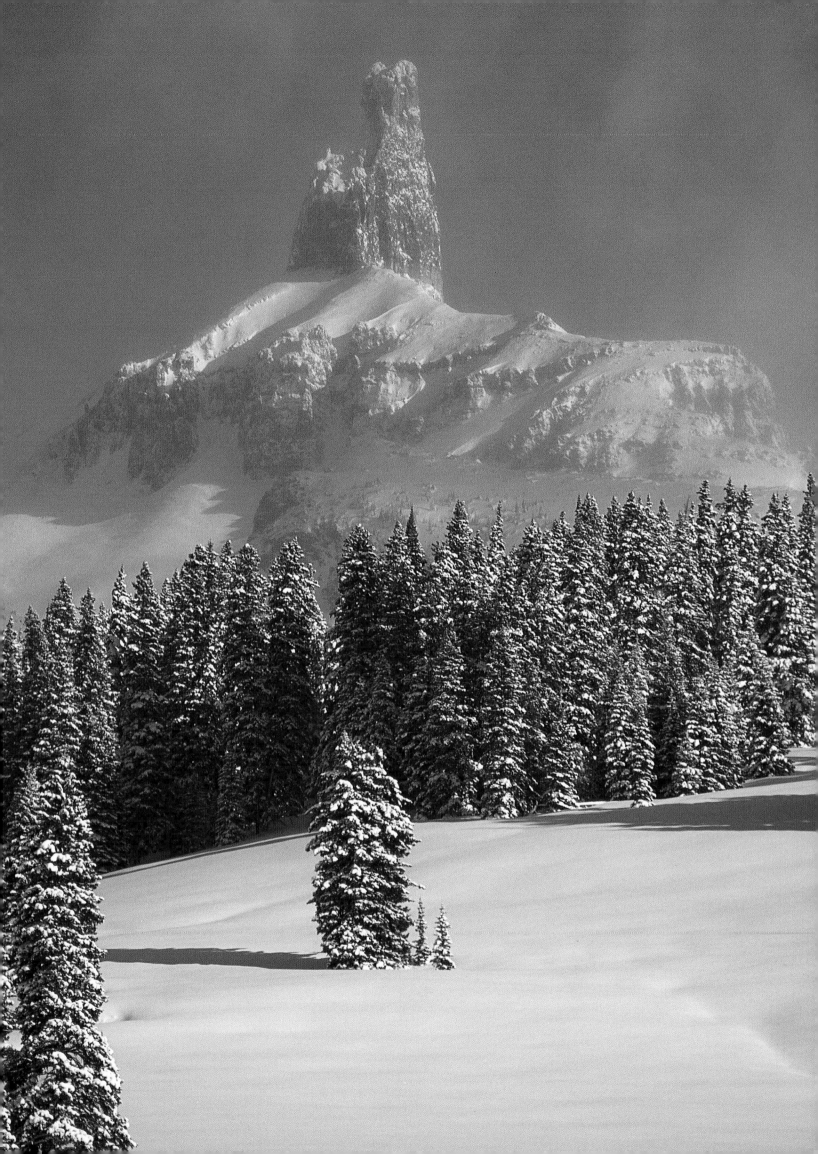

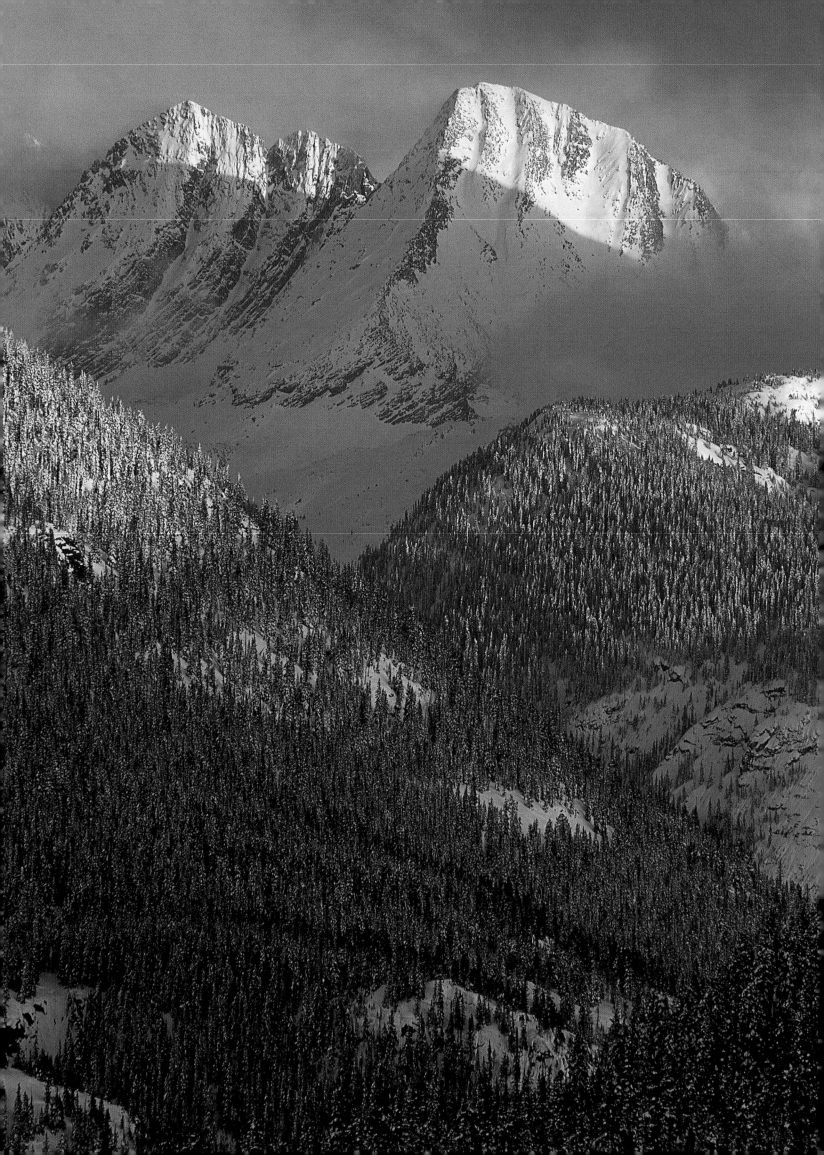

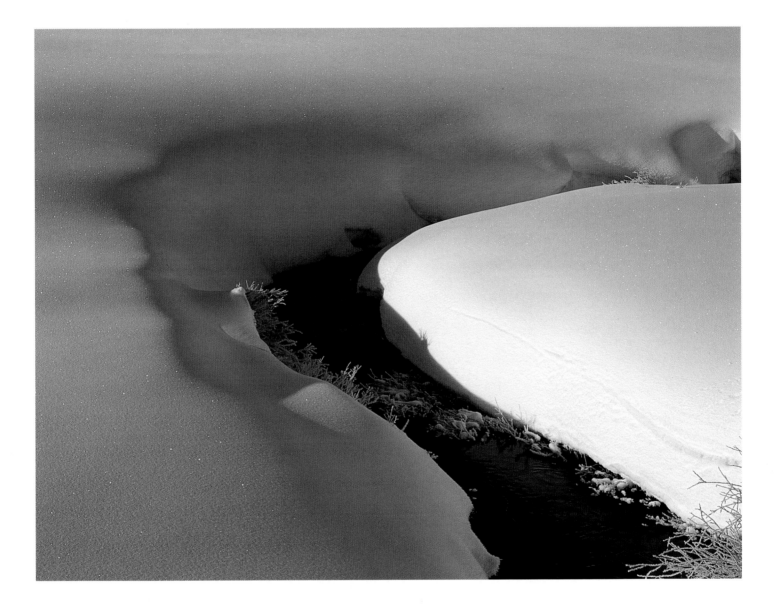

ABOVE *After a long dry spell, East Lime Creek has been transformed into a winter wonderland, near Molas Pass.*

OVERLEAF *Alpine sunflowers brighten a hillside above the Navajo River, South San Juan Wilderness.*

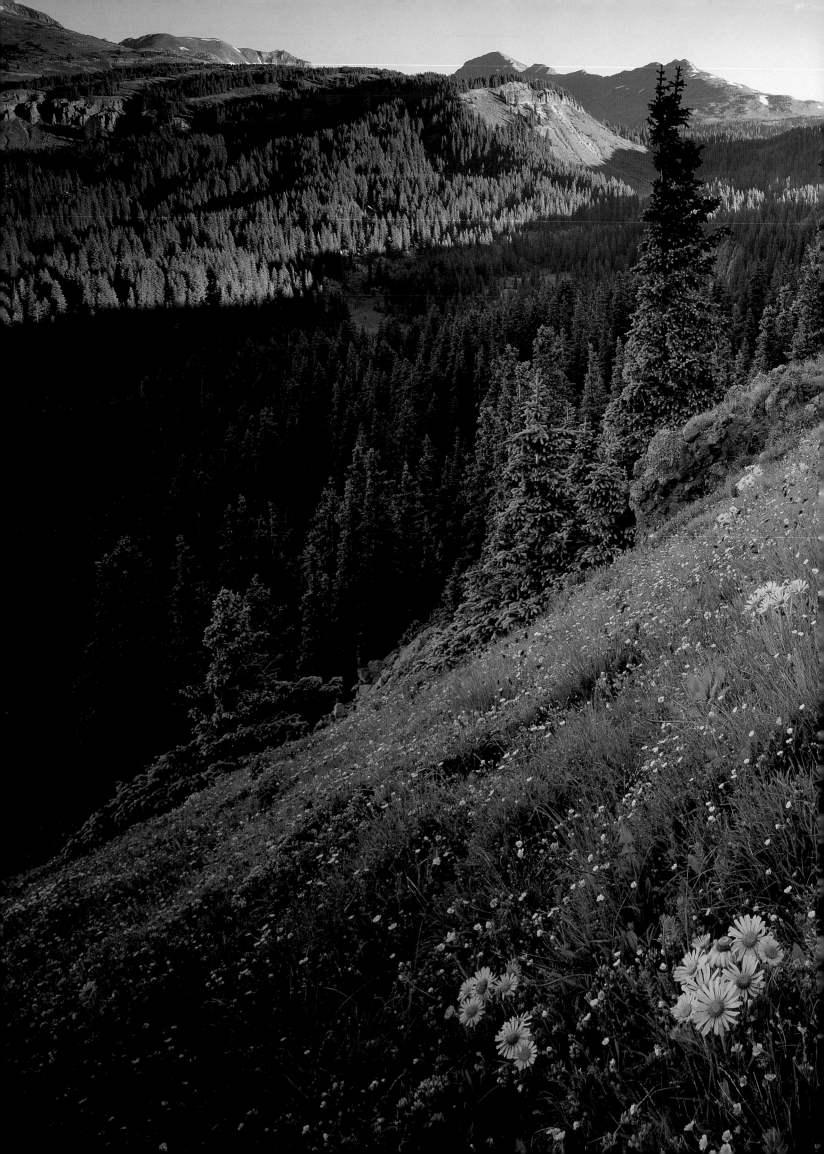

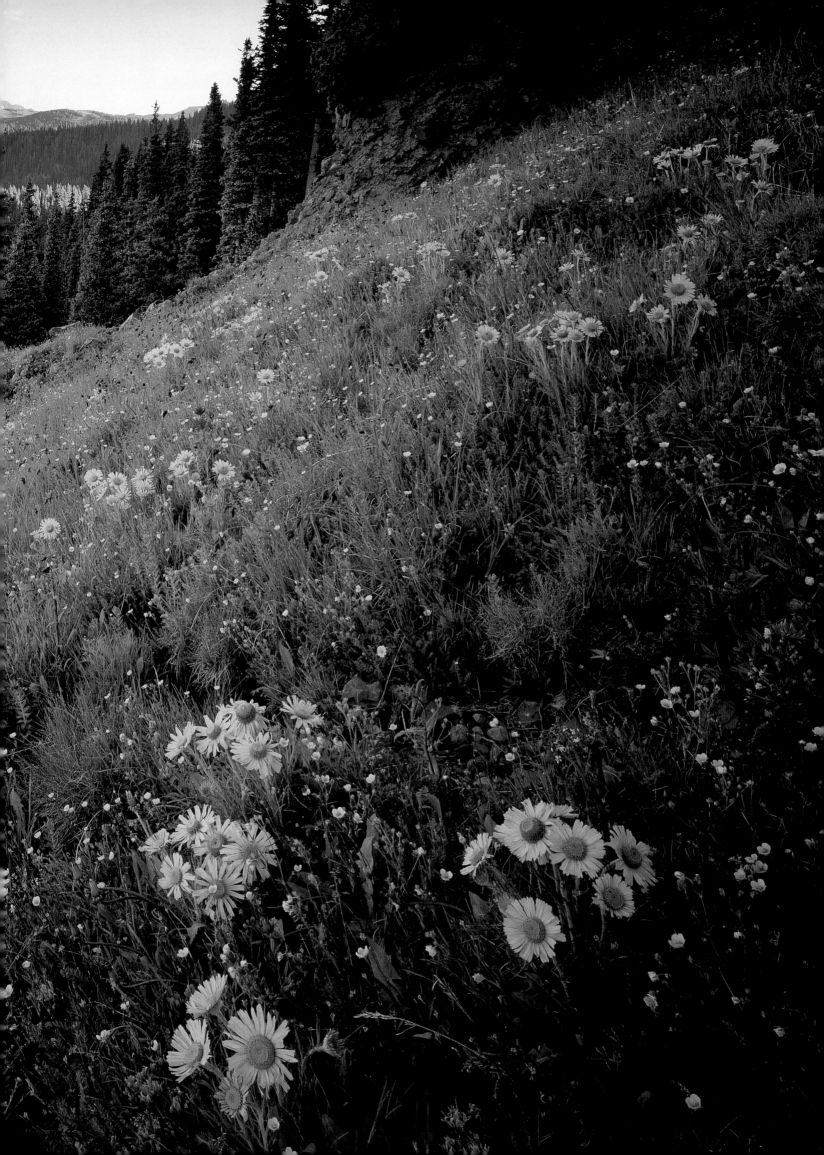

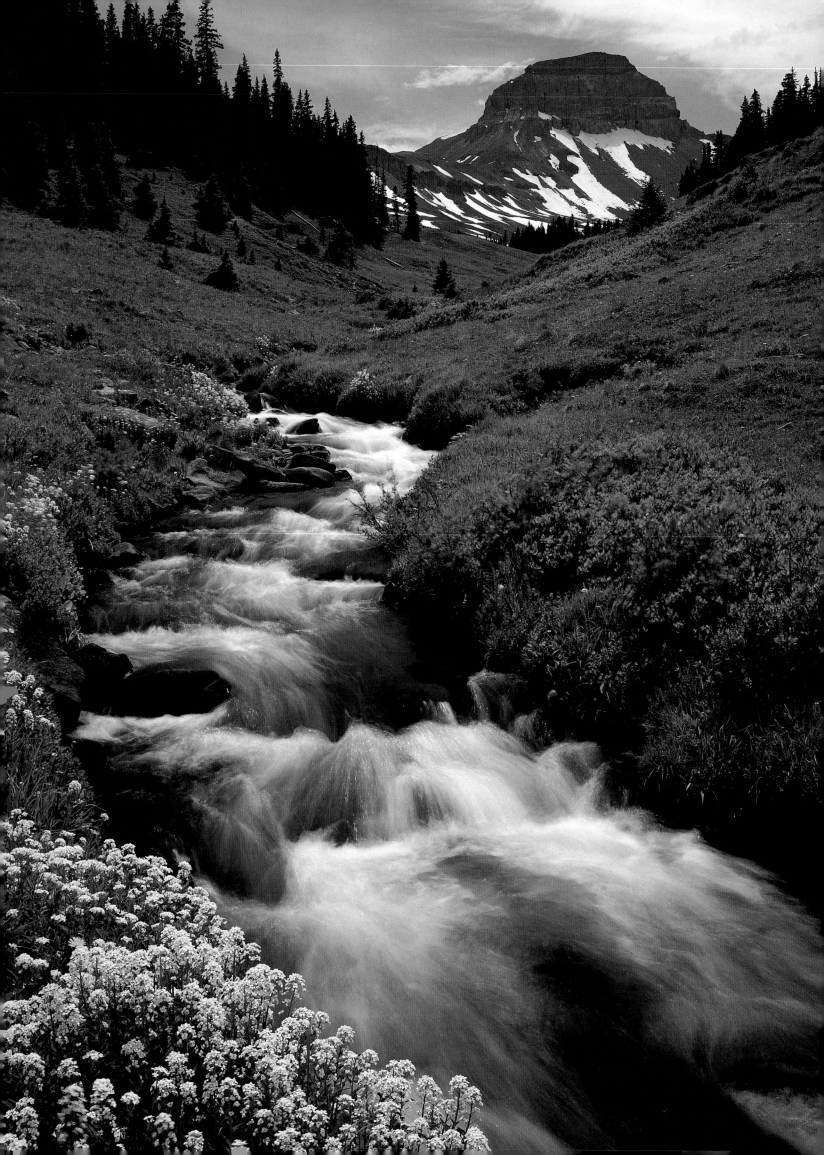

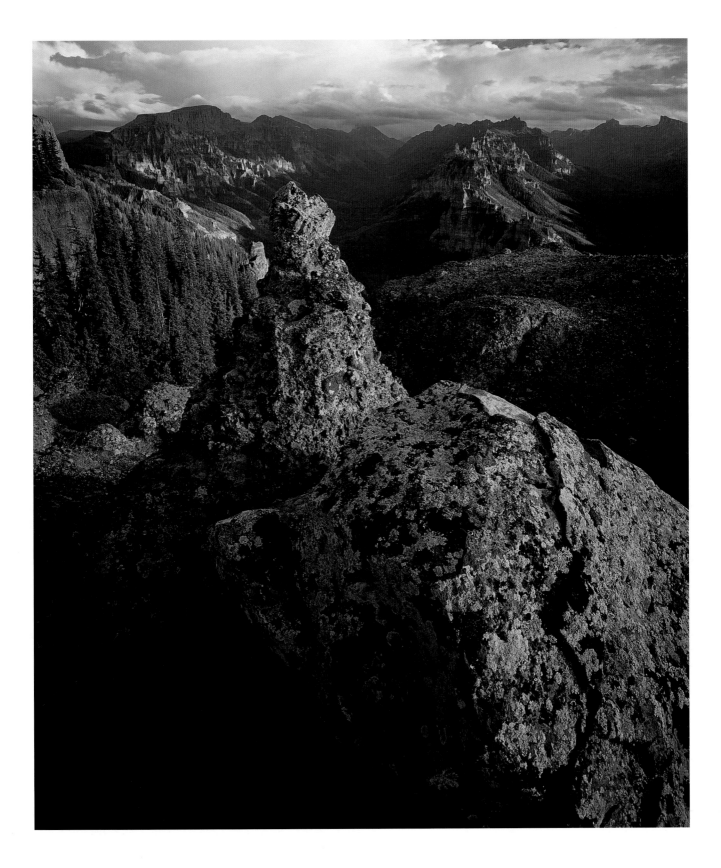

LEFT *Flowers adorn the banks of Big Blue Creek with 14,309-foot Uncompahgre Peak rising beyond, Uncompahgre Wilderness.*

ABOVE *Even where other plant life cannot find root, lichens flourish on boulders and rock pinnacles of the San Juans.*

ABOVE *Elegant rock pinnacles, reminiscent of medieval European cathedrals, reach for the clouds above a fork of the Cimarron River.*
RIGHT *Volcanic influences formed the Sneffels Range, ruled by 14,150-foot Mount Sneffels on the right.*

120

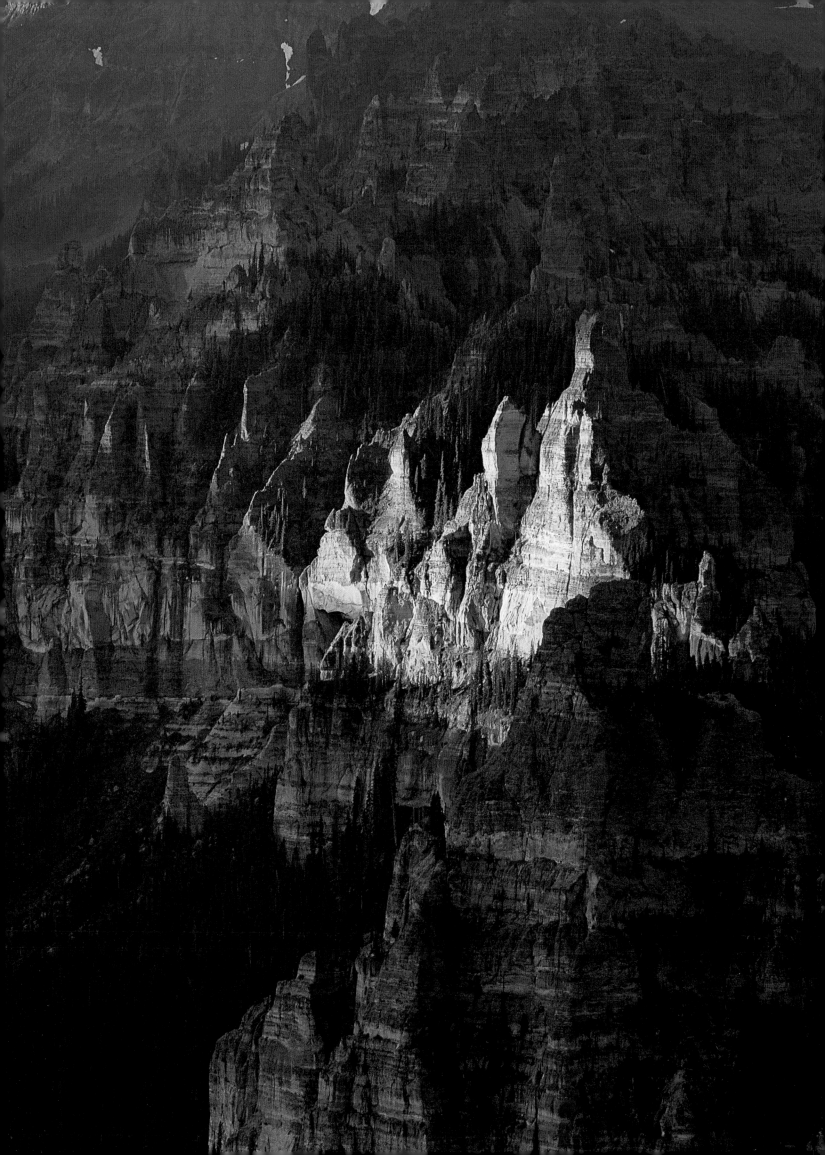

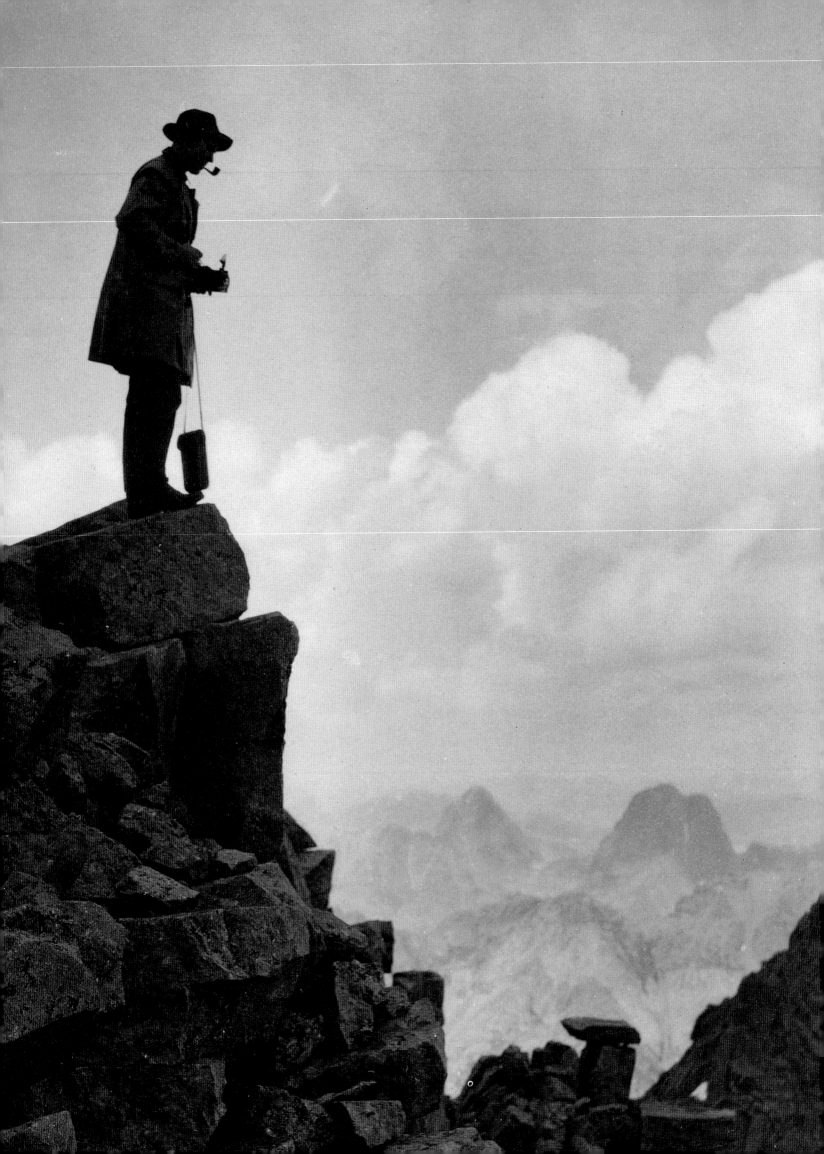

HIGH LIFE *The People*

The inhabitants of the Rocky Mountains tend to be just a bit different from most other folks. It may be that living in the shadows of giants, constantly gazing upward upon the vertiginous heights, slowly alters a person's perspective on the world. Whatever the reason, the people who live here seem to take on the characteristics of the mountains around them. Isolation breeds independence of both thought and action, and long winters teach self-reliance. Perhaps it is due to factors such as these, or just a relative lack of oxygen getting to the brain, but life in the Rocky Mountains has produced many memorable characters.

There have been visionaries, like William Jackson Palmer and John Wesley Powell. Palmer, a Quaker, nevertheless enlisted in the Civil War to fight the horror of slavery, eventually rising to the rank of General! As a railroad engineer, he mapped many early routes, and later founded the Denver & Rio Grande, and the city of Colorado Springs in the process. Powell is most often remembered for his nine-hundred-mile descent by boat of the Green and Colorado Rivers, through the Grand Canyon, in 1869. A pioneer of the U.S. Geological Survey, his early recognition of the crucial importance of the water resources of the region was one of the wellsprings of the conservation movement.

The small, picturesque mountain town of Lake City is undoubtedly best known for a somewhat less savory character. In the winter of 1873–74, a prospecting party

from Utah reached the camp of the Ute chief Ouray, who warned them not to try to reach the Breckenridge gold strike in winter, and invited them to stay at the camp until spring. Most accepted, but Alferd Packer, along with five other men, pushed on. Soon, they became trapped in the mountains by heavy snow and cold temperatures. Six weeks later, Packer emerged near Lake City, alone. He told a story of hardships, of an injury that prevented him from keeping up with the others, of near-starvation while subsisting on roots and small game. But his appearance and behavior didn't match his story, which gradually unraveled. A few months later, the bodies of the other men were found; Packer had apparently demonstrated true Rocky Mountain grit and resourcefulness by killing and then dining on his companions.

Eventually arrested for murder, Packer escaped before his trial. He was recaptured nine years later and finally brought before a court. In a widely believed but almost certainly apocryphal story, the presiding Democratic judge is supposed to have hollered, "There was only seven dimmycrats in all Hinsdale County, and you, you voracious man-eatin' s.o.b., you done 'et five of 'em." (The county votes Republican to this day.)

Though sentenced to hang, Packer managed to escape the gallows because he had been arrested under the laws of Colorado Territory and tried under the laws of Colorado State. He did, however, spend fifteen years in jail for

LEFT *William Ervin enjoys an aperitif on the summit of Mount Eolus (14,083 feet), Needle Range, Weminuche Wilderness, 1920.*
ABOVE *A camper prepares to retreat from an imminent squall, northwest fork of Big Blue Creek, Uncompahgre Wilderness.*

manslaughter. Today, Packer is memorialized by the Alferd Packer Memorial Grill in the cafeteria at the University of Colorado in Boulder; The Alferd Packer Feasting and Friendship Society based in Lake City (dedicated to "Serving Our Fellow Man"); and the best-selling item in Lake City bookstores: an Alferd Packer cookbook.

Early mining towns in the Rockies developed a reputation for fast money and wild times. Mining was hard, dirty, and, above all, dangerous work; miners were a rough and tumble lot by necessity, and the towns they built were no different. With the discovery of silver in Creede in 1890, a town appeared almost overnight. With a reputation for day and night hell-raising, Creede attracted such notorious Old West personalities as Calamity Jane, Bat Masterson, Poker Alice, and Soapy Smith; Bob Ford, the man who shot Jesse James in the back, was eventually shot dead in his own saloon in Creede. When the Holy Moses mine in Creede went bust, the town essentially disappeared as fast as it was born.

Law and order grew slowly in the high country. Problems were particularly bad in quickly growing, wealthy communities like Leadville. One newspaper wrote that "for a number of years nothing was so cheap in Leadville as human life. Nor was the murderous instinct confined to the lower and less cultivated element..." While colorful tales of gunfighters, bankrobbers, and shootouts did make for good headlines, the most common

problem for mountain lawmen was keeping a measure of control over the dogs and the drunks.

Of all the Colorado mountain towns, perhaps the most telling example of the boom-and-bust cycle is the historic community of Telluride. Telluride relied heavily on silver to keep the good times rolling, and fell on hard times when the Sherman Act, which had subsidized the price of silver, was repealed by Congress in 1893. The country went to the gold standard and Telluride went to the dogs. Not long after, rich gold veins were discovered and Telluride exploded again. In time, the gold began to dry up and more hard times were in store.

Telluride was known as "To hell you ride" when the town was a brawling mining camp in the 1870s and 1880s. Today the richest ore in the Rockies is snow, and the phrase has been reborn for its skiing and snowboarding connotations. Developed as a ski town, Telluride is booming like never before. Long, steep runs and plentiful powder, combined with awesome natural beauty, have brought the good times back to this small town—with a vengeance. Vast amounts of money have poured into Telluride in recent years, and the population seems to double every season. Although managing to preserve much of its Victorian architecture, Telluride may be in danger of losing the very spirit that has made it uniquely successful. It could be that the greatest challenge the people of the Rocky Mountains will face in the coming century is the people themselves.

ABOVE *Avalanche blocks from Dallas Peak dwarf a hiker above Blue Lake, east fork of Dallas Creek, Mount Sneffels Wilderness.*
RIGHT *With so many peaks in Colorado, this one, even at 13,134 feet, remains unnamed, from Dallas Divide, near Ridgway.*

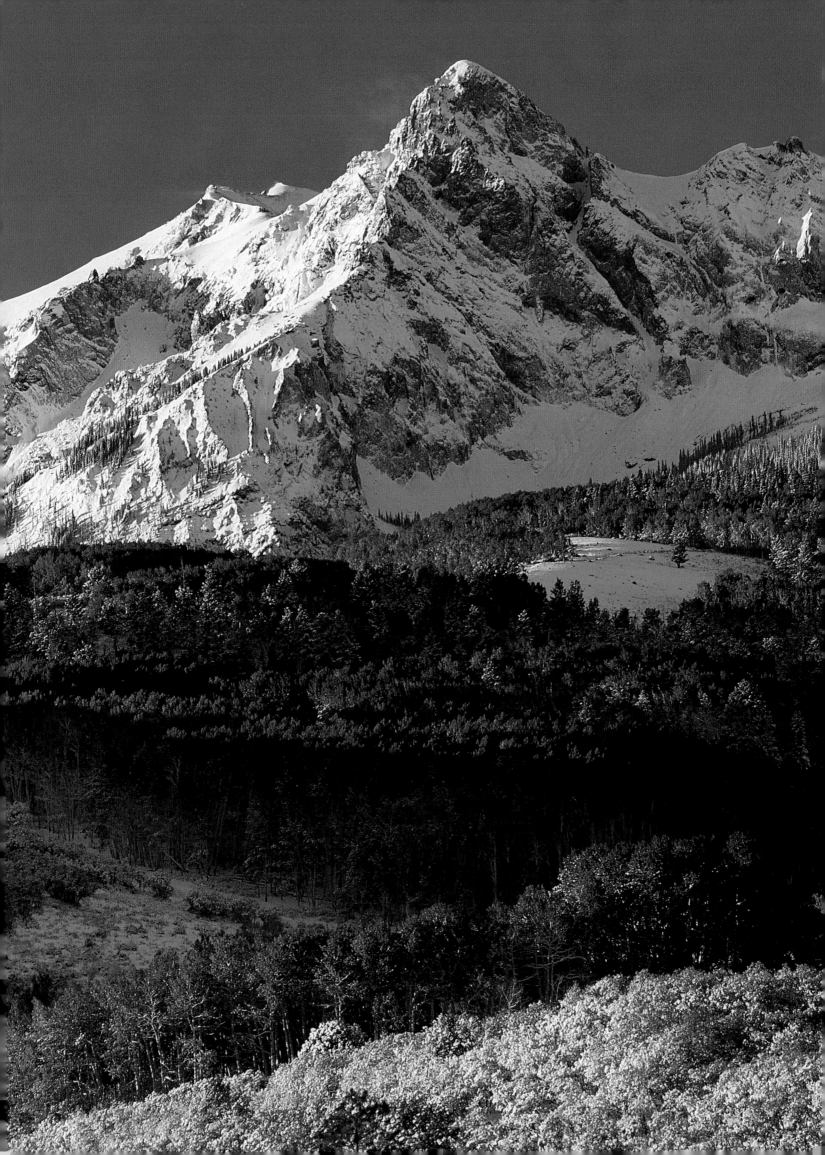

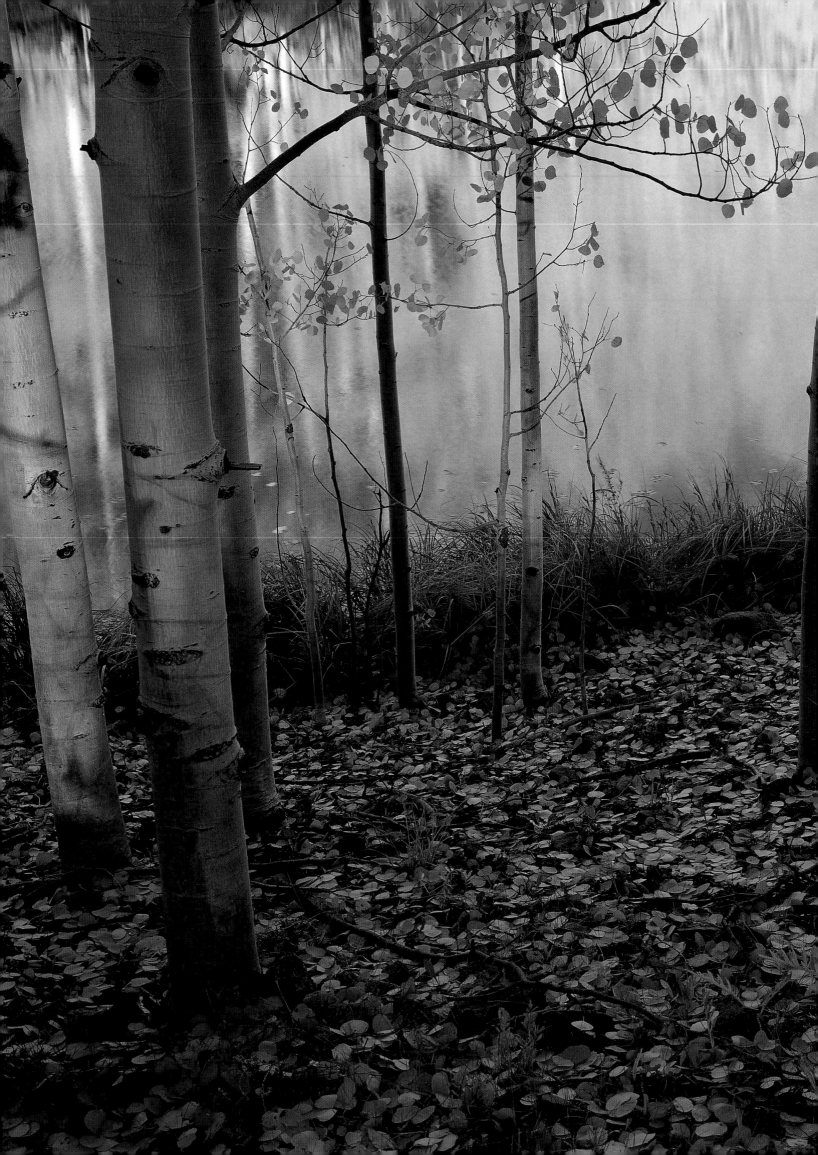

REFLECTIONS *The Good Old Days*

As far as I'm concerned, any day in the mountains is a good day. I would rather endure a fierce rainstorm in the mountains than confront rush hour in the city. In 1988, however, I created my own rush hour on Mount Evans when Sandra and I were married near the summit. Though *we* thought it was the best mountain day ever, I still find myself apologizing to our flatlander guests for depriving them of oxygen on that blustery August morning.

Certainly mountains are much more traveled today than at any time in history; nonetheless, with a bit of map study and a little extra sweat, it is still relatively easy to find places untrampled by fellow trekkers. Backcountry travel is our favorite way of finding solitude, but I still greet my fellow hikers as comrades, rather than intruders into "my" space.

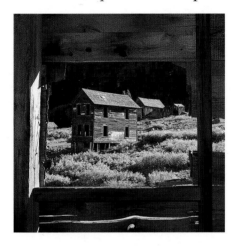

Ernest Hemingway wrote that mountain climbing, motor racing, and bullfighting were the only true sports; the rest were merely games. I concur with the first two-thirds of his sentiment. I have spent much of my life around racing, and was greatly influenced by drivers who courted the reaper and generally got away with it. I wonder if my passion for mountaineering was somehow cultivated by watching these brave drivers.

For proving that almost anything is possible, I acknowledge Gilles Villeneuve, Jody Scheckter, Eddie Miller, Bob and Buddy Lazier, and Scott Pruett, great role models all. For involving a teenager in their pursuits, I thank Jerry Hansen, Gary Passon, and Paul Newman.

Thanks to Herm Johnson and Ken Ziebell for advice during my formative painting and pinstriping days. For trusting a kid to decorate their cars, I want to thank John Barker, Bob Schader, Mark Clayton, and Tom Lamm. Many thanks to the exceptional teachers Richard Schmidt, Ernest Nicolette, and Beth Andersen.

For high ambition, thanks to mountaineers Dave Osborne, Walt Borneman, and Rick Ridgeway. For artistic inspiration, thanks to Jim Popp, Bob Stocker, and David Muench. And for trail support, thank you to Mike and Chuck Costello and Mark Talbot.

Thank you also to my first client in the real world, Steve Anderson, then of Empire-Lakewood Nissan.

I am indebted to Chuck Renstrom's Colorline Photographics of Lakewood, Colorado. Thanks also to Reed Photo-Imaging for exceptional care, and for my supportive photography clients, too many to list here.

I also wanted to thank Trails Illustrated/National Geographic Maps for helping us find our way, and Merrell Performance Footwear for traction to get there.

Special thanks go out to my parents Keith and Eunice for showing me the land, and to Jacob and Elsie Gillmann for Sandra. Heartfelt thanks to Dick Lamm, and Graphic Arts Center Publishing® for believing in me.

Without these people, I'm not sure where or what I would be today. These are the good old days.

—Eric Wunrow

LEFT *The waters of a serene pond near Lizard Head Pass reflect the autumn radiance of an aspen forest, San Miguel Mountains.*
ABOVE *A window to the past reveals an aging hotel that is soon to be buried in winter snows, ghost town of Animas Forks.*

14,059 feet

12,520 feet

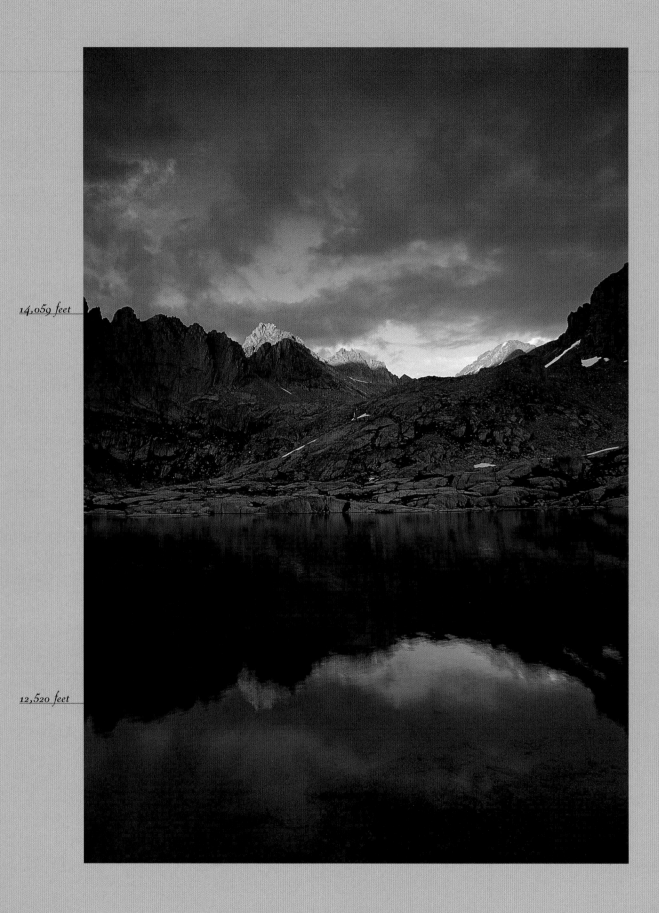

Red-tinted Sunlight Peak 14,059 feet, and Sunlight Spire, 13,995 feet, shown here with Windom Peak, are aptly named.

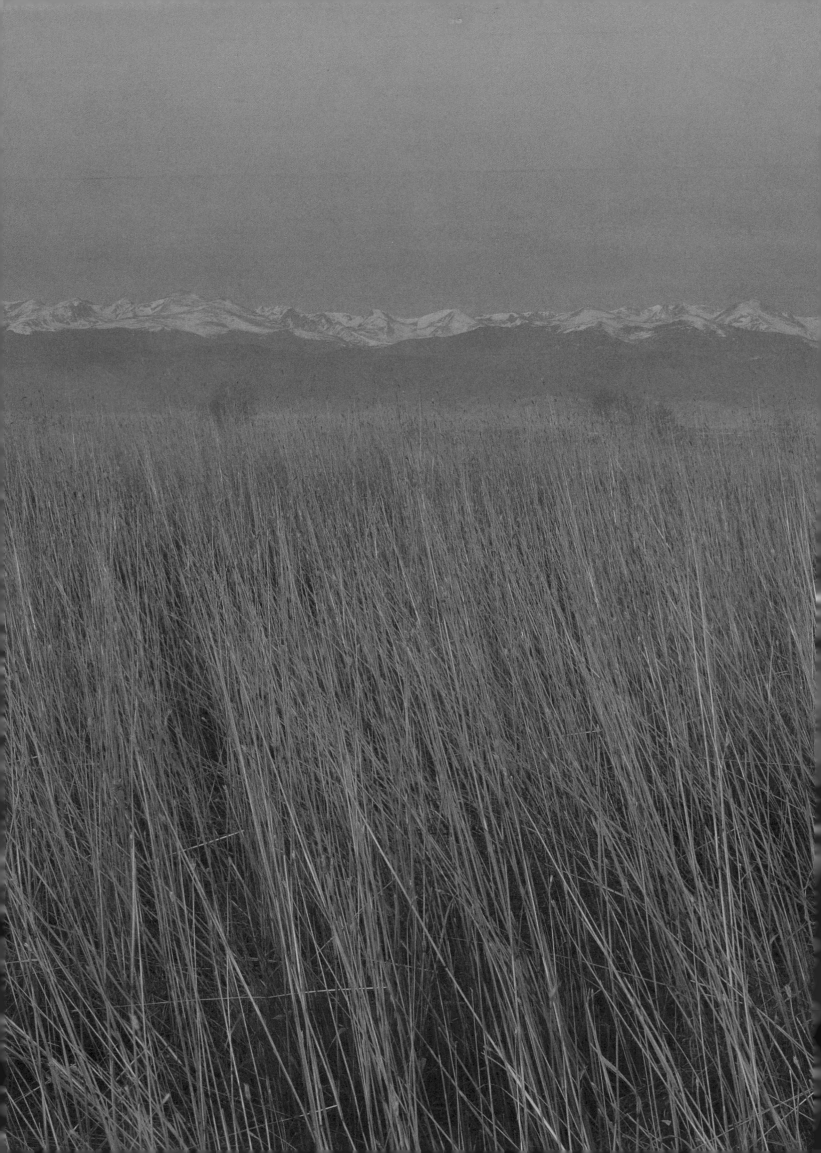